Arthur Dove:

A Retrospective

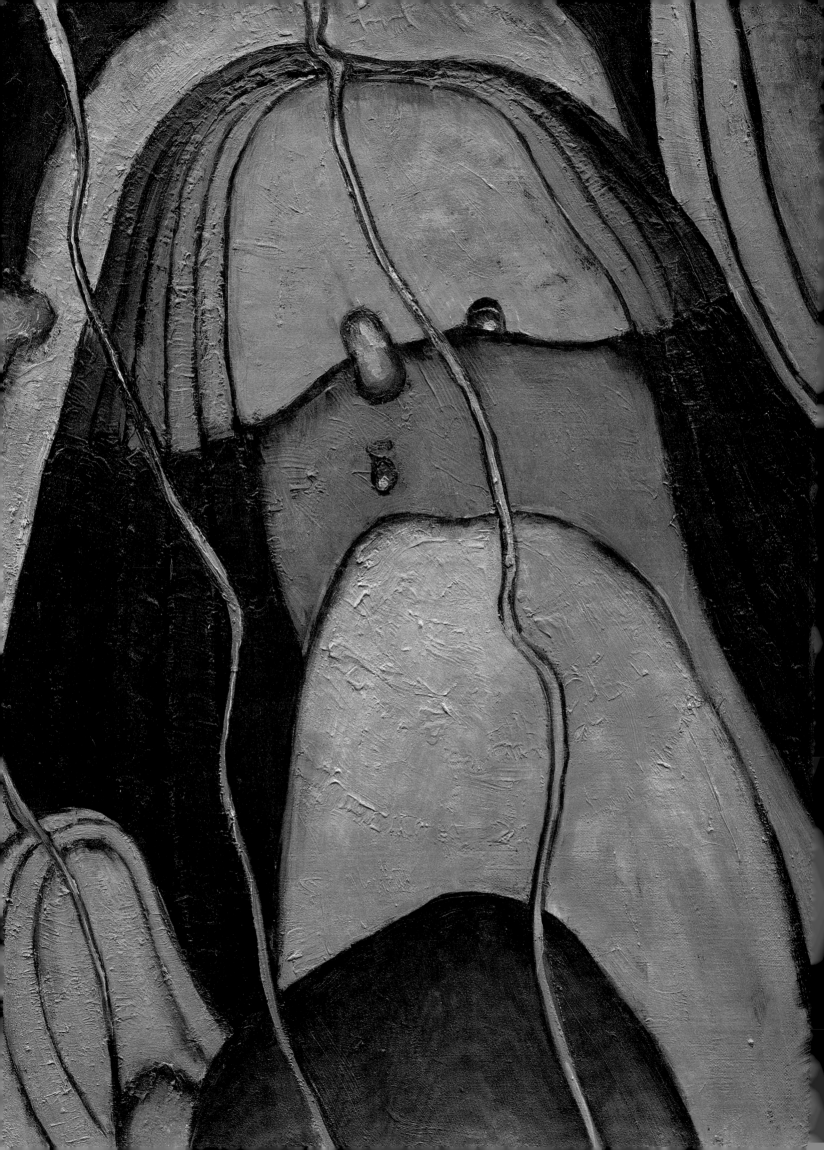

Arthur Dove: *A Retrospective*

DEBRA BRICKER BALKEN

in collaboration with
WILLIAM C. AGEE
and
ELIZABETH HUTTON TURNER

Addison Gallery of American Art, Phillips Academy,
Andover, Massachusetts,
and
The MIT Press, Massachusetts Institute of Technology,
Cambridge, Massachusetts,
in association with
The Phillips Collection, Washington, D.C.

The exhibition was organized by the Addison Gallery of American Art, Phillips Academy, Andover, Massachusetts, and The Phillips Collection, Washington, D.C.

Exhibition Dates

The Phillips Collection, Washington, D.C.
September 20, 1997–January 4, 1998

Whitney Museum of American Art, New York
January 15–April 12, 1998

Addison Gallery of American Art, Andover, Massachusetts
April 25–July 12, 1998

Los Angeles County Museum of Art
August 2–October 4, 1998

Published by the Addison Gallery of American Art, Phillips Academy and The MIT Press in association with The Phillips Collection.

Editor: M. E. D. Laing
Indexer: Karla Knight
Design and typesetting: Katy Homans
Printing: Meridian Printing, East Greenwich, Rhode Island

ISBN 0-262-02433-0 (cloth)
ISBN 0-262-52240-3 (paper)

jacket/cover: Arthur G. Dove, *Pine Tree*, 1931 (detail), pl. 56, Oil on canvas, 30 x 40 in., The Cleveland Museum of Art, Leonard C. Hanna, Jr., Fund

frontispiece: Arthur G. Dove, *River Bottom, Silver, Ochre, Carmine, Green*, 1920 (detail), pl. 21, Oil on canvas, 24 x 18 in., Michael Scharf

The exhibition "Arthur Dove: A Retrospective" was supported by major grants from Refco Group Ltd., J. Mark Rudkin (Phillips Academy class of 1947), the National Endowment for the Arts, a federal agency, the Glen Eagles Foundation, and the John S. and James L. Knight Foundation.

The catalogue was supported by Michael J. Scharf (Phillips Academy class of 1960).

The Whitney Museum of American Art presentation was made possible by generous gifts from Edward E. Elson (Phillips Academy class of 1952) and Leonard A. Lauder.

Library of Congress Cataloging-in-Publication Data

Balken, Debra Bricker.

Arthur Dove: a retrospective / Debra Bricker Balken in collaboration with William C. Agee and Elizabeth Hutton Turner.

 p. cm.

Published on the occasion of an exhibition organized by the Addison Gallery of American Art, the Phillips Academy, Andover, Mass., and the Phillips Collection, Washington, D.C., shown at the Phillips Collection, Sept. 20, 1997–Jan. 4, 1998 and at three other museums.

Includes bibliographical references and index.

ISBN 0–262–02433–0 (hardcover). — ISBN 0-262-52240-3 (pbk.)

1. Dove, Arthur Garfield, 1880–1946—Exhibitions. I. Dove, Arthur Garfield, 1880–1946. II. Agee, William C. III. Turner, Elizabeth Hutton, 1952– . IV. Addison Gallery of American Art. V. Phillips Academy. VI. Phillips Collection. VII. Title.

N6537.D63A4 1997

759.13—dc21

 97–13748

 CIP

Contents

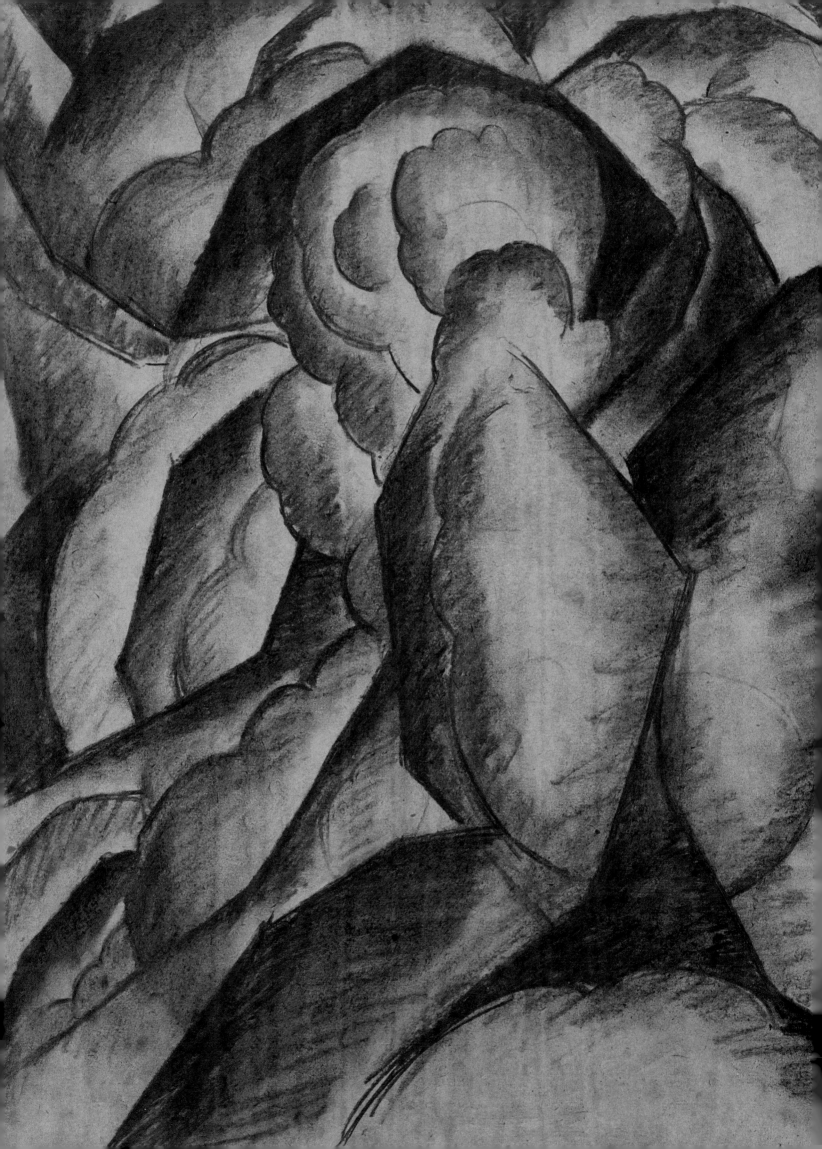

Lenders to the Exhibition

Addison Gallery of American Art, Phillips Academy, Andover, Massachusetts

Albright-Knox Art Gallery, Buffalo

Amon Carter Museum, Fort Worth

The Art Institute of Chicago

Brooklyn Museum of Art

Carnegie Museum of Art, Pittsburgh

The Cleveland Museum of Art

Colorado Springs Fine Arts Center

Columbus Museum of Art, Ohio

The Corcoran Gallery of Art, Washington, D.C.

Fisk University, Nashville, Tennessee

Heckscher Museum of Art, Huntington, New York

Honolulu Academy of Arts

Herbert F. Johnson Museum of Art, Cornell University, Ithaca, New York

The Kemper Museum of Contemporary Art & Design, Kansas City

McNay Art Museum, San Antonio

The Metropolitan Museum of Art, New York

Milwaukee Art Museum

Munson-Williams-Proctor Institute Museum of Art, Utica, New York

Museum of Fine Arts, Boston

National Gallery of Art, Washington, D.C.

New Jersey State Museum, Trenton

Philadelphia Museum of Art

The Phillips Collection, Washington, D.C.

San Diego Museum of Art

Sheldon Memorial Art Gallery, University of Nebraska–Lincoln

Terra Foundation for the Arts, Chicago

Fundación Colección Thyssen-Bornemisza, Madrid

The University of Arizona Museum of Art, Tucson

The University of Iowa Museum of Art, Iowa City

Washington University Gallery of Art, Saint Louis

Whitney Museum of American Art, New York

Yale University Art Gallery, New Haven, Connecticut

Jane Voorhees Zimmerli Art Museum, Rutgers, The State University of New Jersey, New Brunswick

Curtis Galleries, Minneapolis

Anonymous (5)

The Bedford Family Collection

Mr. and Mrs. Barney A. Ebsworth

Mr. and Mrs. Barney A. Ebsworth Foundation

Elaine and Henry Kaufman

William H. Lane Collection

Edward Lenkin and Katherine Meier

Mr. & Mrs. Meredith J. Long

Roy R. Neuberger

Dr. & Mrs. Meyer P. Potamkin

The Rifkin Family

Michael Scharf

Michael Scharf Collection

Michael Scharf G.I.T.

Arthur G. Dove
Drawing [Sunrise II], 1913 (detail), pl. 13
Wolffe carbon on manila paper mounted on board
21⁷⁄₁₆ x 17¹⁵⁄₁₆ in.
Addison Gallery of American Art, Phillips Academy, Andover, Massachusetts

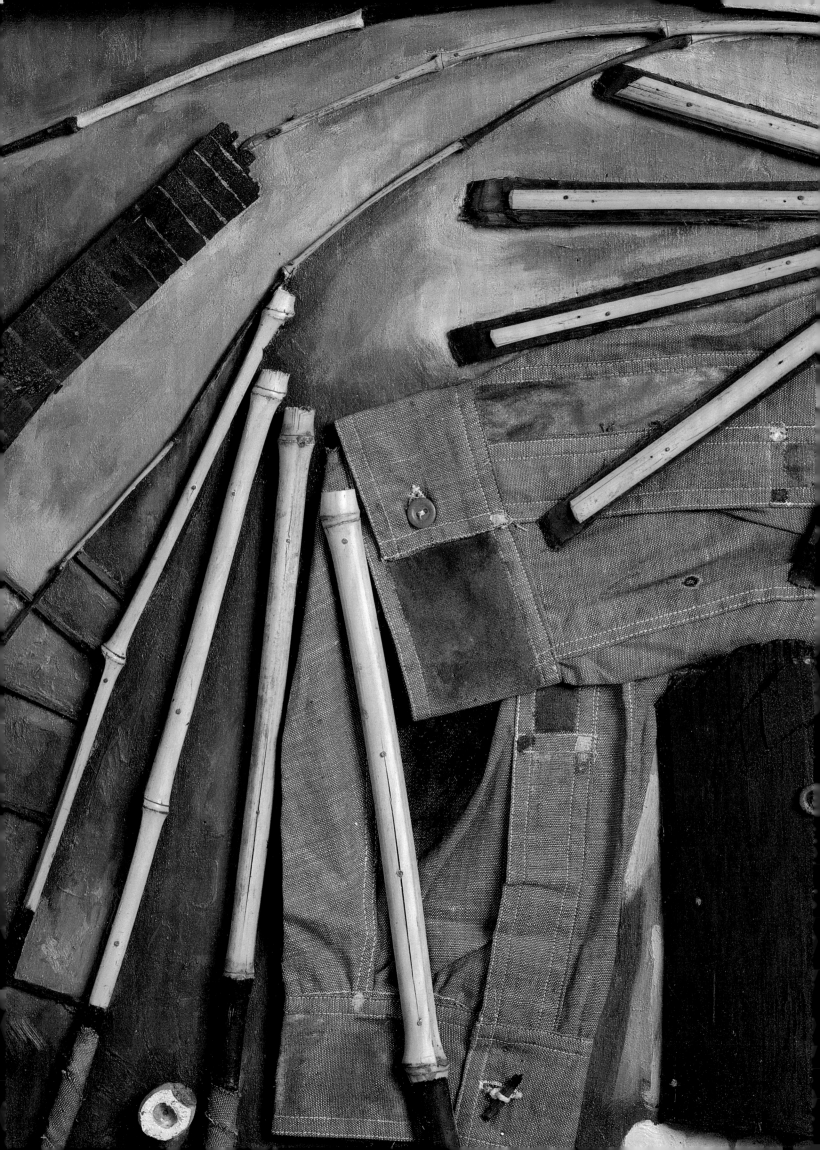

Foreword and *Acknowledgments*

Arthur Dove (1880–1946) has long occupied a central place in the history of American modernist painting. From the moment he exhibited his radical abstract paintings of 1910/11 at Alfred Stieglitz's 291 Gallery in New York, his work became the subject of widespread critical discussion. Although Dove has been credited as the first artist in the twentieth century to produce an abstract painting, he recoiled from the self-conscious efforts of European artists to take such a breakthrough into the area of intellectual speculation. He came to abstraction through emotion, not by design or expectation. Like his close friend Georgia O'Keeffe, Dove was basically interested in recording a sensation or feeling, rather than theorizing about art and its ongoing stylistic permutations. Nature, rather than culture, remained the primary subject matter of his work.

Nevertheless, while Dove's life unfolded quietly in Westport, Connecticut, on Long Island Sound, in Geneva, New York, and later in Centerport, Long Island, he was more than acquainted with the preoccupations of science, psychoanalysis, and philosophy, in addition to the prevailing visual languages of his own profession. A number of correspondences obtain between the formal attributes of Dove's paintings, with all their lyricism and exuberance, and the thinking, for example, of the contemporary French philosopher Henri Bergson, whose notions of the élan vital centered on intuition and unmediated experience in the formation of art rather than on reason and cerebration. Other links have been made between the straightforward sensuality of Dove's work and the popularization of Freud's and Havelock Ellis's theories on sexuality, which became increasingly known in America in the 1920s. Dove found support in such ideas for his antipathy to the burgeoning materialism of an increasingly industrialized America. They also reinforced and gave currency to the connection that he retained with the natural world.

Dove's work was caught up in a complex historical narrative that straddled the idealism of nineteenth-century America, with its ethical and spiritual investment in nature, and the heightened emphasis given to subjectivity

Arthur G. Dove
Goin' Fishin', 1925 (detail), pl. 31
Assemblage of bamboo, denim shirt sleeves, buttons, wood, and oil on wood panel
21¼ x 25½ in.
The Phillips Collection, Washington, D.C.

in the early twentieth century. Dove, along with John Marin and O'Keeffe, moved in the circle of Stieglitz and perpetuated the genre of landscape painting, finding possibilities rather than limitations for the redefinition of art. The fecundity and self-renewal of nature became metaphoric of creativity. Dove, in particular, placed a premium on packing his paintings with multiple significations. While art in Europe in the first two decades of this century followed a reductivist, geometric trajectory, Dove's painting was characterized by immediacy and warmth. Beyond its uninhibited sensuality, his work possessed a radical content that came from the description of intangible elements such as movement, space, and above all, light. These features were suggestive of abstract shapes and lines and quickly developed for the artist into a formal preoccupation that proved international in its scope and practice.

For all the visibility that Dove enjoyed during his lifetime, after his death in 1946 his work soon became overshadowed by Abstract Expressionism. Moreover, Clement Greenberg, a major critical proponent of Abstract Expressionism, disliked the work of artists in the Stieglitz circle with the exception of John Marin. Consequently, Arthur Dove's remarkable achievement was buried, deemed provincial and minor. While a few exhibitions have attempted to rectify this situation, especially the San Francisco Museum of Art's traveling retrospective in 1974–76, no major assessment of Dove's career has been attempted in over twenty years.

It seems more than fitting that two premier collections, the Addison Gallery of American Art and The Phillips Collection, join forces on this timely project. Both institutions have continued to exhibit the work of acclaimed and underrecognized American artists since they were opened in 1931 and 1921 respectively, and their rich holdings of early twentieth-century modernist American art are highly regarded nationally for their breadth and importance. At the Addison, the first three directors, Charles Sawyer, Bartlett Hayes, and Christopher Cook, encouraged exhibitions of developments in contemporary American art, underscoring the connection of these developments to history and to the current preoccupations of humanists and scientists. Duncan Phillips, the founder of The Phillips Collection, was Dove's primary patron from 1926 onward. Phillips held the first retrospective of Dove's work in 1937. In 1947, as a tribute to the artist just five months after his death, Phillips organized a second retrospective of his paintings. The fifty-four paintings by Dove that it owns and its archive of correspondence between painter and patron still distinguish The Phillips Collection as the foremost repository of the artist's work.

A project of this scope necessarily involves the help and talents of numerous individuals. We are very grateful to Toni Dove, a third-generation artist, who approached Debra Bricker Balken to assemble a retrospective of her grandfather's work. Ms. Dove was a constant source of help, as was her father, the late William Dove, with archival inquiries. We are deeply indebted to Ms. Balken, the independent curator and scholar who first brought this project to the Addison and who has served as Project Director. The exhibition also benefited from the expertise and experience of its co-curators, Professor William C. Agee and Elizabeth Hutton Turner, Curator, The Phillips Collection, who joined the curatorial team once this exhibition was formalized in late 1994 as a joint project of the Addison and The Phillips Collection.

At the Addison, we are particularly appreciative of the efforts of B. J. Larson, Director of Development and Publicity, who worked with the Directors on the funding of the exhibition; Allison Kemmerer, Assistant Curator, who proofread the manuscript and worked with Ms. Balken on aspects that related to the production of the catalogue; Juliann McDonough, Curatorial Assistant, who coordinated all requests for illustrations for the three essays that appear in the catalogue; Alison Cleveland, Assistant to the Director, who has been a constant source of help with myriad details on the project and who with Arlene Burpee of Park Street Travel, Andover, coordinated arrangements for travel that pertained to the development of the exhibition and

catalogue; and Denise Johnson, Registrar, who provided advice and editorial assistance.

At The Phillips Collection, we would like to thank Elsa Mezvinsky Smithgall, Curatorial Assistant, and her predecessor, Leigh Bullard Weisblat, Assistant Curator, for their enormous help to Ms. Balken and to Dr. Turner. Special thanks to Johanna Halford-MacLeod, Executive Assistant to the Director; Marilyn Montgomery, Director of External Affairs; Joy Hallinan and her predecessor, Cathy Sterling, Director of Corporate and Foundation Relations; Karen Porterfield, Corporate Affairs and Grants Coordinator; Joseph Holbach, Registrar, and Pamela Steele, Associate Registrar; Elizabeth Steele, Associate Conservator; Stephen Phillips, Assistant Curator for Administrative Affairs; and Michael Bernstein, Director of Financial Affairs and Technology.

We are very pleased to be able to share this exhibition with the Whitney Museum of American Art, New York, and the Los Angeles County Museum of Art. To our colleagues at both institutions, we extend our deepest gratitude for their interest in and support of the project. In particular, we would like to thank our colleagues at the Whitney Museum of American Art: David Ross, Director, Willard Holmes, Deputy Director, and Adam Weinberg, Curator of Collections; and our colleagues at the Los Angeles County Museum of Art: Graham Beal, Director, and Ilene Susan Fort, Curator of American Art.

Ms. Balken, Prof. Agee, and Dr. Turner conducted research at the Archives of American Art at the Boston, New York, and Washington offices; to Robert Brown, Arlene Graham, Nancy Miloy, Judy Throm, and Richard Wattenmaker we are deeply indebted for the help and courtesy extended to the individual curators. The staffs of the Beinecke Rare Book and Manuscript Library, Yale University, Boston Public Library, The Museum of Modern Art Library, New York Public Library, Newberry Library, Chicago, and Weidner Library, Harvard University were particularly helpful to Ms. Balken, as were Kermit Champa, Professor of Art History, Brown University; Douglas Dreishpoon, Curator of Collections,

Weatherspoon Art Gallery, University of North Carolina at Greensboro; and Shirley Reece-Hughes, intern, Dallas Museum of Art, who shared their unpublished essays. Prof. Agee's research was assisted by Mitzi Caputo, Curator at the Huntington Historical Society; Anne Cohen DePietro, Curator at the Heckscher Museum, Huntington, Long Island; Pam Koob, graduate student at Hunter College, New York; Charles C. Eldredge, Professor of Art History, University of Kansas, Lawrence; Ruth Pasquin, Curator, Arkansas Art Center, Little Rock; Heather Lammers, Registrar, McNay Art Museum, San Antonio, Texas; Novelene Ross, Chief Curator, Wichita Art Museum; and Melissa G. Thompson, Registrar, Amon Carter Museum, Fort Worth, Texas. At The Phillips Collection, Dr. Turner was able to rely upon the knowledge and expertise of Karen Schneider, Librarian, and the assistance of interns Susan Burress, Mike Owens, and Brooke Williams. Dr. Turner also benefited from the kindness and assistance of Steve O'Malley, Curator, and Charles C. W. Bauder, Executive Director, Geneva Historical Society; Diana Turnbow, Curatorial Assistant, Herbert F. Johnson Museum of Art, Cornell University; Ed Owen, photographer; Justine Wimsatt, Wimsatt & Associates; Irene Konofal, Conservator, Museum of Fine Arts, Boston; and John and Diane Rehm, who shared their knowledge of Dove and of Helen Torr.

An exhibition that draws on over fifty lenders not only relies upon the extraordinary generosity of numerous people but also involves the advice and counsel of countless individuals. We are indebted to all the museums and private collectors that parted with their treasured paintings, drawings, and pastels for this exhibition, and we offer them our deepest thanks. For their special efforts, we would like to highlight the involvement of Mr. and Mrs. Michael Scharf; Mrs. William H. Lane; Mrs. Daniel Terra; Mr. and Mrs. Peter Bedford; Mr. and Mrs. Roy Neuberger; Dr. and Mrs. Meyer P. Potamkin; Lowery Sims, Curator, The Metropolitan Museum of Art, New York; Richard Armstrong, Director, Carnegie Museum of Art, Pittsburgh; Thomas Branchik, Chief Conservator, Williamstown Art

Conservation Center, Massachusetts; and Philippe Alexandre, Director of Special Projects, Tibor de Nagy Gallery, New York, and formerly of Terry Dintenfass Gallery, New York.

Our collaboration with the MIT Press is one which has been especially productive and happy from the outset, and we acknowledge Roger Conover for this fruitful relationship. We would like to thank Mary Laing, who edited the publication with great sensitivity and intelligence, and Karla Knight, who composed the index. We are also delighted with Katy Homans's graphic interpretation of the ideas expressed herein. Her design, as always, is sympathetic both to the artist and to the authors.

Without the commitment of our funders this exhibition would have never have been possible. Refco Group Ltd. is the principal corporate sponsor of "Arthur Dove: A Retrospective." An initial grant from the National Endowment for the Arts was important in enabling us to develop the project. We would like to extend deep thanks to J. Mark Rudkin, a Phillips Academy alumnus, who provided funding at the outset for curatorial research; to the Glen Eagles Foundation and to Betsy Frampton; and to the John S. and James L. Knight Foundation and to Penny McPhee, Director of Arts and Culture, for their great interest in the exhibition. We are especially indebted to Michael Scharf, a Phillips Academy alumnus, and his wife, Fiona, for their generous contribution toward the publication of this catalogue. The presentation of this exhibition at the Whitney Museum of American Art could not have happened without the kind patronage of Edward E. Elson, a Phillips Academy alumnus, and Leonard A. Lauder.

Finally, exhibitions are tributes to artists. In Arthur Dove we celebrate an extraordinary early twentieth-century modernist. To participate in this endeavor to reveal the currency and renewed significance of his work has been a great privilege.

Charles S. Moffett Jock Reynolds

Director *Director*

The Phillips Collection *Addison Gallery of American Art*

Arthur G. Dove
The Critic, 1925
Collage
19¾ x 13½ x 3⅝ in.
Whitney Museum of American Art, New York
Purchase, with funds from the Historic Art Association of the Whitney Museum of American Art, Mr. and Mrs. Morton L. Janklow, the Howard and Jean Lipman Foundation, Inc., and Hannelore Schulhof

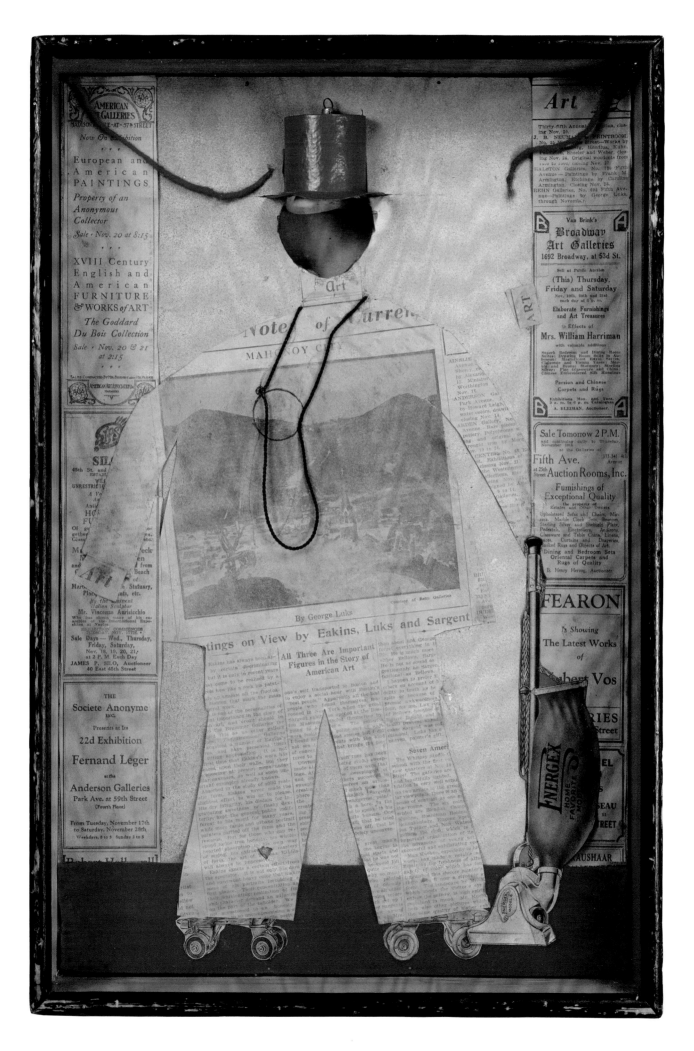

NOTE TO THE READER

The use of a solidus, as in 1911/12, indicates that a work dates from one or other of the two years cited. The en-dash, as in 1911–12, is used to indicate a period over which the work was executed.

DIMENSIONS

Dimensions are given in inches. Height precedes width.

ABBREVIATIONS

Dove Papers
Arthur and Helen Torr Dove Papers, Archives of American Art, Smithsonian Institution, eleven microfilm reels (N70/51, N70/52, 38–30, 725, 954, 1150, 2803, 4681, and 4682).

Morgan 1988
Ann Lee Morgan, ed., *Dear Stieglitz, Dear Dove* (Newark: University of Delaware Press, 1988). In references to or quotations from this edition of the correspondence between Arthur Dove and Alfred Stieglitz, the dates cited for Dove's letters, which were generally not dated, are those assigned by the editor (see pp. 13–15).

Arthur Dove:

A Retrospective

Continuities and Digressions in the Work of Arthur Dove from 1907 to 1933

DEBRA BRICKER BALKEN

I wanted, as men do, to belong. To what? To an America alive, an America that was no longer a despised cultural foster child of Europe, with unpleasant questions about its parentage, to an America that had begun to be conscious of itself as a living home-making folk, to an America that had at last given up the notion that anything worth while could ever be got by being in a hurry, by being dollar rich, by being merely big and able to lick some smaller nation with one hand tied behind its broad national back.
—Sherwood Anderson, *A Story Teller's Story*

No one is ahead of his time, it is only that the particular variety of creating his own time is the one that his contemporaries refuse to accept. And they refuse to accept it for a very simple reason and that is that they do not have to accept it for any reason.
—Gertrude Stein, *Composition as Explanation*

FILIAL ACTS AND RADICAL GESTURES

Toward the end of the 1920s, Arthur Dove (1880–1946), alienated by the pervasive materialism of an increasingly industrialized America, declared, "The creative person cannot want anything, whereas the rest of the world wants everything it's lack of imagination cannot supply."[1] While Dove's antipathy to the values of a mechanized culture was part of a larger, widespread intellectual development that gained currency in America from the mid-1910s onward, his investment in the imagination and in creativity grew out of his complex biography, a situation that explains the early aesthetic ingredients of his work.

The case that Dove would continue to mount throughout his career for the autonomy of the imagination was shaped, like many modernist artistic gestures, by defiance. His father, a brick manufacturer in Geneva, New York, had designed Dove's future as a lawyer, a profession deemed to maintain and extend the family's middle-class status. But these expectations did not match his son's sensitivity and psychological makeup. In 1901, soon after transferring from Hobart College, Geneva, to enter the prelaw program at Cornell University, Dove became overwhelmed with misgivings about his

Fig. 1
Arthur Dove in Paris, 1908–9
Courtesy Arthur G. Dove Estate

Fig. 2
Calendar of Birds and Beasts: Spring, 1905
Lithograph
17¾ x 13⅛ in.
Collection of the Corcoran Gallery of
Art, Washington, D.C., Museum
Purchase, Mary E. Maxwell Fund

prescribed career. He enrolled in elective art classes with Charles Wellington Furlong which rekindled fond memories of his childhood mentor, Newton Weatherly, a farmer and avocational naturalist and artist, who had introduced Dove at the age of nine to both painting and the outdoor world. Dove realized through these courses that a compromise had to be struck. Graphic illustration (then a potentially lucrative line of work) seemed to be a concession that would appease both father and son. In 1903, Dove moved to New York where he began to build a professional life as a free-lance illustrator (fig 2).

The monetary gains of working for publications such as *Century*, *Cosmopolitan Magazine*, and *Life* mollified a still-dominant father; the opportunity to exercise some degree of originality in his assignments satiated Dove's desire for an independent, creative existence. This balance was soon unsettled, however, by the growing realization that illustration was a conventional discipline, mediated by the content requirements of a more powerful patron. Around 1907, Dove, with the encouragement of John Sloan and William Glackens, both of whom Dove had met in New York and who worked as part-time illustrators, began to try his hand at pure painting. The diversion immediately developed into a lifelong occupation. In May 1908, Dove, with his wife, Florence Dorsey, sailed for France on a fifteen-month trip painting mainly in the South of France.[2]

Dove's earliest artistic efforts are notably derivative and formulaic, indebted at first to the lingering American vogue for Impressionist painting. A work such as *Stuyvesant Square*, 1907 (fig. 3), for example, mimics the feathered brushwork and muted tones of the synthetic, repetitious landscapes of Ernest Lawson, an artist whom Dove knew in New York. But these painterly devices and prototypes were surpassed in France for more confident studies of nature that eased the sometimes clumsy, tentative compositional underpinnings of *Stuyvesant Square* into fluid, authoritative pictorial statements. A certain artistic poise defines *The Lobster*, 1908 (fig. 4), a work that Dove placed in the Salon d'Automne in Paris in 1909. While marked by influences that emanated largely from Matisse

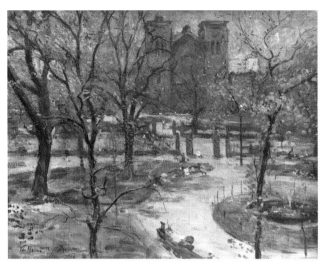

Fig. 3
Stuyvesant Square, 1907
Oil on canvas
25 x 35 in.
Warren Hunting Smith Library, Hobart
and William Smith Colleges, Geneva,
New York, Bequest of Paul M. Dove,
1981

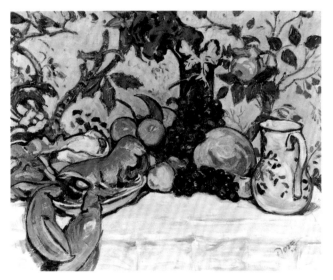

Fig. 4
The Lobster, 1908
Oil on canvas
25¾ x 32 in.
© Amon Carter Museum, Fort Worth,
Texas, Acquisition in Memory of Anne
Burnett Tandy, Trustee, Amon Carter
Museum, 1968–1980 (1980.29)

and his propensity for vibrant color contained by a pro-
nounced black outline, the still life nonetheless reveals
enough singularity and competence to withstand the
charge of imitation. At least Alfred Stieglitz, who was
shortly to become Dove's lifelong dealer, patron, and
close friend, must have viewed *The Lobster* as an inventive
work, one that whatever its debt to European styles of
experimentation, possessed a currency that American
audiences were in need of knowing.

That Stieglitz chose to exhibit *The Lobster* at his
Gallery of the Photo-Secession (familiarly known as 291
from its original address at 291 Fifth Avenue) in 1910 is
telling. While in France, Dove's activities as a painter
remained confined largely to rural settings. The heady
intellectual environment of Paris, with its avant-garde
preoccupations, seems almost to have eluded him. Dove's
interactions with other artists were confined to a small
group of American expatriates such as Alfred Maurer, Jo
Davidson, Max Weber, Arthur B. Carles, and Patrick
Henry Bruce. The circle of Gertrude Stein, which drew
on an international group of writers and artists, while
within his social reach, was not a sought-after locus for
Dove. Like all subsequent pivotal junctures in his profes-
sional and private life, Dove's trip to France unfolded
quietly, without exhilaration and the belief that Europe
was a totalizing, defining experience. If anything, the
imprint of French aesthetic practices on his work was
a generalized one, radically attenuated upon his return
to America into a vague, eventually disconnected
experience.

Dove's return to New York in 1909 and immed-
iate association with Stieglitz (an introduction effected
through Maurer) amounted, unlike his awkward, hesitant
absorption of French culture, to a more fundamental,
equal pairing. Having made the critical decision to forgo
working as an illustrator after his trip abroad, Dove was
in need not only of an artistic identity but also of emo-
tional bolstering. In Stieglitz, he located a compelling
combination: a passionate advocate for modernist art and
a patriarchal figure who could fill in for a disapproving
father bewildered by his son's career decisions.

Dove's feelings of kinship with Stieglitz were ignited instantly and sustained over a lifetime: "I do not think I could have existed as a painter without that super-encouragement and the battle he has fought day by day for twenty-five years. He is without a doubt the one who has done the most for art in America."[3] Stieglitz, eager to back those artists and writers who fitted into his aesthetic program, was quick to disparage the behavior of an artist's father who could not comprehend an absolute commitment to painting: "Dove's father . . . had said that if Dove could afford to give up such an income [as a commercial illustrator] he need not expect anything from him—and had him cut off in his will, without a cent."[4] With Stieglitz as a powerful surrogate, Dove came to refer to his own parent as his "other 'old man.'"[5] Clearly, a mutuality of interests and needs was recognized from the beginning.

Shortly after the exhibition of *The Lobster* in 1910 at 291, Dove's work reveals a remarkable transformation. In fact, a dramatic about-face is enacted in his painting for which there is no foreshadowing. In his small abstractions of 1910/11, alternately murky and luminous in tone, he relinquished any obligation he might have felt earlier to convey nature with some degree of verisimilitude. *Abstraction No. 4*, 1910/11 (pl. 4), like others from the series, transforms whatever landscape or scene Dove used as its basis. While some vague reading of treelike shapes and of hills or mounds could be coaxed from the work, its abstract compositional attributes for the most part resolutely defy identification. How to explain this abrupt about-face? Stieglitz is part of the accounting.

The lineup of exhibitions at 291, although varied and idiosyncratic, determined by what Stieglitz could import from Europe or draw from the community of modernist artists active in New York, had some bearing on this stark development. In addition to shows of photography by Edward Steichen, Stieglitz, Gertrude Kasebier, and others (all of whom promulgated a wispy, ethereal style patterned on painting), 291 reacquainted Dove with the work of Cézanne, Matisse, Rodin, Weber, and Maurer and introduced him to that of John Marin,

Marsden Hartley, and Abraham Walkowitz. Through this partial, fragmented array of modernist positions, Dove must have gleaned, in addition to the ideas he had assimilated in France, a sense of the burgeoning avant-garde initiative to purge art of any external reference. Moreover, in the pages of *Camera Work* (Stieglitz's quarterly publication), Dove would have come across, particularly around this period, essays, quotations, and excerpted passages of theoretical tracts by writers and artists such as Nietzsche, Henri Bergson, Sadakichi Hartman, Marius de Zayas, and Benjamin de Casseres, all of which were loosely unified around the conviction that art should be guided less by an overarching narrative than by formalist or compositional features that issued from the artist's intuition. As the Polish-born sculptor Elie Nadelman concluded in a note published in *Camera Work* in 1910, "It is form in itself, not resemblance to nature, which gives us pleasure in a work of art."[6]

In hindsight, Dove came to view his work in France as a "blind alley,"[7] one that prolonged the "disorderly methods" of the defunct styles of Post-Impressionism.[8] A more rigorous, concrete reformulation of nature based on the observation of its structural components became a consuming ambition. According to Helen Torr, Dove's second wife and an artist herself, "when he returned [from Europe] he spent much time [in Geneva] in the woods analyzing tree bark, flowers, butterflies etc,"[9] in addition to fishing and painting with his old friend Newton Weatherly. The desire to track and study nature's holdings as part of his reconceived artistic project brought about a move to Westport, Connecticut, where in 1910 Dove purchased a farm which he hoped would yield enough income to support his family (his son, William, was also born that year) and his painting. The abstractions of 1910/11, while a daring break from his derivations of French landscape painting, eased into assertive statements of the underlying movements that animate nature. In the heaving vegetal shapes that comprise a work such as *Plant Forms*, of around 1912 (pl. 8), Dove fixed the ephemeral processes of growth into an abstract pattern of curvilinear and

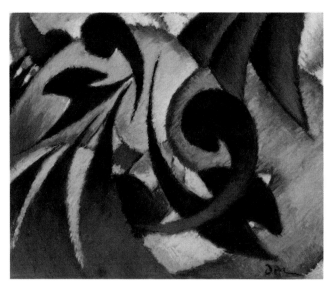

Fig. 5
Nature Symbolized No. 2, ca. 1911
Pastel on paper
18 x 21⅝ in.
The Art Institute of Chicago, Alfred
Stieglitz Collection (1949.533)

Fig. 6
Max Weber (1881–1961)
Forest Scene, 1911
Watercolor and graphite on paper
12½ x 8 in.
Whitney Museum of American Art,
New York, Purchase, with funds from
the Felicia Meyer Marsh Purchase Fund
and an anonymous donor (81.7)

vertical lines, conferring structure on what he might have once cast as an impression.

The welter of nature's random rhythms, rendered in *Plant Forms* in exuberant profusion, is carried through a series of pastels—collectively known as the Ten Commandments, a designation later imposed by either Stieglitz or Dove[10]—that were probably made in rapid succession. *Nature Symbolized No. 1* or *Roofs* (pl. 9), *Nature Symbolized No. 2* (fig. 5), *Movement No. 1*, *Team of Horses*, and *Sails* (pls. 7, 12, 11), for example, all of which date from 1911/12, similarly delineate something of the erratic, unknowable workings of nature while projecting an almost geometric plan on top of its motion. Outside of these twin pursuits, the pastels are distinguished by their vibrant, shimmering color, a trait that adds to their sense of animation. Dove saw this body of work as formative and self-defining, following on the heels of numerous attempts to picture the fundamental properties common to both nature and art:

> There was a long period of searching for a something in color which I then called "a condition of light." It applied to all objects in nature, flowers, trees, people, apples, cows. These all have their certain condition of light, which establishes them to the eye, to each other, and to the understanding.[11]

Max Weber remembers a walk with Dove in Westport in 1911 sometime shortly before the production of the Ten Commandments and advising him to disavow retrograde narrative content in art: "It isn't what you see there; you must always symbolize."[12] By this, Weber meant the reduction of a subject to its essential compositional forms rather than the embellishment of an elliptical, distant idea.[13] Certain visual correspondences obtain between Weber's *Forest Scene* of 1911 (fig. 6) and Dove's *Plant Forms* of about the same year, in the similar tumescent, rounded shapes that tower toward phallic conclusion, although these linkages remain isolated and singular. Weber may have reinforced Dove's instincts to continue to move his painting into the area of pure abstraction, to represent nature as a dynamic, enigmatic mechanism. However, Dove's focus on the

intersections between art and nature, on the unifying elements of light and color, was entirely his own.

The language that Dove employed in his statements about these pastels exudes a surety of purpose as well as a desire to be situated outside the prevailing canon of landscape painting:

> Yes, I could paint a cyclone. Not in the usual mode of sweeps of grey wind over the earth, trees bending and a furious sky above. I would paint the misty folds of the wind in comprehensive colors; I would show repetitions and convolutions of the range of the tempest. I would paint the wind and a landscape chastised by the cyclone![14]

Moreover, he resisted any discursive analysis of his work, believing words would reify and detract from its intangible meaning. Instead, Dove drew parallels between his painting and the abstract medium of music:

> As to going further and explaining what I felt, that would be quite as stupid as to play on an instrument before deaf persons. The deaf person is simply not sensitive to sound and cannot appreciate [it]; and a person who is not sensitive to form and color as such would be quite as helpless.[15]

The exhibition of these pastels in 1912 at 291 in New York and subsequently at the Thurber Galleries in Chicago established Dove as the foremost practioner of abstract painting in this country. A few critics were uncertain about how to place his work; an offhanded allusion to Futurist painting was thrown out by one writer as a point of comparison,[16] but Dove would not have seen examples of this until 1917 when Stieglitz exhibited a group of paintings, drawings, and pastels by Gino Severini at 291. Most interpreters, however, wrote precise appropriate descriptions that picked up on the innovative formal traits of Dove's paintings. One reviewer considered him to be "absolutely original,"[17] while another saw these pastels as "plain pictures that mean nothing at all except that a certain combination of shapes and colors pleased the artist."[18] Later, these kinds of straightforward pronouncements would settle into more diacritical assessments that would sift through Dove's

intentionality as well as probe his relationship to current cultural preoccupations. As the writing on Dove's work began to build, "his inner consciousness,"[19] as one critic put it, became an area of scrutiny, one that was eventually framed within the discourse of nationalism.

The radicalness of Dove's abstract paintings of 1910/11 and 1912—works that seem to parallel if not pre-date by maybe a year the production of Kandinsky's *Improvisations* (fig. 7), generally touted as the first European paintings to dispense totally with figuration—was a feat upon which Stieglitz capitalized to buttress his growing claims for America's artistic parity with Europe. That Dove got to the forefront of abstraction "independently" of foreign influence, as Stieglitz was quick to note,[20] clearly revealed an idiosyncratic, native intelligence that could hold its own with European aesthetic developments. While it is possible that Dove knew of Kandinsky's tract *Concerning the Spiritual in Art* before it was excerpted in *Camera Work* in July 1912—Stieglitz was acquainted with Kandinsky's work and writing "for some years"[21] and may have shared his enthusiasm with Dove before the appearance of Kandinsky's work first in a large group show of contemporary German graphics held at the New York branch of the Berlin Photographic Company in December 1912,[22] and later in 1913 in the Armory Show—still, his underlying impetus to capture "the sensations of light from within and without,"[23] as he put it, derives less from a metaphysical experience of nature than from a highly sensuous and quasi-scientific yearning to record its numerous optical effects.

Another broad similarity between Kandinsky and Dove exists in the way in which each artist tied his visual ideas to music. But these analogies, again, were part of a larger intellectual inquiry that surfaced in the work of numerous European and American artists around 1912–13, including Hartley, Walkowitz, and Stuart Davis,[24] and remain but an aspect of Dove's ongoing elaboration of his perceptions of nature. The singularity of Dove's pastels of 1912 is more the outcome of a highly confident and defiant individuality that, while shaded by the talk, figures, and events surrounding Stieglitz's

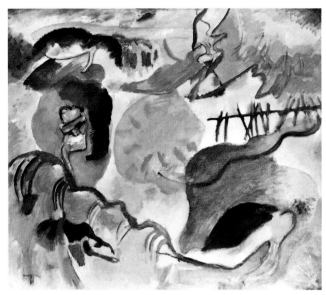

Fig. 7
Wassily Kandinsky (1866–1944)
The Garden of Love (Improvisation Number 27),
1912
Oil on canvas
47⅜ x 55¼ in.
The Metropolitan Museum of Art,
Alfred Stieglitz Collection, 1949
(49.70.1)

gallery, was unswayed by the authority and weight of European modernism. As Dove stated later, "I could not use anothers philosophy except to help find direction any more than I could use anothers art or literature."[25]

"A MALE VITALITY IS BEING RELEASED"

As early as 1914, Arthur Jerome Eddy, a Chicago collector and one of the first Americans to summon up a definition of modernist art, identified a type of "virile impressionism," singular to the United States.[26] This distinctly gendered term was intended to denote the aesthetic prowess of artists such as Winslow Homer, John Singer Sargent, and Arthur B. Davies, among many others, whose "manner of viewing nature and . . . mode of painting [were] quite different from the more superficial refinements of Impressionism . . . and Post-Impressionism."[27] While the designation didn't stick, the idea of the American artist marking his work with his "virility" became a means for subsequent writers to discuss the painting of Dove. Paul Rosenfeld, for example, one of Dove's primary advocates from the 1920s onward, dwelt on the artist's "virile and profound talent. . . . A tremendous muscular tension is revealed in the fullest of the man's pastels. . . . A male vitality is being released. . . . And in everything he does, there is the nether trunk, the gross and vital organs, the human being as the indelicate processes of nature have shaped him."[28]

The emphasis on Dove's masculinity became part of a larger intellectual agenda that gained momentum in New York in the early 1920s and that sought to define the indigenous traits of American cultural expression. Sherwood Anderson, a friend of Dove's and a member of the loose-knit colony of writers and artists that congregated in Westport in the 1910s, including Van Wyck Brooks, Paul Strand, Rosenfeld, and Marin among others, wrote to Dove in 1921:

> *There is some faint promise of rebirth in American art but the movement may well be just a stupid reaction from Romanticism into realism—the machine. To be a real birth the flesh must come in. And thats why, I suppose, I have, since seeing the first*

piece of your work, looked to you as the American painter with the greatest potentiality for me.[29]

Ironically, following the visibility that Dove acquired through the exhibition of his pastels in 1912 in New York and Chicago, his output diminished in quantity, confined until 1921 primarily to charcoal drawings, a few pastels, and an occasional painting. The demands of maintaining a marginal livelihood through farming prohibited the time and concentration required to sustain a consistent, continuous body of artistic work. Whatever remarkable gains had been made by his elucidation of the abstract components of nature were offset by a period of retrenchment. Besides the labor involved in tending to his chickens and crops, Dove began to rethink the course of his aesthetic mission. The prospect of forgoing figuration entirely seemed daunting, if not restricting. Moreover, he spurned the theoretical implications of his work in an effort to focus solely on sensory feeling:

> *Theories have been outgrown, the means is disappearing, the reality of the sensation alone remains. It is that in its essence which I wish to set down. It should be a delightful adventure. My wish is to work so unassailably that one could let one's worst instincts go unanalyzed, not to revolutionize nor to reform, but to enjoy life out loud.*[30]

The body of work that emanates from Dove's years in Westport, although meandering and varied, extends many of the issues present in the pastels of 1912. *Drawing [Sunrise II]* and *Pagan Philosophy* of 1913 (pls. 13, 14), for example, restate the pulsating surge of nature's growth patterns in *Plant Forms* through their fractured landscape shapes. In the interstices of abstraction and figuration, Dove continued to mine and rework many of his early pictorial devices and themes, clarifying ideas that related to nature's fugitive processes either through spare, architectonic statements such as *Nature Symbolized*, 1917–20 (fig. 8),[31] in which organic elements are reduced to bold geometric shapes, or through lavish, ample declarations of the complexity of the structure of light, as in

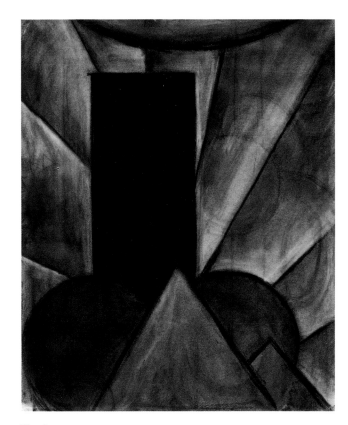

Fig. 8
Nature Symbolized, 1911–12 [1917–20]
Charcoal on paper
21 ¼ x 17⅞ in.
The Museum of Modern Art, New York,
Given anonymously

Photograph ©1997 The Museum of Modern Art, New York.

Sun on Water; Abstraction, Number 2; Thunderstorm; and *Abstraction Untitled, Nature Symbolized,* also of about 1917–20 (pls. 18, 16, 25, 17). Whatever the differing formal approaches, a heightened sensuality pervades all of these drawings, a trait that Dove believed was self-evident and that obviated the need for analysis and reasoning. As Anderson noted, Dove's work of this period possessed an unbridled creativity that aspired to the "flesh."

During the Westport years, Dove and Stieglitz began to refer to their "ideal,"[32] a reference to their resistance to the rampant materialism that was sweeping America in the 1910s and 1920s. Not only did this ideal justify Dove's difficult life-style but it also furnished Stieglitz with a platform from which to proclaim the spiritualized and intuitive content of American painting. Although the 291 gallery folded in 1917, in part because of World War I and Stieglitz's dwindled finances, his disdain for the mechanization of American life and all its new, bourgeois domestic amenities continued to fuel his advocacy of a pure, transcendent art until the end of his life in 1946. But this stance was disabused of any nostalgic longing for the past. Like Dove, who stated that he would "rather have today than yesterday,"[33] Stieglitz was in search of an aesthetic standard or model that would establish authentic aspects of American culture. A shared emphasis on the direct rather than mediated experience of nature formed a central part of the two men's cultural outlook. Hence, the machine was passed off by Stieglitz as too pedestrian a subject for art, incapable of serving like the landscape as an agent for the revelation of one's interior life.

This ideal, however, was also shaped by external, critical forces. As early as 1915, charges that American art was too derivative and dependent upon outside influences began to emanate from a number of largely exiled foreign artists. Marcel Duchamp, for example, who met Stieglitz upon his arrival in New York in 1915, thought the impulse of American art was misdirected: "If only America would realize that the art of Europe is finished—dead—and that America is the country of the art of the future, instead of trying to base everything she

does on European traditions."[34] Likewise, Marius de Zayas, once an exhibitor at 291 and an active contributor to *Camera Work* until 1915 (fig. 9), defected from Stieglitz's cause, stating: "The inhabitants of the artistic world in America are cold blooded animals. . . . They have the mentality of homosexuals. They are flowers of artificial breeding."[35]

The sexualized rhetoric used to try to destabilize whatever gains American modernist art had made during this period is striking. Francis Picabia, who returned to New York in 1915 after participating in the Armory Show two years earlier, went one step further than de Zayas and depicted Stieglitz as a broken camera or machine, its phallic-shaped bellows incapable of operation, in *Ici, c'est ici Stieglitz* (fig. 10). While Picabia had once thought of Stieglitz as "a God,"[36] and had been compared to Dove by Stieglitz in 1913 in a show of his nonillusionistic, abstract works at 291,[37] the industrialized aspects of American culture quickly became for him a more potent area of visual investigation. In particular, the machine proffered an oddly erotic language of forms that could more easily subvert the values of a dominantly materialistic society. Unlike Stieglitz and Dove, whose ideal repudiated the power of the machine, Picabia, along with Duchamp, de Zayas, and eventually the American Man Ray, addressed the issue head on. Their witty, sometimes caustic parodies of a new consumerist culture involved questioning the conventions and codes of advertising used in the mass media to invest the machine with authority.

Frequently, their transgressive statements sought to undermine the traditional image of masculinity. For instance, Duchamp's *Chocolate Grinder, No. 2* of 1914 (fig. 11) or "bachelor machine" as he named most of his imagery of this period, represents a commonplace household object as a fetish, desexualized and stripped of mystery, whereas Man Ray's *Image of Man,* 1918 (fig. 12), exploits the phallic character of another domestic implement, the eggbeater. While this unsettling of masculinity was not entirely lost on Stieglitz—he remained alternately perplexed, intrigued, and hurt by

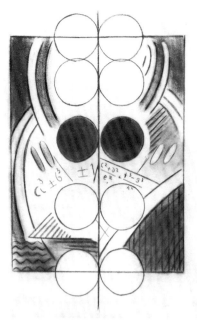

Fig. 9
Marius de Zayas (1880–1961)
Alfred Stieglitz
From *Camera Work*, April 1914, 46:37
Photogravure print
9¼ x 7 in.
Courtesy George Eastman House

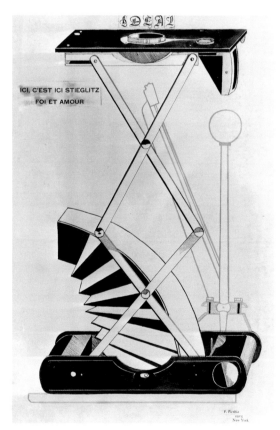

Fig. 10
Francis Picabia (1879–1953)
Ici, c'est ici Stieglitz, 1915
Pen and red and black ink on paper
29⅞ x 20 in.
The Metropolitan Museum of Art,
Alfred Stieglitz Collection, 1949
(49.70.14)

Fig. 11
Marcel Duchamp (1887–1968)
Chocolate Grinder, No. 2, 1914
Oil, graphite, and thread on canvas
25½ x 21¼ in.
Philadelphia Museum of Art, The
Louise and Walter Arensberg Collection
('50–134–70)

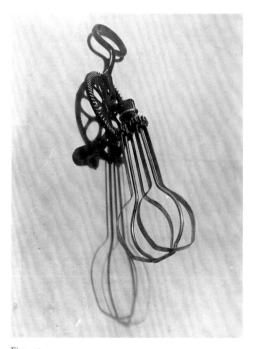

Fig. 12
Man Ray (1890–1976)
Image of Man, 1918
Gelatin silver print
19¹⁵⁄₁₆ x 15⅛
Jedermann, N.A. Collection

this iconoclasm—it nonetheless could not occupy a place in his evolving formulation of a nationalist aesthetic. As de Zayas pinpointed in one of his put-downs, Stieglitz felt that the real thrust of visual culture in America stemmed from an engagement of the senses: "Stieglitz wanted to work this miracle. He wanted to discover America. Also, he wanted the Americans to discover themselves. But, in pursuing his object, he employed the shield of psychology and metaphysics. He has failed."[38]

Although quarrels with Stieglitz's "psychology and metaphysics" continued to escalate, soon issuing from differing factions and culminating in mid-1924 in diatribes by writers such as Thomas Craven (a conservative, whose crankiness and academic standards are now the legend of art criticism), Stieglitz also attracted a considerable following. While Craven would have Stieglitz as "probably the most accomplished photographer in the world, [but one who] shares the delusions of the laborious old botanical copyists. He asks us to believe that the reduplication of natural phenomena carries an emotional freightage identical with that of the creative act,"[39] Waldo Frank depicted him as a "prophet," a figure responsible for having "launched the art of a new century in a new world."[40] On the subject of these polarized interpretations, Dove made his allegiances plainly known, affirming of Stieglitz, "I have always been glad to know him more than any other man."[41] In fact, his feelings of protectiveness for Stieglitz intensified from 1915 onward, and he defended at every turn Stieglitz's abhorrence of business, industry, and the stifling effects of mass production on sensory experience.

As the literary world took up the cause of vernacular American expression beginning in 1916 (Frank's and Rosenfeld's joint venture, The Seven Arts, though a short-lived publication, played a pivotal role in this reformulation), the work of Dove and other members of the Stieglitz circle became emblematic of a native sensibility. The "masculine vitality" that Rosenfeld identified in Dove's work was a distinguishing feature of a programmatic effort that would be restated and stretched by writers such as Anderson, Frank, and Edmund Wilson, as well as by a younger generation of critics such as Elizabeth McCausland well into the 1930s.

AESTHETIC CONTINUITIES AND DIGRESSIONS

For all of Dove's cheer and desire "to enjoy life out loud," a sense of entrapment and inevitability filled many of his letters to Stieglitz prior to 1921. Financial hardship, parental rejection, and diminished time to paint were the recurring subjects of his correspondence. In May 1917, Dove wrote, "I hope to be painting again by the first of June, if things go no worse, but the future for anything here doesn't look very bright."[42] Stieglitz privately questioned whether Dove would ever paint again.[43] What with a family to support and the sense of guilt that his inadequate income as a farmer must have induced, Dove was forced by 1918 to return to New York and resume his career as an illustrator. Westport became for him a summer retreat until 1920 when his life was dramatically altered.

Shortly before the death of his father the following year, he left his wife for Helen Torr (fig. 14), an artist married to the illustrator Clive Weed. Thereafter, he and Reds, as Torr was known, spent seven years living on the *Mona*, a forty-two-foot yawl that they sailed within the vicinity of Halesite, Port Washington, Lloyd Harbor, and Huntington Harbor on Long Island Sound. Although commercial illustration continued to provide a primary source of income, Dove's reinvigorated life also allowed for the renewal of painting. Torr, unlike his wife, had no misgivings about his chosen vocation. She remained utterly convinced of his worth as an artist and of his place in history. With this emotional reinforcement, Dove was "left in doubt as to how good" farming had been.[44]

If Dove's work from 1911 through 1920 reveals a recycling and testing of formative ideas, the ensuing decade was characterized by markedly erratic artistic interests. Certain stylistic threads and themes emerge from this mix of investigations, however. One such thread exists in his ongoing description of natural elements, a subject so central to Dove's being that it

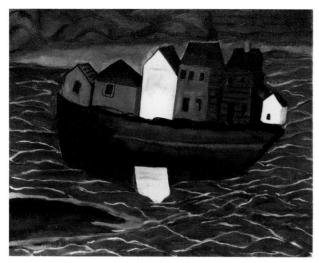

Fig. 13
Helen Torr (1886–1967)
Houses on a Barge, 1929
Oil on canvas
16 x 21 in.
The Metropolitan Museum of Art, Gift
of Mrs. Cynthia Polsky, 1988
(1988.371.2)

Fig. 14
Arthur Dove and Helen Torr Dove
Courtesy Arthur G. Dove Estate

dominated whatever momentary aesthetic digressions held his attention. A neat continuum can be traced through images such as *#4 Creek*, of around 1919, *River Bottom, Silver, Ochre, Carmine, Green*, 1920, and *Penetration*, 1924 (pls. 19, 21, 20), all of which develop the surging, vertical dynamism packed in earlier compositions like *Plant Forms* into heightened, clearly sexualized landscapes. In the teeming abundance of nature, Dove began to locate an analogue for his own generative powers as an artist. His immersion in nature became so complete that little separation or distance was perceived between the fecundity of the landscape and the creativity of the artist.

On the origins of *#4 Creek*, Dove told a contemporary writer "that he drew it while knee-deep in flowing water, looking downstream into the woods; but that his friends called it *Penetration*—which came nearer to his intention."[45] Herbert Seligmann, who chronicled Stieglitz's activities as a dealer from 1925 to 1931, recalled that *Penetration* was "done at Sherwood Anderson's request after he had seen the same subject drawn in black and white."[46] The subject plainly lived up to Anderson's expectation that American art should be of the "flesh." It also contributed to the growing number of critical comparisons between Dove's work and that of Georgia O'Keeffe in the mid-1920s. For many writers, the gendered forms in a painting such as O'Keeffe's *Black Iris III*, 1926 (fig. 15), were the feminine counterparts of Dove's phallic imagery. Rosenfeld, for example, paired their work in a metaphoric coupling:

> *Dove is very directly the man in painting as Georgia O'Keeffe is the female; neither type has been known in quite the degree of purity before. Dove's manner of uniting with his subject matter manifests the mechanism proper to his sex as simply as O'Keeffe's method manifests the mechanism proper to her own.*[47]

While O'Keeffe recoiled from any public discussion of her sexuality, her allegiance to Dove, above any other artist of the Stieglitz circle, was unwavering; she believed him to be "the only American painter who is of the earth."[48] Having "discovered" him in Eddy's *Cubists and Post-Impressionism* of 1914,[49] two years in advance of

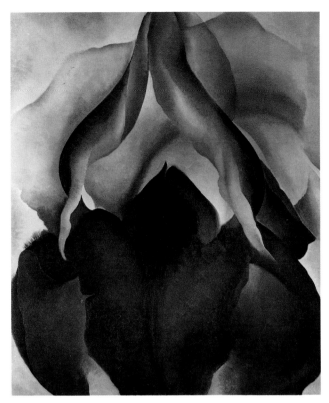

Fig. 15
Georgia O'Keeffe (1887–1986)
Black Iris III, 1926
Oil on canvas
36 x 29⅞ in.
The Metropolitan Museum of Art,
Alfred Stieglitz Collection, 1949
(69.278.1)

her association with Stieglitz, O'Keeffe was caught by Dove's simple, direct distillations of nature. Dove responded with equal fervor to her "burning" landscapes.[50] Their mutual, lifelong professional support often resulted in emotional bolstering. When in 1930 Samuel Kootz took on the "Puritan hang-over of shame at any revelation of emotion" in most American painting, while at the same time denigrating O'Keeffe's eroticized imagery,[51] Dove wrote to Stieglitz in defense of her work: "The bursting of a phallic symbol into white light may be the thing we all need."[52]

The dominant upward motion in compositions such as *#4 Creek*; *River Bottom, Silver, Ochre, Carmine, Green*; and *Penetration* forms a typology or trope that can be tracked through numerous subsequent paintings from *Sunrise*, 1924, with its rising profusion of clouds, through *Autumn*, 1935, *Moon*, 1935, and *Golden Sun*, 1937 (pls. 22, 60, 62, 68), all of which state with increasing sparsity the radiant swell of nature. These images, in effect, constitute a summation of the aesthetic ideas that Dove forged and diffused in alternately figurative and quasi-abstract works such as *Seagull Motif (Violet and Green)*, 1928, *Fog Horns* of 1929, *Snow Thaw* of 1930; and *Pine Tree* and *Fields of Grain as Seen from Train* of 1931 (pls. 44, 48, 51, 56, 57). Although varied and compositionally diverse, these paintings are nonetheless infused with a luminous, upbeat sensuality that derives from Dove's physical encounter with the natural world.

These stylistic delineations and spin-offs, however, do not solely define Dove's output of the 1920s and early 1930s. Alongside his renditions of nature coexist a number of separate entities of work. One such group is given to images of the machine, a seeming incongruity for Dove, who depicts it as a compelling aesthetic object rather than as a commonplace commodity ripe for parody. Unlike Duchamp's ironical representations of the absurd domestic offshoots of mass production, Dove's *Gear* and *Lantern*, both of around 1922 (figs. 16, 17), fix on the abstract beauty of the machine. These pictures of essentially nineteenth-century technological devices are less idealizations of the modern period (unlike the sleek

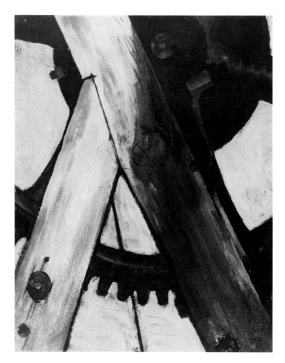

Fig. 16
Gear, ca. 1922
Oil on board
22 x 18 in.
Courtesy Richard York Gallery, New
York

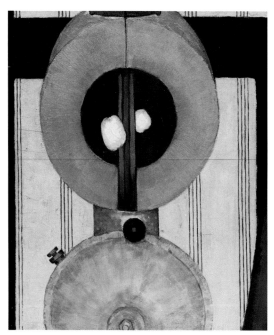

Fig. 17
Lantern, ca. 1922
Oil and silver paint on wood
21 ⅜ x 18 in. (54.3 x 45.7 cm.)
The Art Institute of Chicago, Alfred
Stieglitz Collection (1949.530)

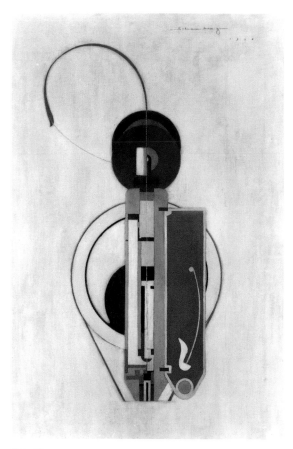

Fig. 18
Morton Schamberg (1881–1918)
Painting VIII (Mechanical Abstraction), 1916
Oil on canvas
30 ⅛ x 20 ¼ in.
Philadelphia Museum of Art, The
Louise and Walter Arensberg Collection
('50.134.181)

mechanical imagery of Dove's contemporary Morton Schamberg [fig. 18]) than a romanticized take on the artifacts of industry.

Dove's follow-through on the subject of the machine awaited later realization. By the end of the decade he would briefly reengage aspects of industry in paintings such as *Telegraph Pole*, 1929, and *The Mill Wheel, Huntington Harbor*; *Silver Tanks and Moon*; and *Sand Barge* of 1930 (pls. 53, 54, 49, 52). However, in all of these works, nature plays a transformative role, fusing icons of progress with the landscape, with water, or with the moon.

In the intervening period, other types of artistic strategies and styles occupied Dove's attention. From 1924 to 1930, he produced a series of collages or assemblages—another seeming oddity in his output—that refashioned found objects and quirky materials into highly inventive landscapes and portraits. Torr recalled, "One day he said, 'I'm tired of putting brush strokes on canvas.' After the next walk we took on the other side of the water in Halesite he collected leaves and things and made his first collage."[53] Dove clearly got the idea for his "things," as he called his collages, from Dada prototypes (he may have visited the salons of Walter and Louise Arensberg in 1915 where New York Dada was launched),[54] but the debunking, nihilistic spirit of the movement completely evaded him. Moreover, by 1923 Dada was on the wane, if not spent, and Dove cannot be integrated as a central or even active figure in the New York chapter of the group. Still, his collages are related to Dada in that they extend one of its fundamental premises: to enlarge the material parameters of art. *Goin' Fishin'*, 1925 (pl. 31), for example, elevates commonplace articles—pieces of bamboo pole, a dissected denim shirt, and bits of wood and bark—into an abstract composition packed with sentiment.[55] *Ralph Dusenberry* (pl. 34) and *Portrait of Alfred Stieglitz* (fig. 19) of 1925, combine quirky, found objects into playful portraits that subtly allude to some trait of the subject's vocation or interest. (A camera lens aptly refers to Stieglitz; and Dove's neighbor Ralph Dusenberry, noted for his ability as a diver and swimmer, is cast as a kingfish.)

Fig. 19
Portrait of Alfred Stieglitz, 1925
Assemblage: camera lens, photographic plate, clock and watch springs, and steel wool on cardboard
15⅞ x 12⅛ in.
The Museum of Modern Art, New York, Purchase

Photograph ©1997 The Museum of Modern Art, New York

Fig. 20
Monkey Fur, 1926
Corroded metal, tin foil, and cloth on
metal and fur
17¹/₁₆ x 12 in.
The Art Institute of Chicago, Alfred
Stieglitz Collection (1949.534)

O'Keeffe felt that part of Dove's urge to make his "things" was economic: "I think he worked with collage because it was cheaper than painting and also it amused him."[56] If money (always a source of anxiety for Dove) was an issue, then he carried the basic sensuality of his painting into these collages. *Rain* and *Starry Heavens* of 1924, *Sea II* of 1925 (pls. 27, 28, 30), and *Monkey Fur*, 1926 (fig. 20), composed of reflective objects such as glass or aluminum covered with either twigs, chiffon, or metallic paint, are imbued with the same uplifting emotion as a painting such as *River Bottom, Silver, Ochre, Carmine, Green*. A certain elegance is effected by the combination of these glistening materials, a feature that dissociates Dove from the anarchy of mainstream Dadaist art. Only *The Critic*, 1925 (pl. 32), Dove's mockery of Royal Cortissoz (the reigning proponent of realist art) and his monocular vision, draws on Dada's ironical and frequently sardonic critiques of contemporary culture. And given Cortissoz's disdain for the work of the American modernists, *The Critic* can also be read as part of Dove's ongoing defense of his mentor, Alfred Stieglitz.

Within the shape of Dove's overall career, the "things" are not nearly as disjunctive as they might initially seem. While limited in number to some twenty-five works, they nonetheless intersect with and cross-fertilize many of his paintings. *Golden Storm*, 1925, and *Silver Log*, 1929 (pls. 29, 45), for example, are worked with metallic paint, a medium undoubtedly suggested by the shiny aluminum surfaces of some of the collages, whereas *Something in Brown, Carmine, and Blue*, 1927 (pl. 42), actually utilizes a tin ground as an active aesthetic component. Moreover, during this period, Dove began to construct many of his own frames for his paintings, applying silver leaf to simple wood moldings to replicate something of the radiance of works such as *Rain* and *Starry Heavens*. But the collages, however elegant and innovative, were ultimately too literal a format for Dove. He came to view their narrative overtones as a hindrance to his more compelling interest in abstract painting. By the end of the decade, pictures such as *Fog Horns*, with its elusive concentric and overlapping shapes, redolent of

the pattern of sound, and *Sun on the Water*, 1929 (pl. 50), with its reduction of light and shadow to quasi-geometric forms, would inform the final direction of his work. In 1929, Dove wrote to Stieglitz:

> Am more interested now than ever in doing things than doing something about things. pure paintings seem to stand out from those related too closely to what the eyes see there. . . . The recent philosophy and fiction also tend to strengthen that idea. It seems to me the healthiest idea that has come from modern painting.[57]

By "recent philosophy and fiction," Dove had a number of authors in mind. Outside of Sherwood Anderson, whose "beautiful simple way of saying things" continued to stir Dove's feelings,[58] writers such as D. H. Lawrence, James Joyce, Sigmund Freud, Havelock Ellis, and eventually Gertrude Stein, in addition to numerous others, engaged his attention. (Dove's and Torr's letters and diaries are filled with constant references to books.) In these literary and psychological sources, Dove found analogues for the sensual, uninhibited nature of his own work. In particular, his reading of Freud and Ellis (figures whose ideas were thoroughly popularized and filtered through the mass media in North America in the 1920s) amplified the frequent phallic allusions in his painting while reinforcing the sexualized rhetoric used by Rosenfeld and Anderson to construe their meaning.

Yet on the subject of language Dove was purposefully resistant, believing that no verbal equivalent existed for his work. While he approved of the discourse of critics, he was adamant that writing was not the property of the visual artist, stating,

> I don't like that—putting it into words. You might put it on the wall as a motto—"Trust your own spirit." So many people want that—the writing on the wall . . . if its a thing you believe in you just believe in it.[59]

This declaration, with all its implicit purity and faith in the imagination, echoes an observation of Henri Bergson which Dove knew from a 1912 issue of *Camera Work*:

> The word, which only takes note of the most of the ordinary function and commonplace aspect of the thing, intervenes between it and ourselves, and would conceal form from our eyes, were that form not already masked beneath the necessities that brought the word into existence.[60]

That Bergson's ideas continued to imprint Dove's work, that Dove continued to mine his emotions as a subject, explains the abstract and quasi-figurative nature of the entire corpus of his painting.

It also explains Dove's ongoing likening of his work to music. Around 1927, he began to paint with the radio on, which resulted in a more calligraphic approach to his work. In paintings such as *George Gershwin—"Rhapsody in Blue," Part II*, *George Gershwin—I'll Build a Stairway to Paradise*, and *Orange Grove in California by Irving Berlin* (pls. 39–41), undulating black lines of varying thickness are the visual analogue of the tempo of a musical score. To Dove, these interlacing lines were emblematic of the rhythm and speed of early twentieth-century culture. They also functioned as a metaphor for the unity of art and music:

> The music things were done to speed the line up to the pace at which we live today. The line is the result of reducing dimension from the solid to the plane then to the point. A moving point can follow a waterfall and dance. We have the scientific proof that the eye sees everything best at one point.
>
> I should like to take wind and water and sand as a motif and work with them, but it has to be simplified in most cases to color and force lines and substances, just as music has done with sound.[61]

THE LATER PHASE

In 1925, Stieglitz reemerged with a project that was known as the Intimate Gallery (a room located in the Anderson Galleries at 303 Park Avenue), which was superseded in 1929 by An American Place (more spacious quarters at 509 Madison Avenue). His new

enterprise was narrowly tailored to present the work of seven American artists (Dove, Hartley, Marin, O'Keeffe, himself, Strand, and X, the unknown), which by 1929 would be honed to "the core of three," as Stieglitz put it—that is, to Dove, Marin, and O'Keeffe. Not only did these venues assure Dove of an exhibition every year or so but they also continued to frame his work within the context of an American identity. What with the establishment of A. E. Gallatin's Gallery of Living Art at New York University in 1927 and The Museum of Modern Art in 1929, both of which placed a premium on European modernist painting and sculpture, Stieglitz became particularly eager to solidify his position as a proponent of American cultural expression. Dove's work, more than ever, was integral to his ongoing crusade to underscore the singularity of American vanguard painting. But with advocates such as Rosenfeld, Frank, Anderson, and Wilson, and eventually critics in the press such as Edwin Alden Jewell of the *New York Times*, Henry McBride of the *New York Sun*, and Murdock Pemberton of the *New Yorker*, Stieglitz's cause was largely won and he settled (albeit with characteristic crotchetiness) into the role of *eminence grise* of the New York art world, an authority who in fact commanded considerable public attention.

Similarly, by the late 1920s Dove's reputation as an artist of weight, while long in coming, was thoroughly established, reinforced by an enthusiastic press and an enlarged community of supportive museum directors and curators. (The market for his work, interestingly, did not begin to accelerate until after his death.) Elizabeth McCausland, a critic who became a passionate proponent of Dove in the mid-1930s, noted that his painting "lacks the fashionable note, the stylish touch. . . . He sees life as an epic drama, a great Nature myth, a fertility symbol."[62] That Dove's work continued to be situated within the context of his "virility," that his intuitive, sensual approach to nature was emblematic of an American sensibility, became defining features of the trajectory of modernist art (at least through the 1950s) in this country.

NOTES

1. Arthur Dove, "Modern Art," Dove Papers, reel 4682 (frame 238), Archives of American Art.

2. For Dove's stay in France, see Ann Lee Morgan, *Arthur Dove: Life and Work, with a Catalogue Raisonné* (Newark: University of Delaware Press, 1984), 13–15, 34–35 n. 6. Recalling the episode more than twenty years later, Dove wrote that he had been in France for eighteen months in 1907–8 (in Samuel M. Kootz, *Modern American Painters* [New York: Brewer & Warren, 1930], 36), but John Sloan's diary records seeing Dove in New York on May 20, 1908, shortly before his departure, and on August 17, 1909, about three weeks after his return; see Bruce St. John, *John Sloan's New York Scene* (New York: Harper & Row, 1965), 220, 328.

3. Arthur G. Dove, "A Different One," in Waldo Frank et al., eds., *America and Alfred Stieglitz: A Collective Portrait* (Garden City, New York: Doubleday, Doran, 1934; repr., New York: Aperture, 1979), 245.

4. Herbert J. Seligmann, *Alfred Stieglitz Talking: Notes on Some of His Conversations, 1925–1931* (New Haven: Yale University Library, 1966), 10.

5. Arthur Dove to Alfred Stieglitz, July 1916; in Morgan, 1988, 48.

6. Elie Nadelman, quoted in "Photo-Secession Notes," *Camera Work*, no. 32 (October 1910), 41.

7. Arthur Dove, quoted in Helen Torr Dove, "Notes," Dove Papers, reel 4682 (frame 63).

8. Arthur Dove, in Arthur Jerome Eddy, *Cubists and Post-Impressionism* (Chicago: A. C. McClurg, 1914), 48.

9. Torr Dove, "Notes."

10. For the probable chronology of these pastels, see William Innes Homer, "Identifying Arthur Dove's 'The Ten Commandments,'" *American Art Journal* 12, no. 3 (1980), 21–32. Although all of these works now bear titles, Dove said shortly after their creation, "I don't like titles for these pictures because they should tell their own story"; quoted in Effa Webster, "Artist Dove Paints Rhythms of Color," *Chicago Examiner*, March 15, 1912, 12.

11. Dove, in Kootz, *Modern American Painters*, 37.

12. Quoted in Homer, "Dove's 'The Ten Commandments,'" 22.

13. Some interpreters of Dove's work have fixed on the word "symbol" to argue for the carry-over of late nineteenth-century romantic imagery as it extends from Albert Pinkham Ryder through Arthur B. Davies. I believe that these ideas, while still in the air, were faded and not central to Dove's more vanguard interests. See, for example, Sherrye Cohn, *Arthur Dove: Nature as Symbol* (Ann Arbor, Michigan: UMI Research Press, 1985).

14. Dove, quoted in Webster, "Artist Dove," 12.

15. Dove, in Eddy, *Cubism and Post-Impressionism*, 49.

16. "Mr. Dove's Italian Cousins," *Chicago Evening Post*, March 16, 1912, 21.

17. John Edgar Chamberlin, "Pattern Paintings by A. G. Dove," *Chicago Evening Mail*, March 2, 1912, 24.

18. Elizabeth Luther Cary, "News and Notes of the Art World: Plain Pictures," *New York Times*, March 3, 1912, sec. 5, 15.

19. Samuel Swift, review of Francis Picabia's "Studies of New York" at 291, *New York Sun*, March 1913; reprinted as "Samuel Swift in the 'N.Y. Sun'" *Camera Work*, nos. 42–43 (April–July 1913), 48–49 (esp. 48).

20. Stieglitz, quoted in ibid., 48.

21. Alfred Stieglitz to Wassily Kandinsky, May 26, 1913, Alfred Stieglitz Papers, Beinecke Library, Yale University.

22. See Gail Levin, "Kandinsky's Debut in America," in Gail Levin and Marianne Lorenz, *Theme and Improvisation: Kandinsky and the American Avant-Garde, 1912–1950*, exh. cat., Dayton Art Institute, Ohio (Boston: Little, Brown, 1992), 10.

23. Arthur G. Dove, "Explanatory Note," in *The Forum Exhibition of Modern American Painters* (New York: Anderson Galleries, 1916; repr., New York: Arno Press, 1968), n.p.

24. See Donna M. Cassidy, "Arthur Dove's Music Paintings of the Jazz Age," *American Art Journal* 20, no. 1 (1988), 4–23.

25. Arthur Dove, "An Idea," Dove Papers, reel 4682 (frame 225).

26. Eddy, *Cubists and Post-Impressionism*, 191.

27. Ibid.

28. Paul Rosenfeld, "American Painting," *The Dial* 71 (December 1921), 665.

29. Sherwood Anderson to Arthur Dove, late 1921, Sherwood Anderson Papers, Newberry Library, Chicago.

30. Dove, "Explanatory Note," *Forum Exhibition*, n.p.

31. I do not believe that *Nature Symbolized* dates from 1911–12, as The Museum of Modern Art states. All of Dove's charcoal drawings are currently dated 1917–20. The Whitney Museum of American Art is aware that the early date of *Abstraction, Number 2* (pl. 16) is problematic.

32. Dove to Stieglitz, May 25 or 26, 1917; Morgan 1988, 54.

33. Arthur G. Dove, "Can a Photograph Have the Significance of Art?" *Manuscripts*, no. 4 (December 1922), n.p.

34. "The Iconoclastic Opinions of M. Marcel Duchamps[sic] Concerning Art and America," *Current Opinion* 59 (November 1915), 346–47.

35. M. de Zayas, [untitled statement], 291, nos. 5–6 (1915), n.p.

36. Francis Picabia, "What Doest Thou, 291?" *Camera Work*, no. 47 (July 1914), 72.

37. Swift, "Samuel Swift in the 'N.Y. Sun,'" 48.

38. De Zayas, [untitled statement], 291.

39. Thomas Craven, "Art and the Camera," *The Nation* 118, no. 3067 (April 16, 1924), 457.

40. Waldo Frank, "The Prophet," in *Time Exposures* (New York: Boni & Liveright, 1926), 179.

41. Dove, "A Different One," 244.

42. Dove to Stieglitz, probably May 22, 1917; Morgan 1988, 53.

43. See Morgan, *Dove: Life and Work*, 1988, 19, n. 24.

44. Dove, "Writings," Dove Papers, reel 4682 (frame 161).

45. Quoted in Sheldon Cheney, *A Primer of Modern Art* (New York: Boni & Liveright, 1924), 239.

46. Seligmann, *Stieglitz Talking*, 24.

47. Paul Rosenfeld, "Arthur G. Dove," *Port of New York: Essays on Fourteen American Moderns* (New York: Harcourt, Brace, 1924), 171.

48. Quoted in Barbara Haskell, *Arthur Dove*, exh. cat. (San Francisco: San Francisco Museum of Art, 1974), 118.

49. Georgia O'Keeffe, quoted in Susan Fillin Yeh, "Innovative Moderns: Arthur G. Dove and Georgia O'Keeffe," *Arts Magazine* 56, no. 10 (1982), 69.

50. Dove, in Kootz, *Modern American Painters*, 38.

51. Kootz, ibid., 20, 48–49.

52. Dove to Stieglitz, December 4, 1930; Morgan 1988, 202.

53. Helen Torr Dove, Dove Papers, reel 4682 (frame 509).

54. William C. Agee, "New York Dada, 1910–30," *Art News Annual* 34 (1968), 113, places Dove at the Arensberg salon, but this claim remains undocumented.

55. This collage was originally titled *Fishing Nigger*. Later, to avoid any suggestion of an ethnic slur, Dove's son, William, encouraged him to alter the title to its present form. See Morgan 1988, 133 n. 3.

56. Quoted in Dorothy Rylander Johnson, "Arthur Dove: The Years of Collage," M.A. thesis, University of Maryland, 1967, 13.

57. Dove to Stieglitz, early October, 1929; Morgan 1988, 180–81.

58. Dove to Anderson, ca. April 12, 1937, Sherwood Anderson Papers.

59. Dove, quoted in Helen Torr Dove, Diary, 1924–29, Dove Papers, reel N70/52 (frame 69).

60. Henri Bergson, "What Is the Object of Art?" *Camera Work*, no. 37 (January 1912), 23.

61. Arthur G. Dove, "An Idea," in exh. brochure (New York: The Intimate Gallery, 1927), n.p.

62. Elizabeth McCausland, "Dove's Oils, Water Colors Now at American Place," *Springfield (Mass.) Union and Republican*, April 22, 1934, sec. E, 6.

1. *Still Life Against Flowered Wall Paper*, 1909
Oil on canvas
25⅝ x 31⅞ in.
Curtis Galleries, Minneapolis, Minnesota

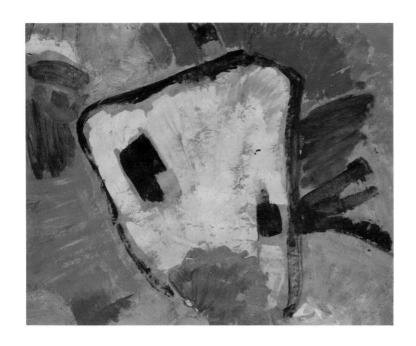

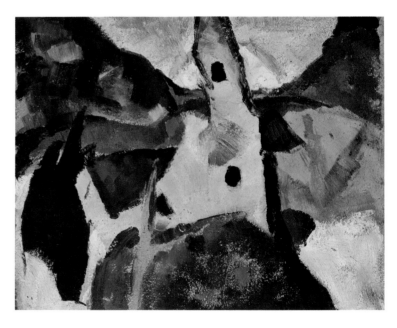

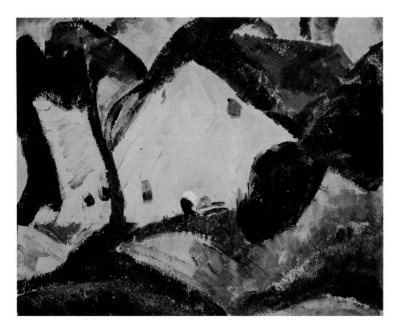

2. *Abstraction No. 2*, 1910/11
Oil on paper on board
8½ x 10½ in.
Private collection

3. *Abstraction No. 1*, 1910/11
Oil on board
8½ x 10½ in.
Private collection

4. *Abstraction No. 4*, 1910/11
Oil on board
8½ x 10½ in.
Private collection

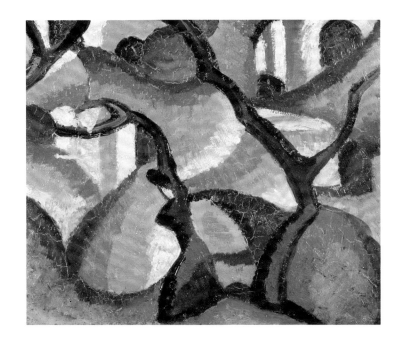

5. *Abstraction No. 3*, 1910/11
Oil on board
9 x 10½ in.
Private collection

6. *Abstraction No. 5*, 1910/11
Oil on board
8½ x 10½ in.
Private collection

7. *Movement No. 1*, ca. 1911
Pastel on canvas
21⅜ x 18 in.
Columbus Museum of Art, Ohio; Gift of Ferdinand Howald

8. *Plant Forms*, ca. 1912

Pastel on canvas

17¼ x 23⅞ in.

Whitney Museum of American Art, New York. Purchase, with funds from Mr. and Mrs. Roy R. Neuberger

9. *Nature Symbolized No. 1, or Roofs*, 1911/12
Pastel on paper
18 x 21½ in.
Michael Scharf Collection

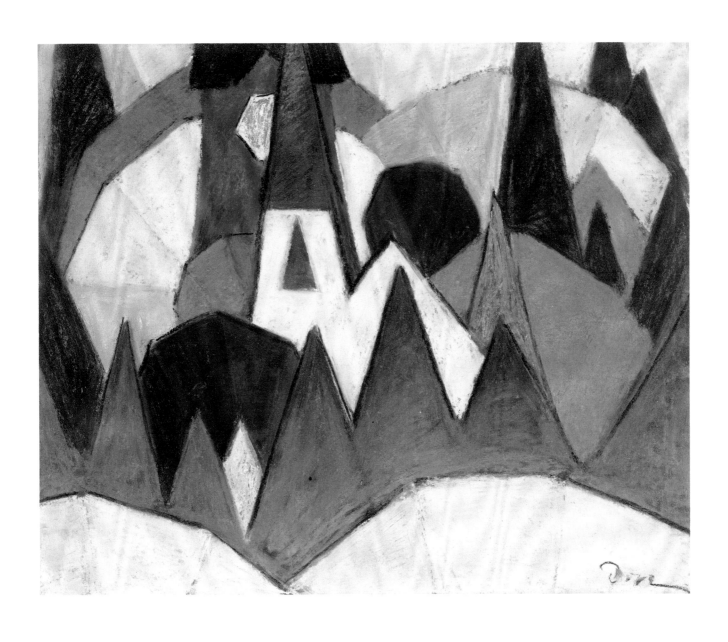

10. *Nature Symbolized No. 3: Steeple and Trees*, 1911/12
Pastel on composition board mounted on panel
18 x 21½ in.
Terra Foundation for the Arts, Daniel J. Terra Collection, 1992.33

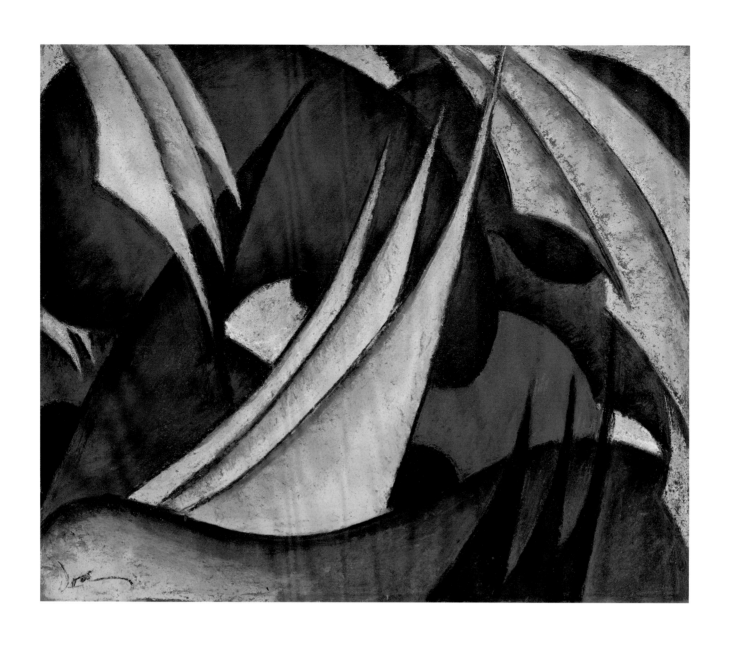

11. *Sails*, 1911/12
Pastel on composition board mounted on panel
17⅞ x 21½ in.
Terra Foundation for the Arts, Daniel J. Terra Collection, 1993.10

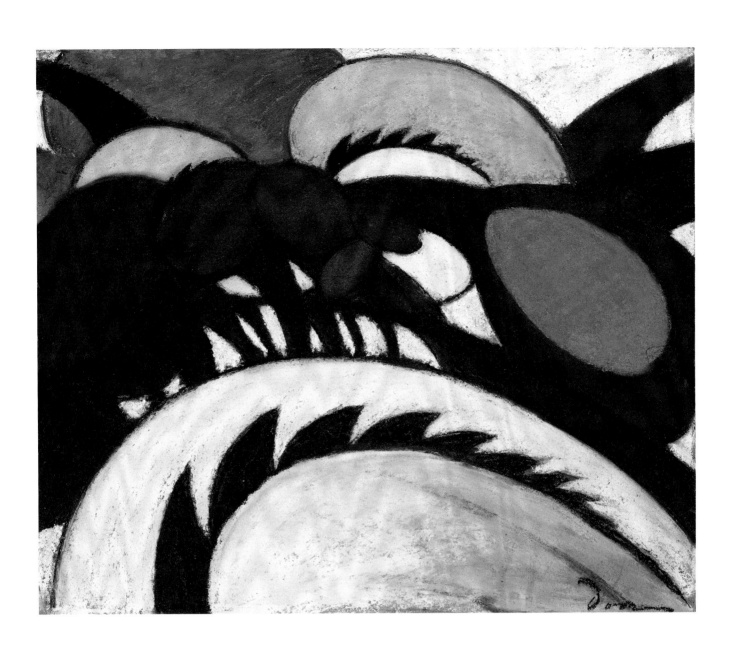

12. Team of Horses, 1911/12

Pastel on composition board mounted on plywood

18⅛ x 21½ in.

Amon Carter Museum, Fort Worth (1984.29)

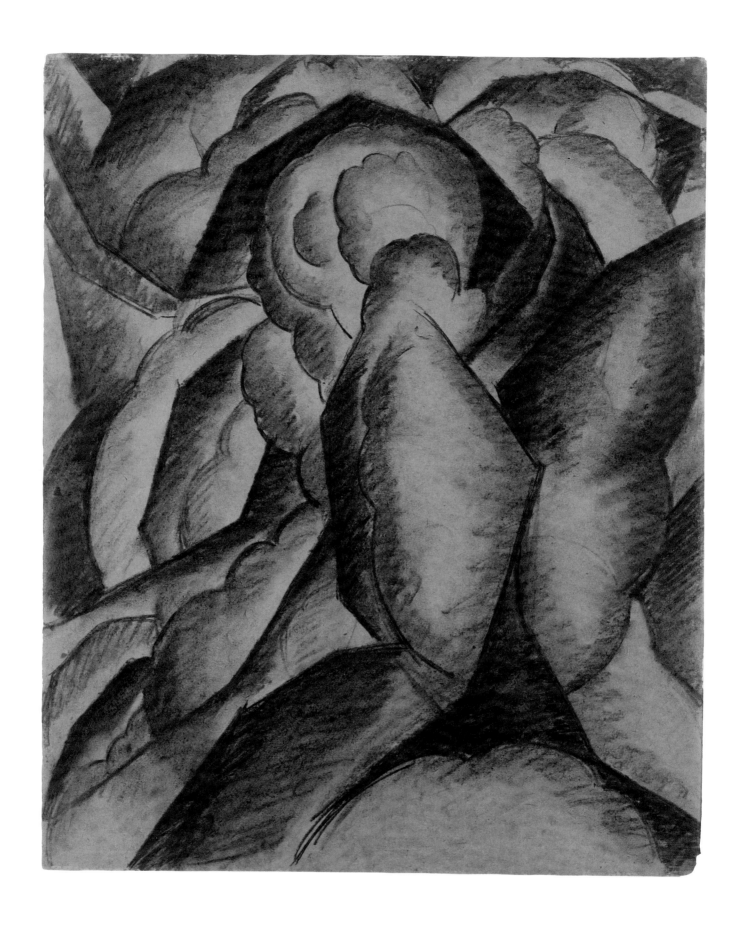

13. *Drawing [Sunrise II]*, 1913
Wolffe carbon on manila paper mounted on board
21⁷⁄₁₆ x 17¹⁵⁄₁₆ in.
Addison Gallery of American Art, Phillips Academy, Andover,
Massachusetts

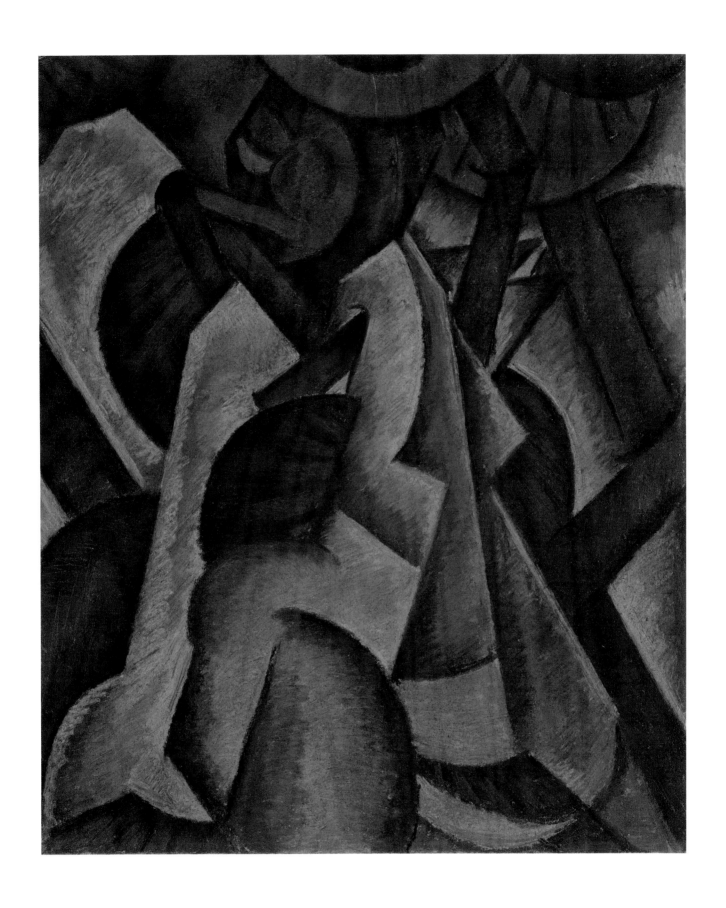

14. *Pagan Philosophy*, 1913
Pastel on cardboard
21⅜ x 17⅞ in.
The Metropolitan Museum of Art, New York, Alfred Stieglitz
Collection, 1949 (49.70.74)

15. *Abstraction*, 1914/17
Oil on canvas on board
18 x 22 in.
Michael Scharf G. I. T.

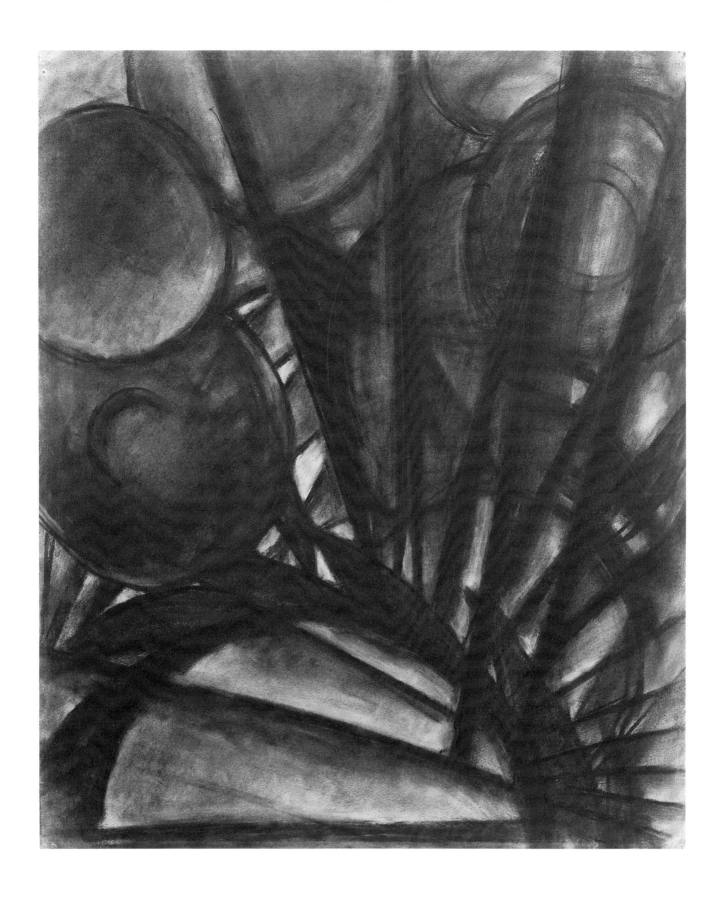

16. *Abstraction, Number 2*, ca. 1911 [1917–20]

Charcoal and graphite on paper

20⅝ x 17½ in.

Whitney Museum of American Art, New York. Purchase

17. *Abstraction Untitled, Nature Symbolized*, 1917–20
Charcoal on paper
20¾ x 17½ in.
Edward Lenkin and Katherine Meier

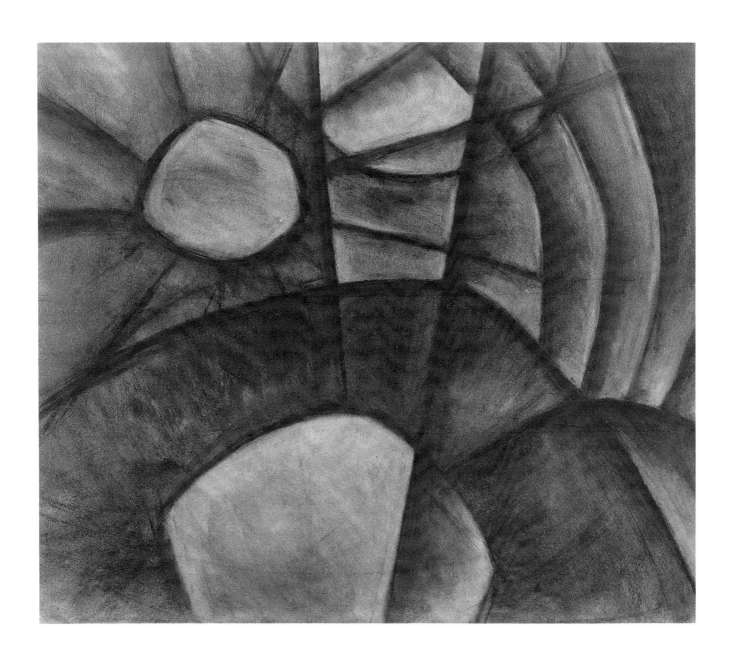

18. *Sun on Water*, 1917/20
Charcoal on paper
20½ x 17 in.
Michael Scharf G. I. T.

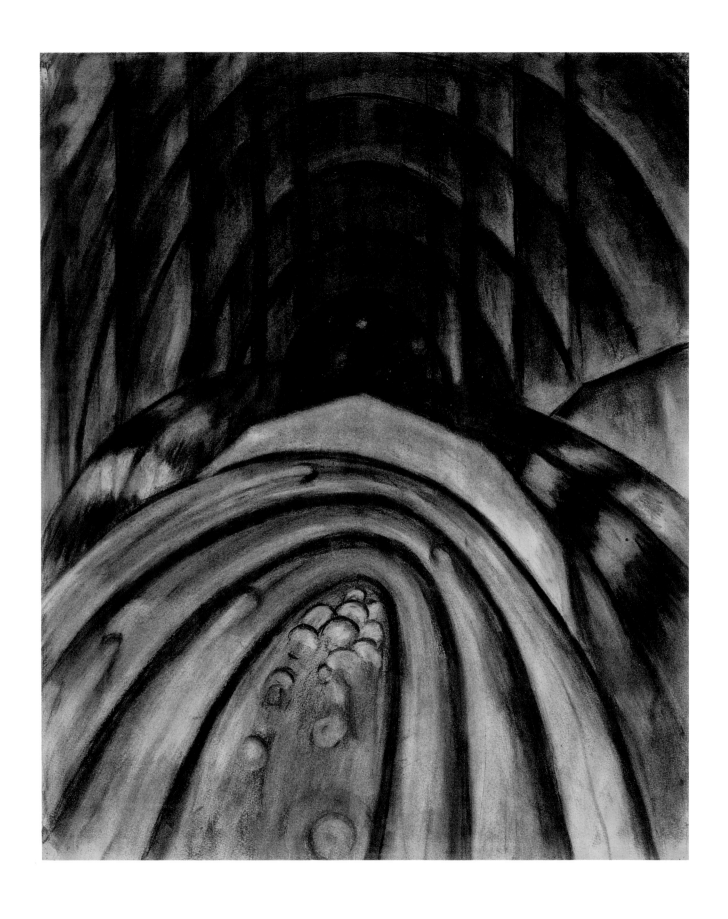

19. # 4 Creek, ca. 1919
Charcoal on paper
21 ½ x 17⅞ in.
The Corcoran Gallery of Art, Washington, D.C., Museum Purchase

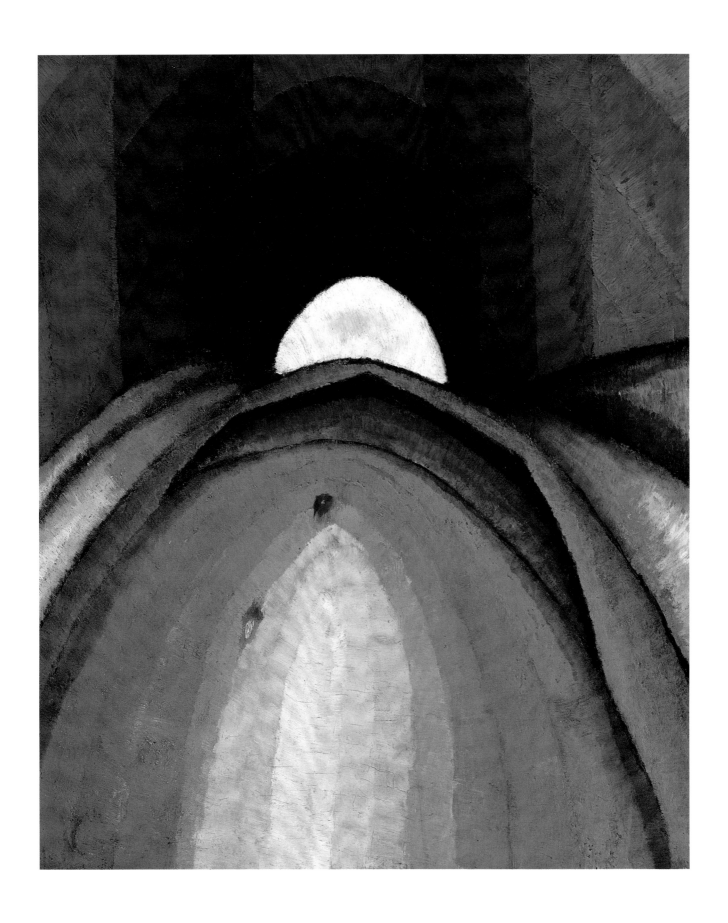

20. *Penetration*, 1924

Oil on board

21¼ x 17¾ in.

The Bedford Family Collection

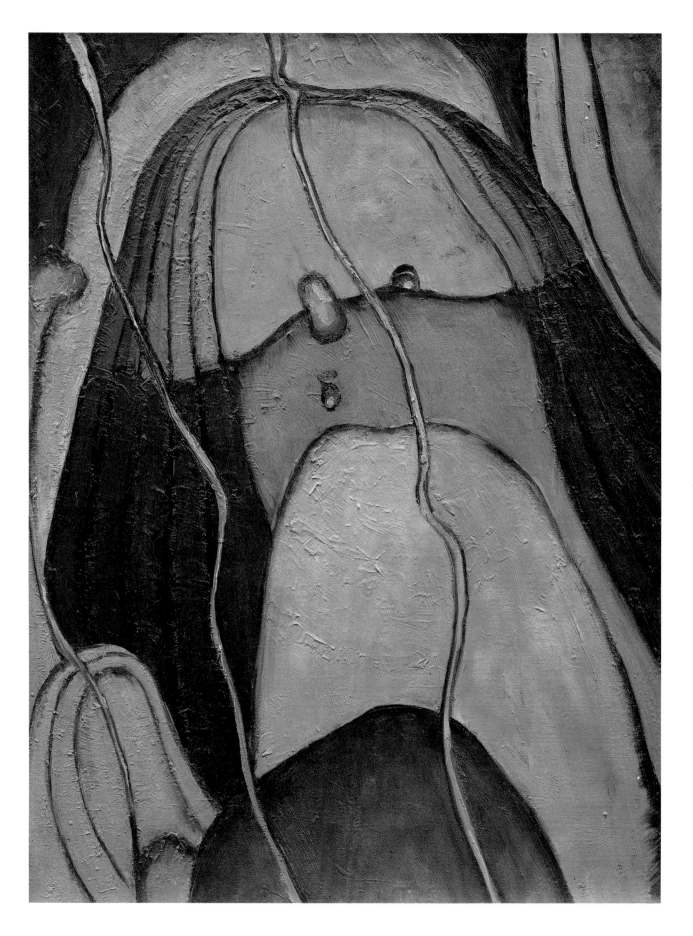

21. *River Bottom, Silver, Ochre, Carmine, Green,* 1920
Oil on canvas
24 x 18 in.
Michael Scharf

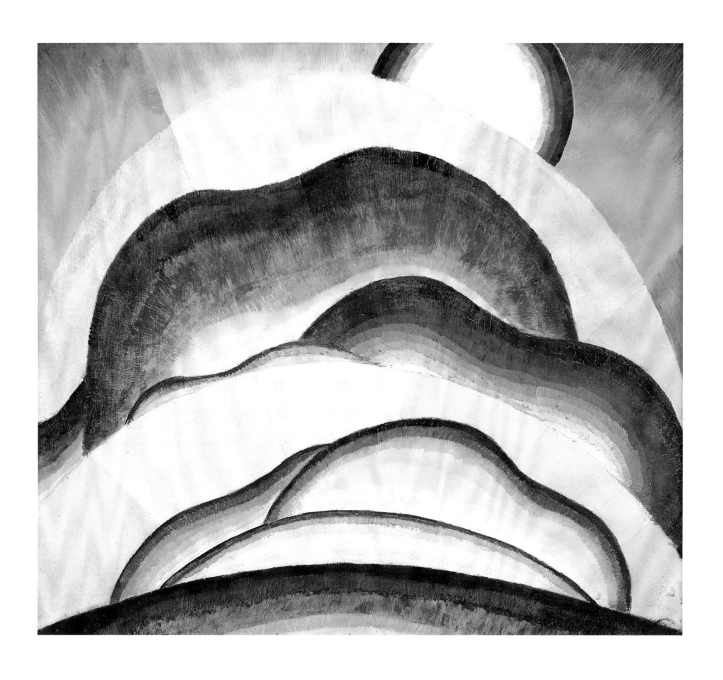

22. *Sunrise*, 1924
Oil on panel
18¼ x 20⅞ in.
Milwaukee Art Museum, Gift of Mrs. Edward R. Wehr

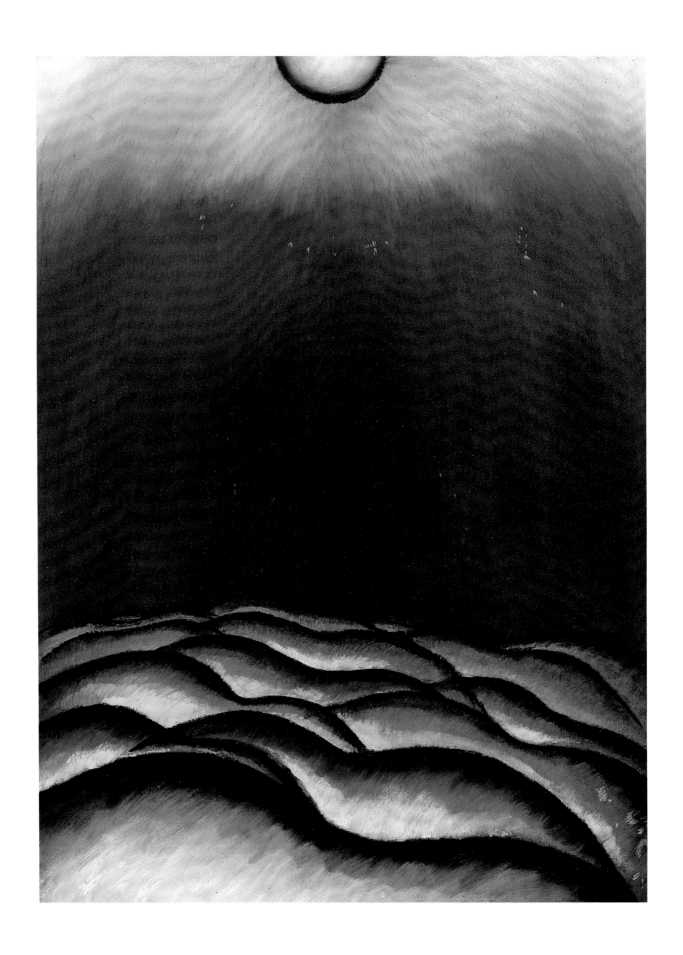

23. *After the Storm, Silver and Green (Vault Sky)*, ca. 1923

Oil and metallic paint on wood panel

24 x 18 in.

New Jersey State Museum Collection, Gift of Mr. and Mrs.
L. B. Wescott, FA 1974.75

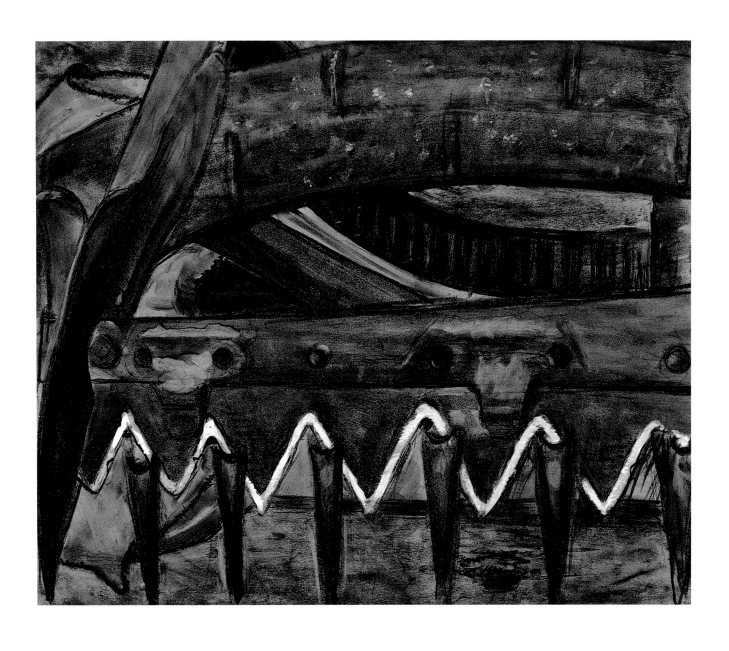

24. *Mowing Machine*, 1921
Charcoal on paper
18⅛ x 21⅞ in.
Alfred Stieglitz Collection, Fisk University, Nashville, Tennessee

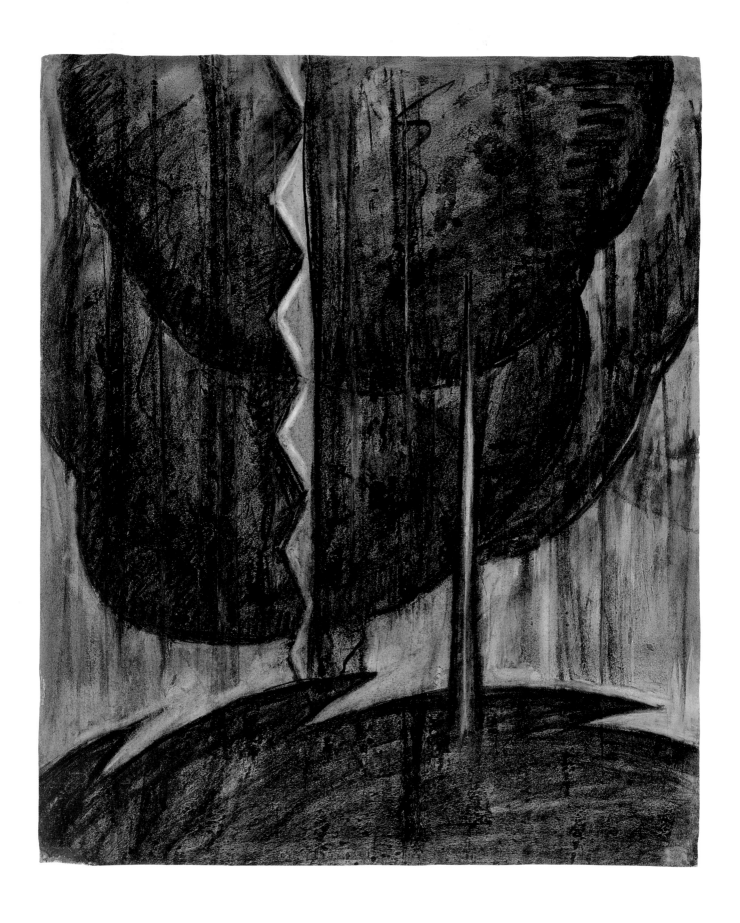

25. *Thunderstorm*, 1917–20

Charcoal on paper

21 x 17½ in.

The University of Iowa Museum of Art, Purchase, Mark Ranney
Memorial Fund, 1976.15

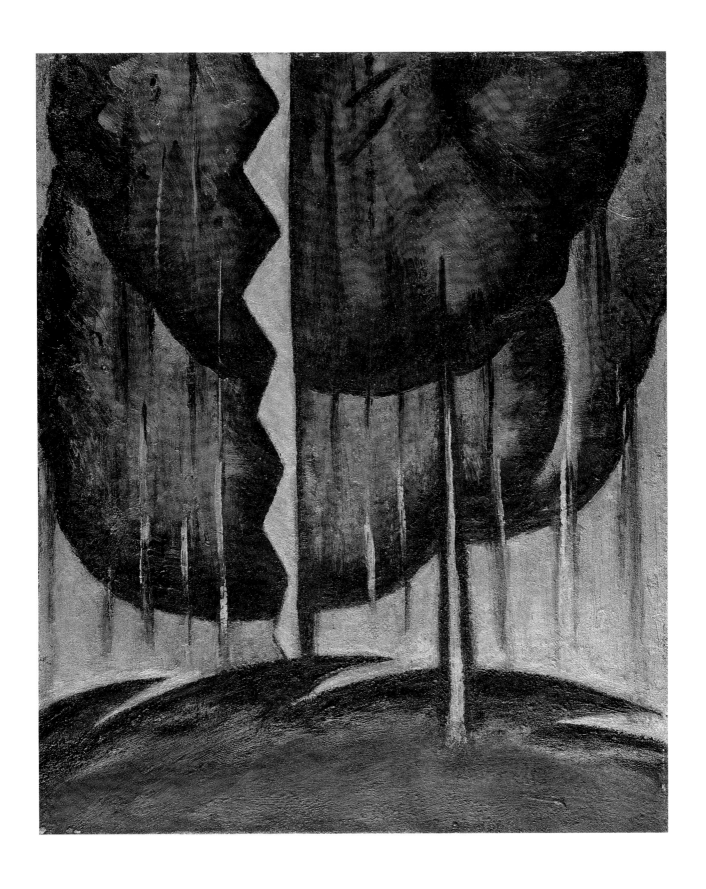

26. *Thunderstorm*, 1921
Oil and metallic paint on canvas
21 ½ x 18 ⅛ in.
Columbus Museum of Art, Ohio; Gift of Ferdinand Howald

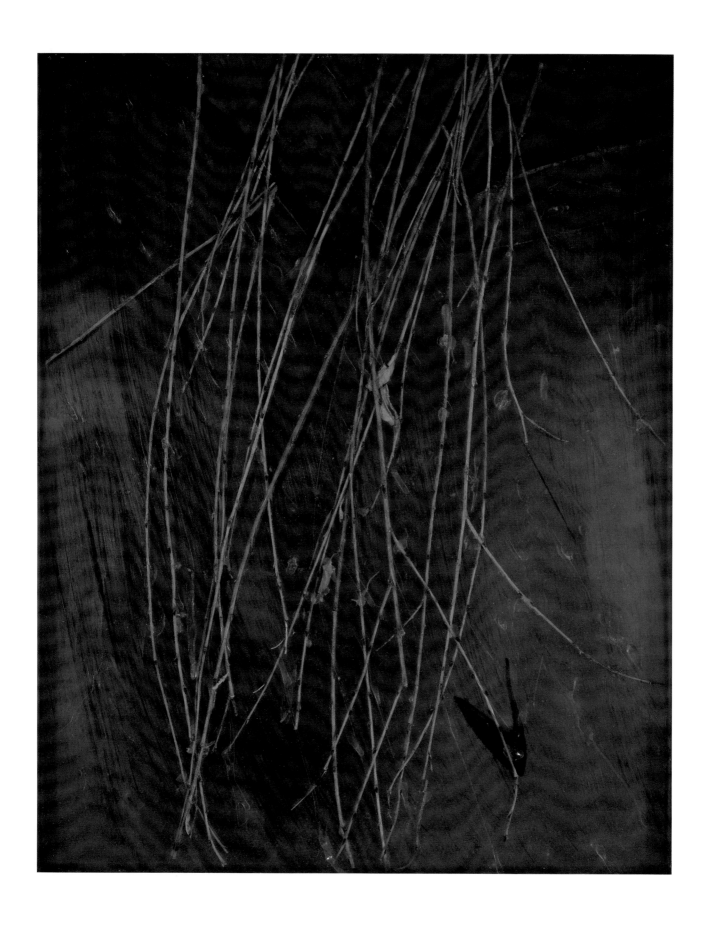

27. *Rain*, 1924
Assemblage of twigs and rubber cement on metal and glass
19½ x 15⅝ in.
National Gallery of Art, Washington, D.C., Avalon Fund 1997.1.1

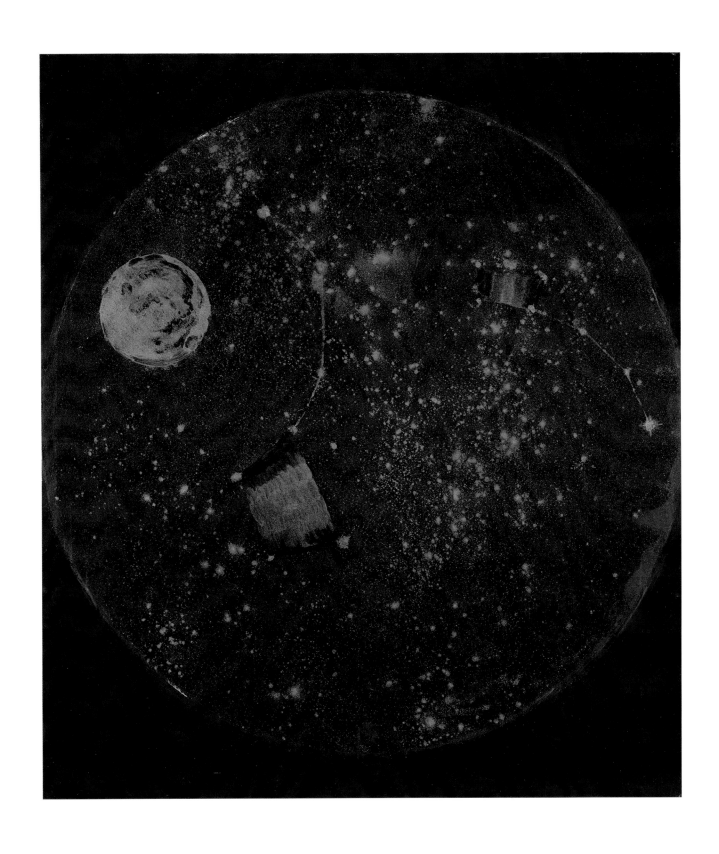

28. *Starry Heavens*, 1924
Oil and metallic paint on reverse side of glass with black paper
18 x 16 in.
Michael Scharf G. I. T.

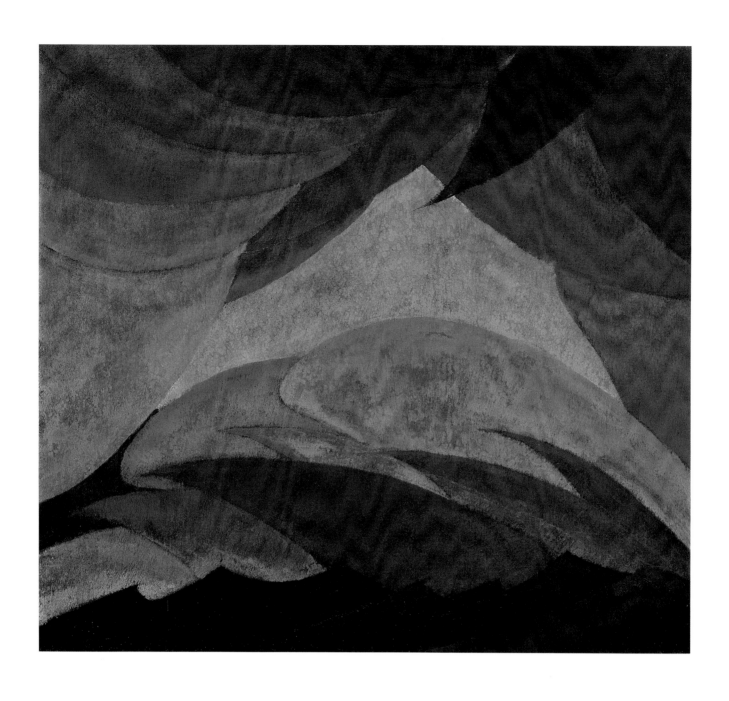

29. *Golden Storm*, 1925
Oil on plywood panel
18⅝ x 20½ in.
The Phillips Collection, Washington, D.C.

30. *Sea II*, 1925
Chiffon over metal with sand
12½ x 20½ in.
Collection of Mr. and Mrs. Barney A. Ebsworth

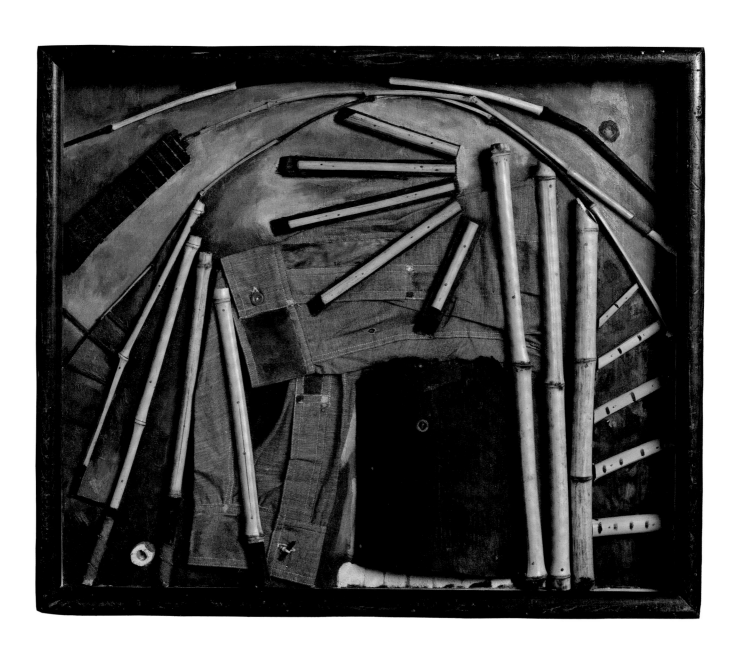

31. Goin' Fishin', 1925

Assemblage of bamboo, denim shirt sleeves, buttons, wood, and oil on wood panel

21¼ x 25½ in.

The Phillips Collection, Washington, D.C.

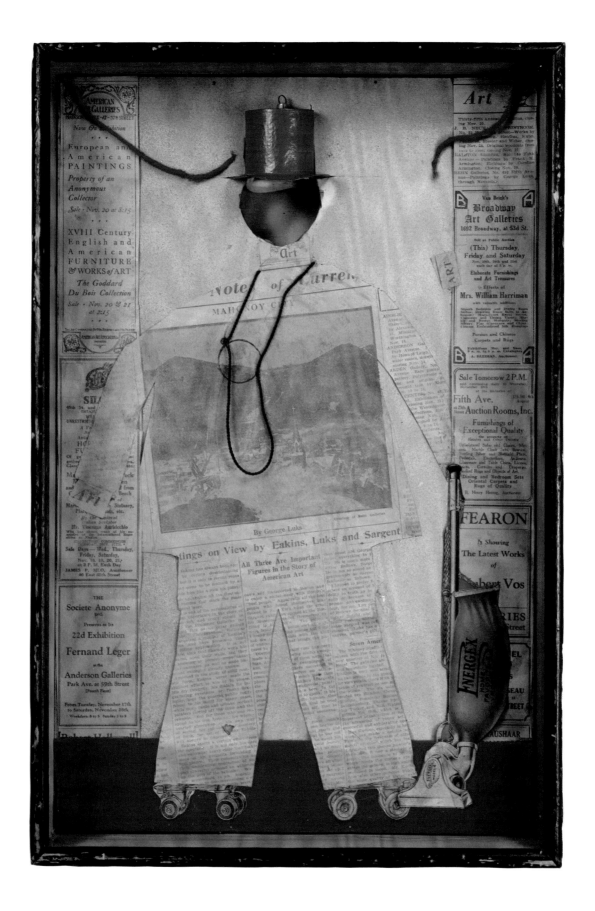

32. The Critic, 1925

Collage

19¾ x 13½ x 3⅝ in.

Whitney Museum of American Art, New York. Purchase, with funds from the Historic Art Association of the Whitney Museum of American Art, Mr. and Mrs. Morton L. Janklow, the Howard and Jean Lipman Foundation, Inc., and Hannelore Schulhof

33. *Ten Cent Store*, 1924

Assemblage of plain and printed paper, fibers, foliage, and paint on paper

18 x 16¼ in.

Sheldon Memorial Art Gallery, University of Nebraska–Lincoln, Nebraska Art Association Collection, Nelle Cochrane Woods Memorial, 1972. N-273

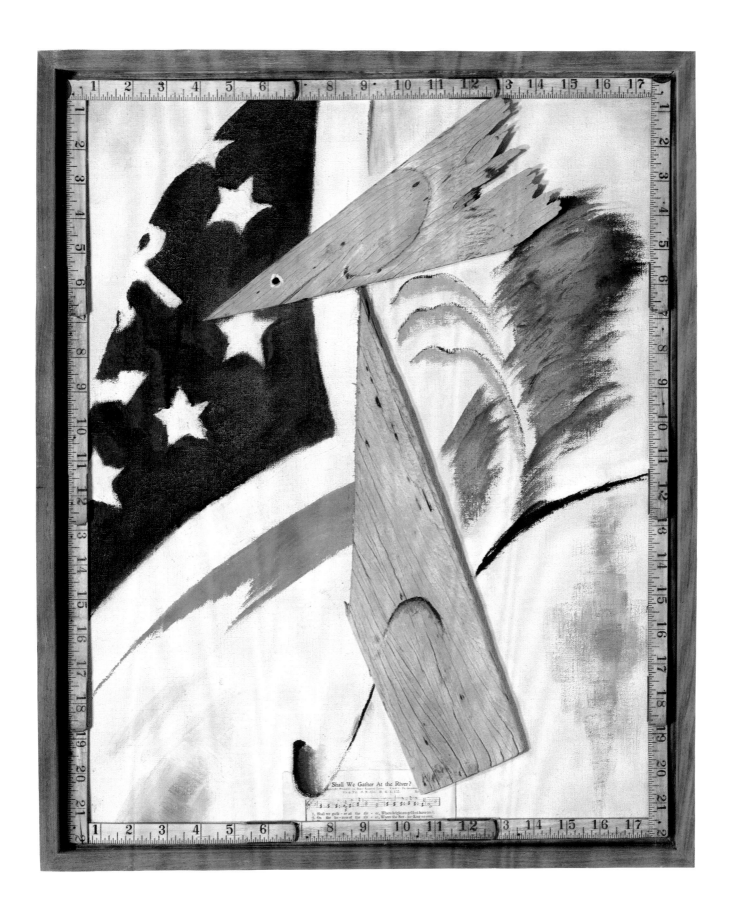

34. *Ralph Dusenberry*, 1924

Oil, folding wooden ruler, wood, and printed paper pasted on canvas

22 x 18 in.

The Metropolitan Museum of Art, New York, Alfred Stieglitz Collection, 1949 (49.70.36)

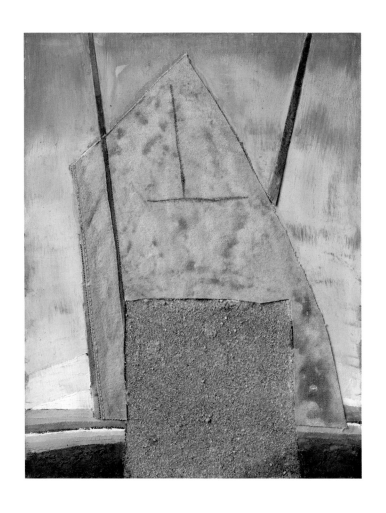

35. *Huntington Harbor I*, 1926
Collage on metal panel
12 x 9½ in.
The Phillips Collection, Washington, D.C.

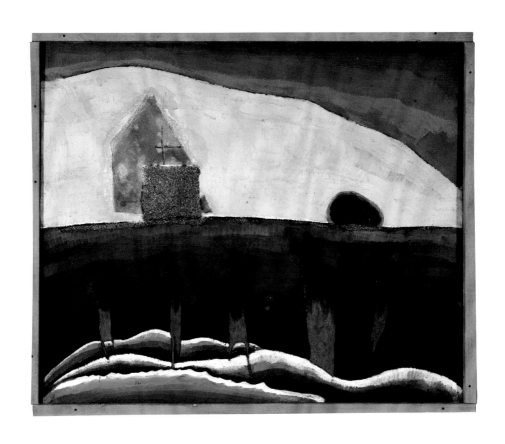

36. *Huntington Harbor II*, 1926

Sand, cloth, wood chips, and oil on metal support

9⅞ x 12⅛ in.

Carnegie Museum of Art, Pittsburgh; Bequest of
Mr. and Mrs. James H. Beal, 1993.189.25

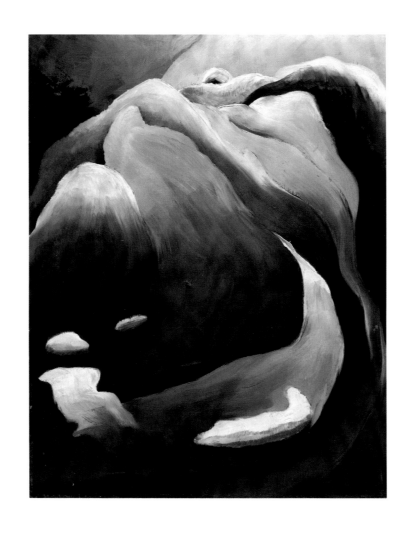

37. *Waterfall*, 1925
Oil on hardboard
10 x 8 in.
The Phillips Collection, Washington, D.C.

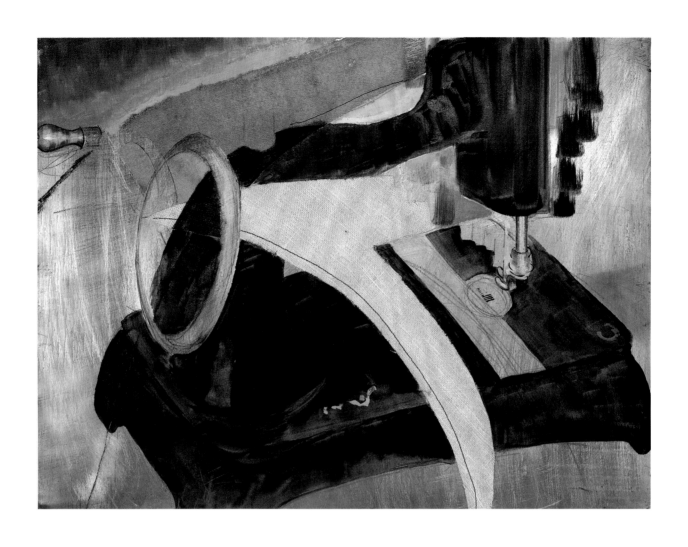

38. *Hand Sewing Machine*, 1927
Oil, cut and pasted linen, and graphite on aluminum
14⅞ x 19¾ in.
The Metropolitan Museum of Art, New York, Alfred Stieglitz
Collection, 1949 (49.92.2)

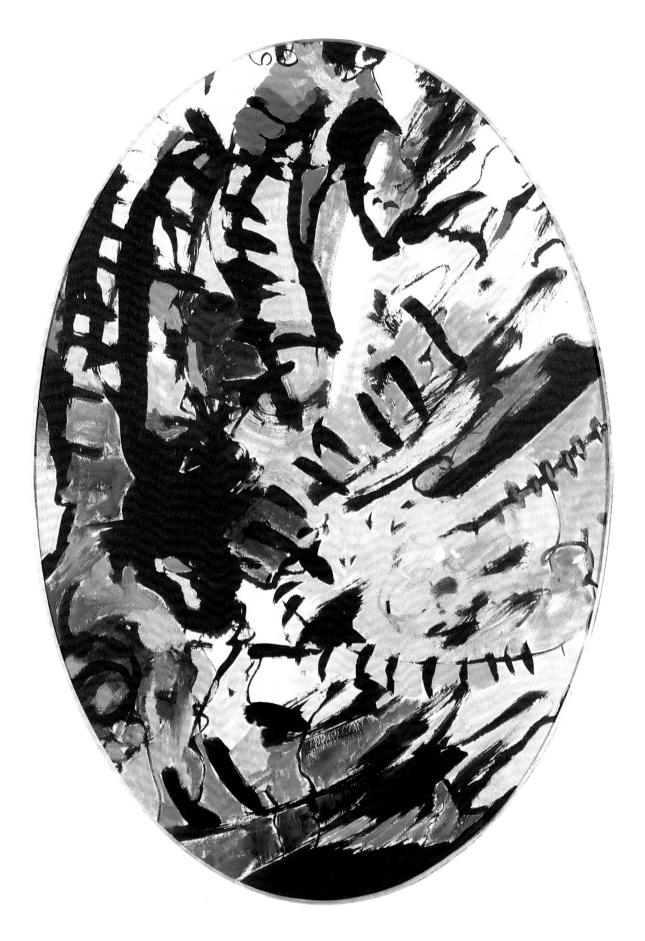

39. *George Gershwin—"Rhapsody in Blue," Part II*, 1927
Oil, metallic paint, and ink on paper
20½ x 15½ in.
Michael Scharf G. I. T.

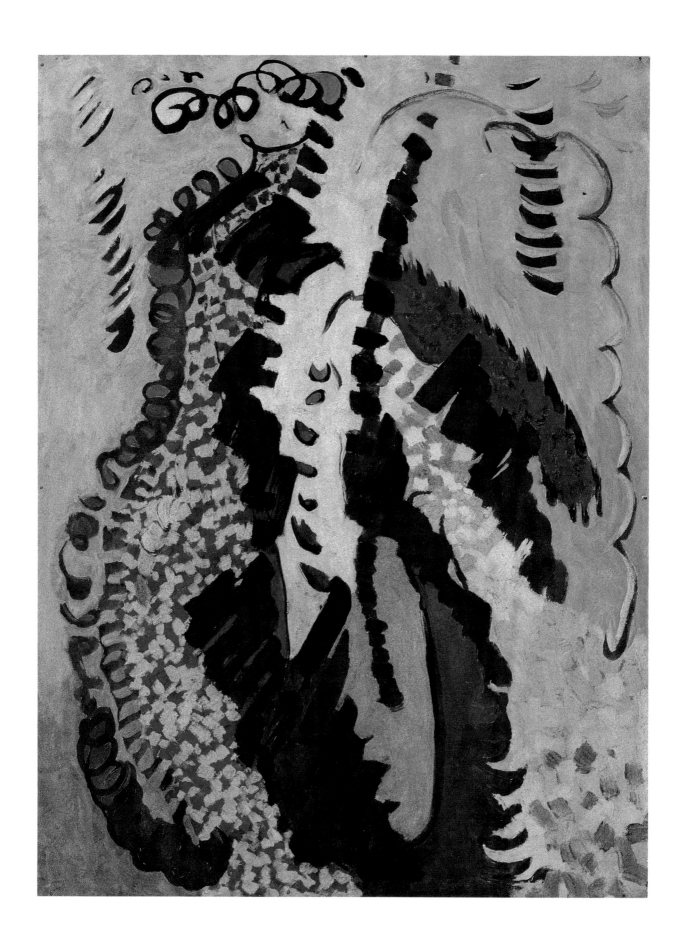

40. *George Gershwin—"I'll Build a Stairway to Paradise,"* 1927

Ink, metallic paint, and oil on paperboard

20 x 15 in.

Museum of Fine Arts, Boston. Gift of the William H. Lane
Foundation 1990.407

41. *Orange Grove in California by Irving Berlin*, 1927
Oil on board
20¹/₁₆ x 15 in.
Fundación Colección Thyssen-Bornemisza, Madrid

42. *Something in Brown, Carmine, and Blue*, 1927
Oil on metal
27¾ x 19⅝ in.
Alfred Stieglitz Collection, Fisk University, Nashville, Tennessee

43. *The Park*, 1927
Oil on cardboard
16 x 21 in.
The Phillips Collection, Washington, D.C.;
Bequest of Elmira Bier, 1976

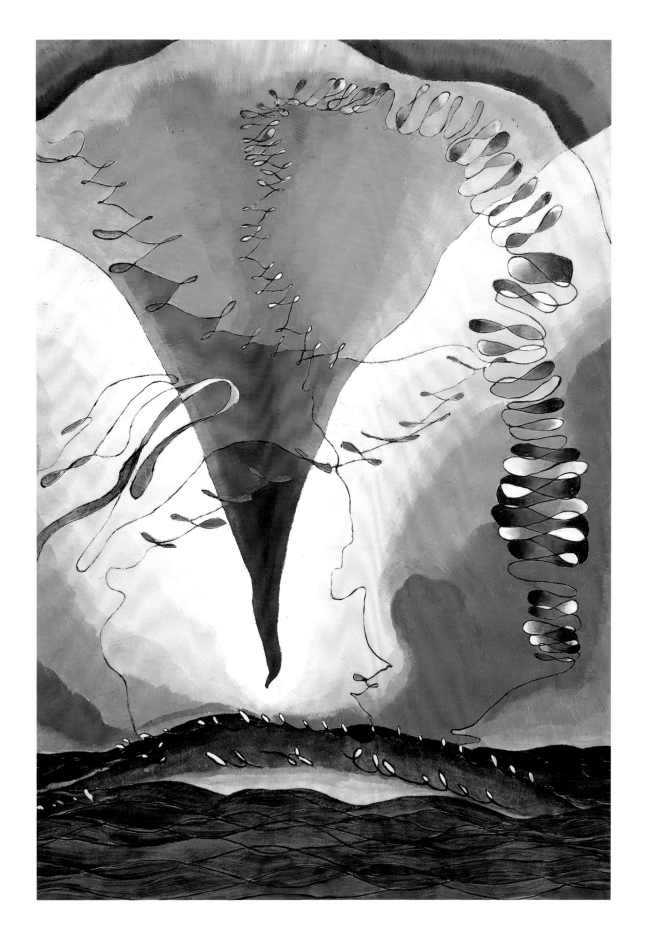

44. *Seagull Motif (Violet and Green)*, 1928
Oil on metal
28 x 20 in.
The Rifkin Family

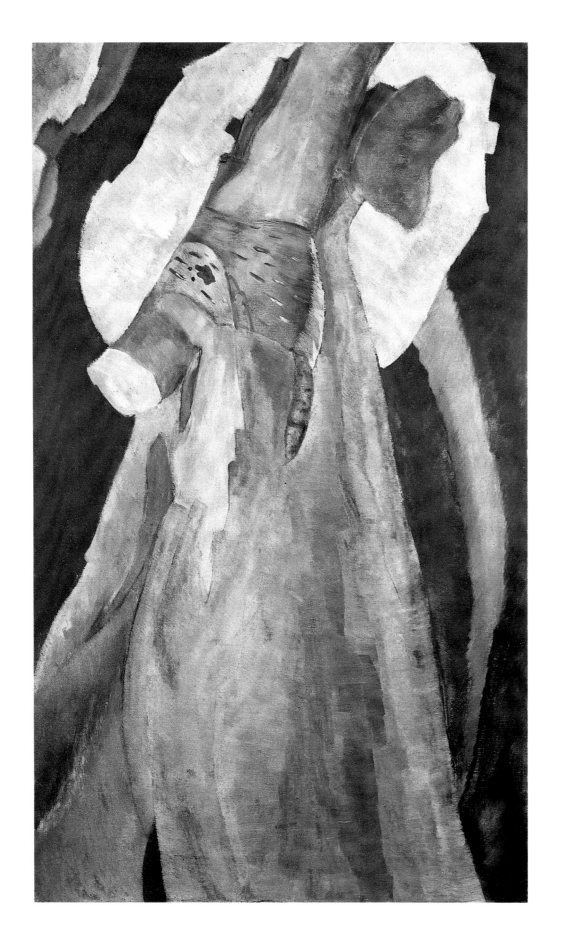

45. *Silver Log*, 1929
Oil on canvas
29⅝ x 17⅜ in.
Private collection of Elaine and Henry Kaufman

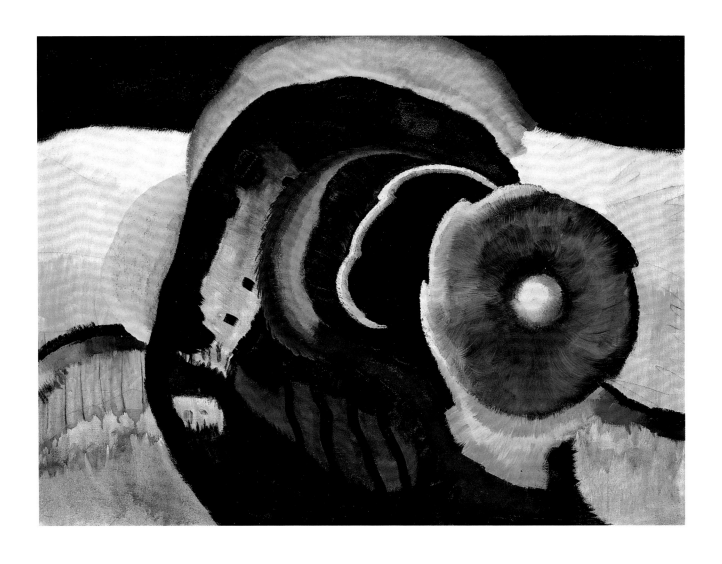

46. *Alfie's Delight*, 1929

Oil on canvas

22¾ x 31 in.

Herbert F. Johnson Museum of Art, Cornell University. Dr. and Mrs.
Milton Lurie Kramer Collection; Bequest of Helen Kroll Kramer

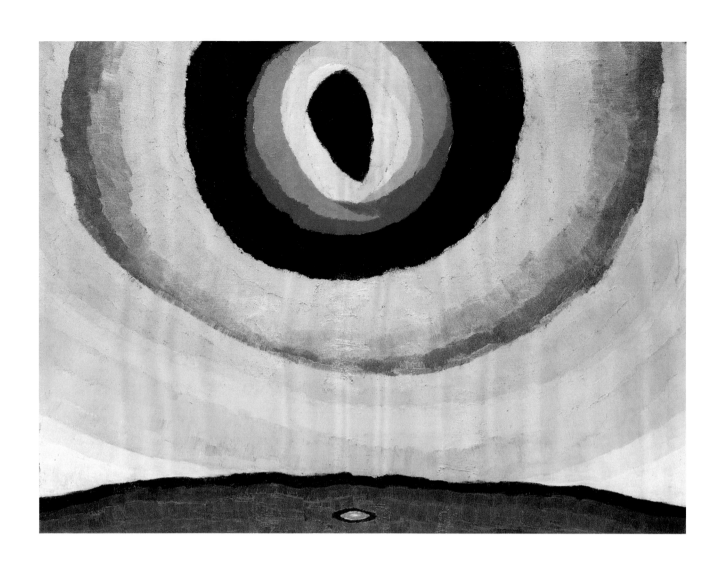

47. *Silver Sun*, 1929
Oil and metallic paint on canvas
21⅝ x 29⅝ in.
The Art Institute of Chicago, Alfred Stieglitz Collection, 1949.531

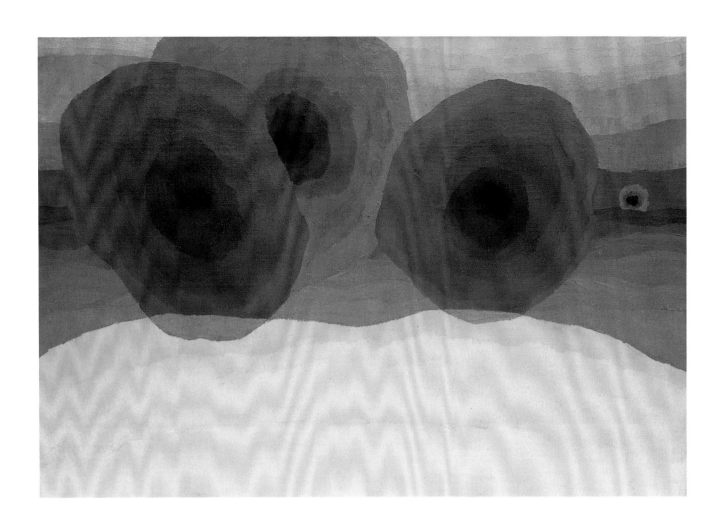

48. *Fog Horns*, 1929
Oil on canvas
18 x 26 in.
Colorado Springs Fine Arts Center

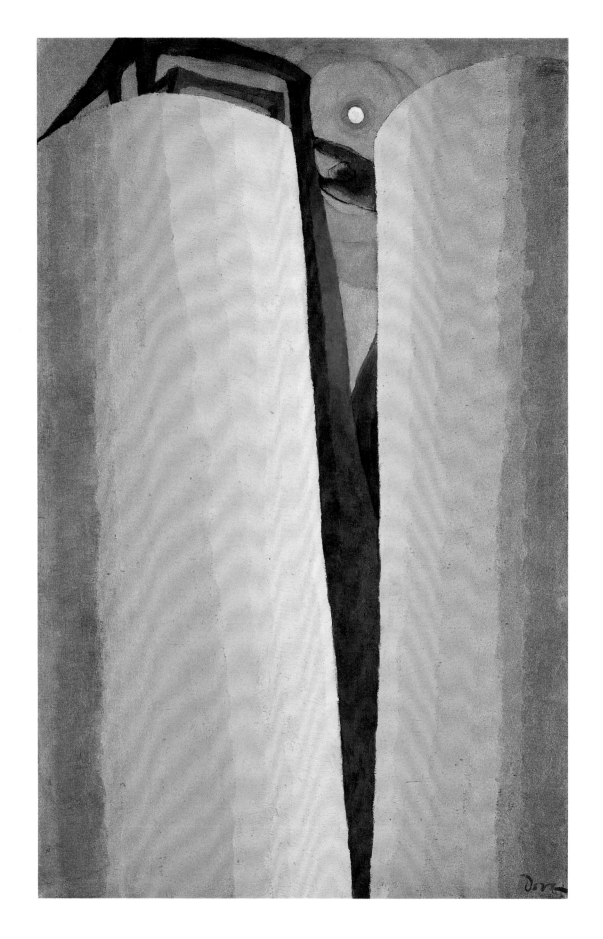

49. *Silver Tanks and Moon*, 1930
Oil and silver paint on canvas
28³⁄₁₆ x 18¹⁄₁₆ in.
Philadelphia Museum of Art: The Alfred Stieglitz Collection

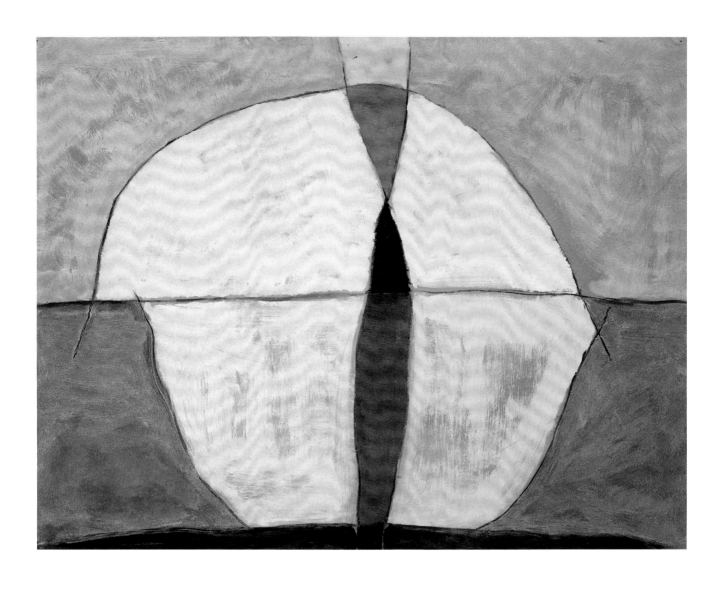

50. *Sun on the Water*, 1929
Oil, metallic paint, and charcoal on paper
14 x 19 in.
Private collection

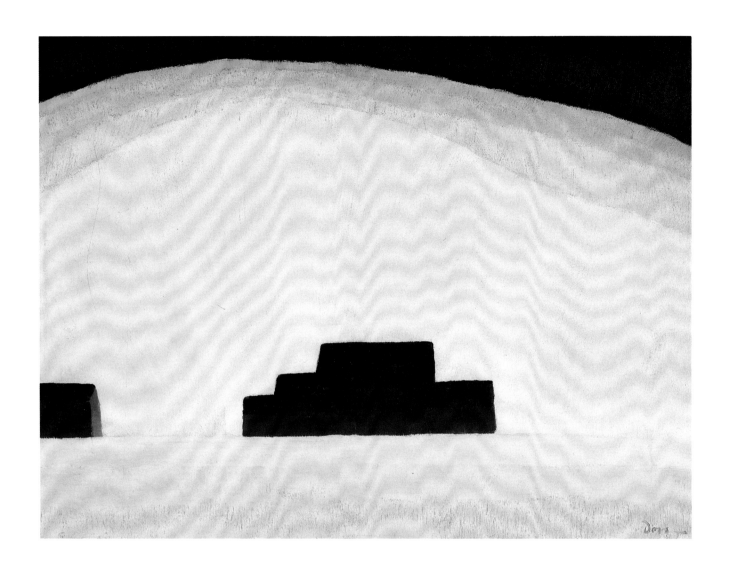

51. *Snow Thaw*, 1930
Oil on canvas
18 x 24 in.
The Phillips Collection, Washington, D.C.

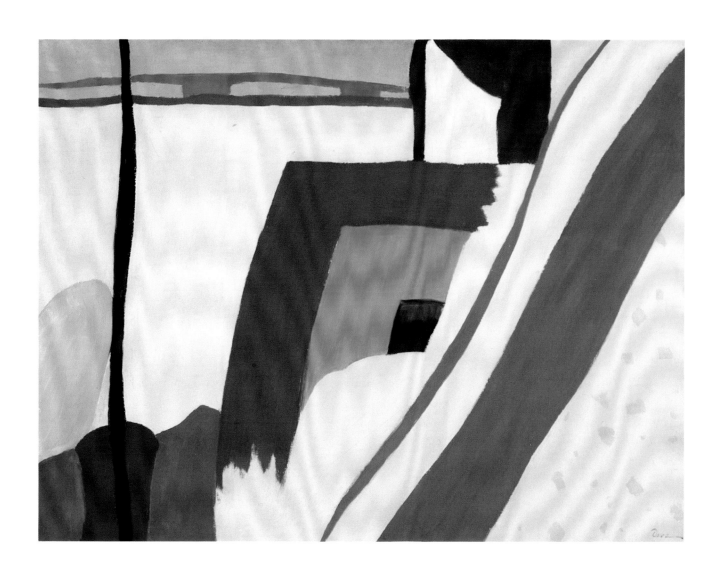

52. *Sand Barge*, 1930
Oil, metallic paint, and charcoal on paper
30⅛ x 40¼ in.
The Phillips Collection, Washington, D.C.

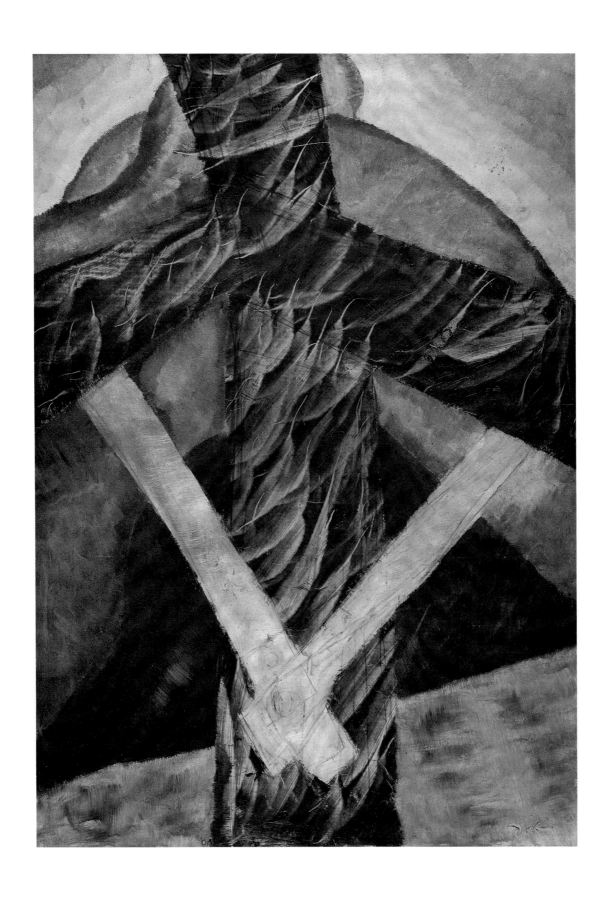

53. *Telegraph Pole*, 1929
Oil, metallic paint, and pencil on steel plate
28⅜ x 20⁵/₁₆ in.
The Art Institute of Chicago, Alfred Stieglitz Collection, 1949.535

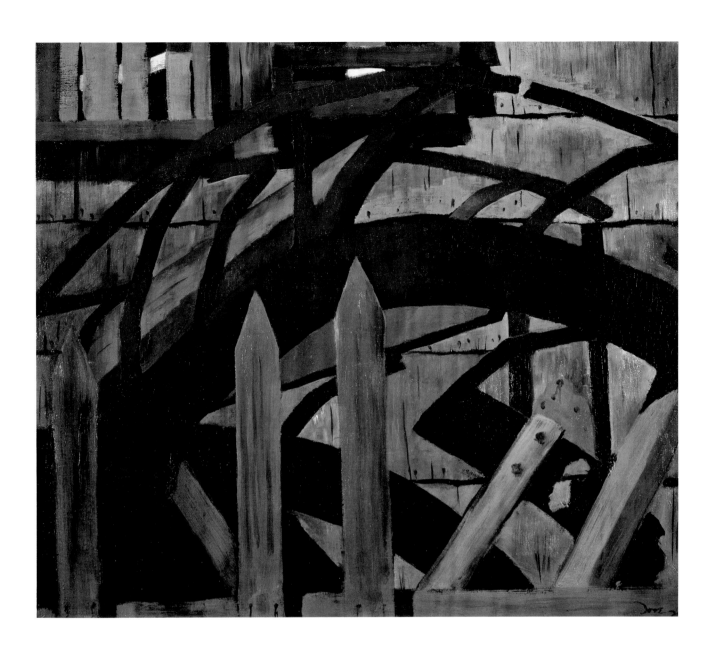

54. *The Mill Wheel, Huntington Harbor*, 1930
Oil on canvas
23¾ x 27⅞ in.
Curtis Galleries, Minneapolis, Minnesota

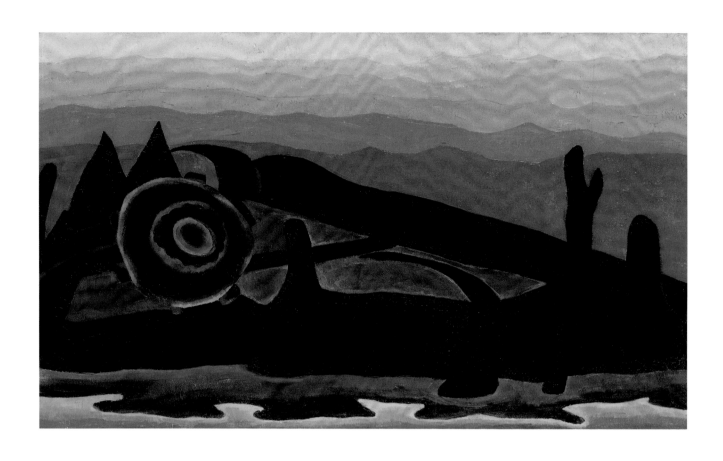

55. *Ferry Boat Wreck*, 1931

Oil on canvas

18 x 30 in.

Whitney Museum of American Art, New York. Purchase, with funds from Mr. and Mrs. Roy R. Neuberger

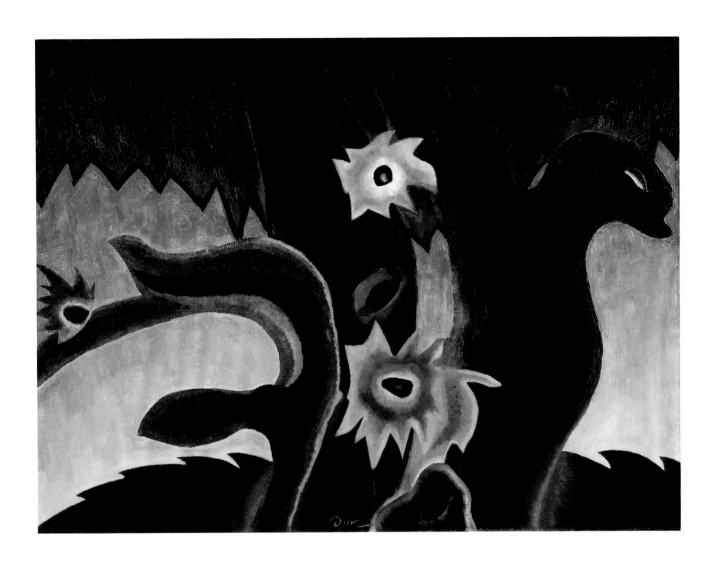

56. Pine Tree, 1931
Oil on canvas
30 x 40 in.
The Cleveland Museum of Art, Leonard C. Hanna, Jr., Fund

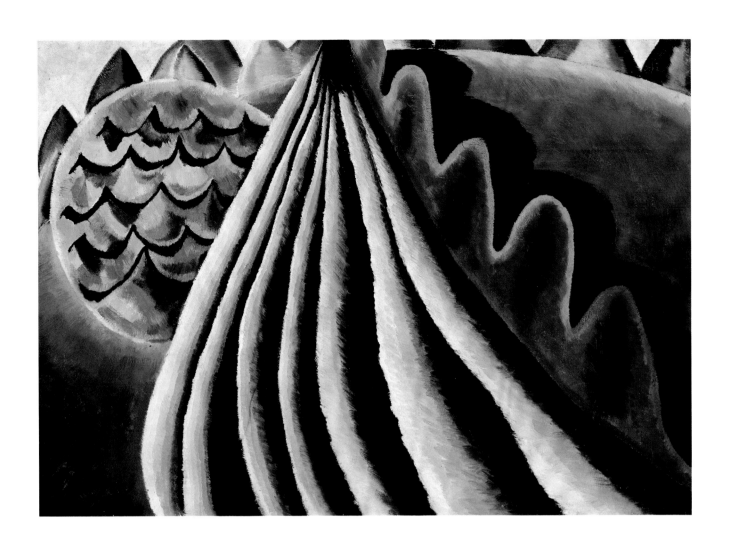

57. *Fields of Grain as Seen from Train*, 1931

Oil on canvas

24 x 34⅛ in.

Albright-Knox Art Gallery, Buffalo, New York; gift of Seymour H. Knox, 1958

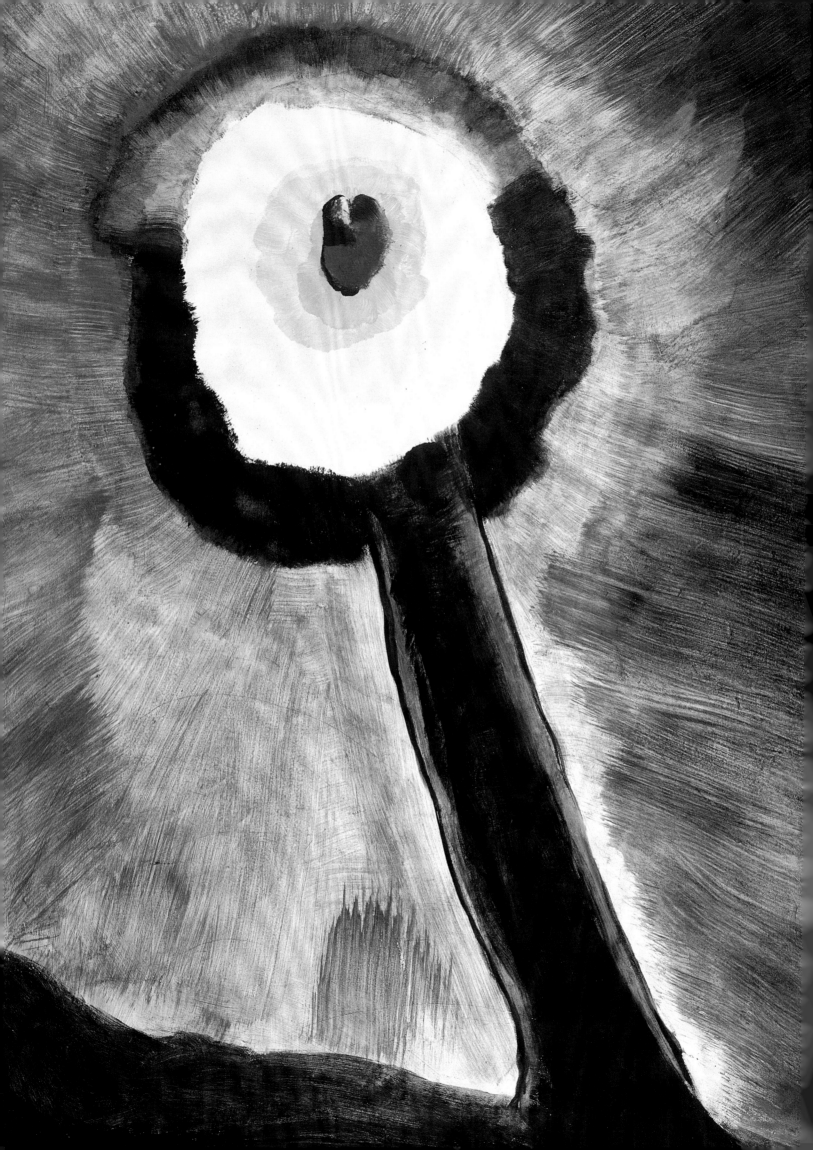

Going Home: Geneva, 1933–1938

ELIZABETH HUTTON TURNER

Arthur G. Dove
Moon, 1935 (detail), pl. 62
Oil on canvas
35 x 25 in.
Collection of Mr. and Mrs. Barney A. Ebsworth
Foundation

Geneva, New York, in the 1930s bridges the beginning and end of Arthur Dove's artistic career. It was a time of valediction to ideas from his earliest abstractions and assemblages as well as of new advances in his understanding of "oils."[1] Here Dove gained the tools to bond color and form with the impulses of mind and imagination. Though settling the family estate exacted an emotional toll, Dove lived through the strain and with amazing discipline focused on issues pertaining to paint. In so doing he arrived at what Sherwood Anderson called "a new sureness of touch"—in a word, maturity.[2]

AN UNWELCOME PROSPECT

In January 1933, while the Black Diamond sped him back to New York City from his mother's funeral in Geneva, Dove passed the time writing a rambling letter to his friend and dealer, Alfred Stieglitz. He described "a green stream following the train," his mother's passing—"Absolutely conscious up to the last 3 or 4 breaths"—and the possibility of moving back to Geneva —in that order.[3] Such seemingly disconnected sequences of thought and sensation organized Dove's actions. America's first abstract artist had vested everything in connecting the seen with the unseen impulses of life and art. His mother had been ill for many years, and it seems not to have occurred to him to mention the imminence of her death to Stieglitz. The thought preyed upon him in other ways. Dove was busy painting green moving into yellow and a ribbon of line fleeing the heaving horizon of earth for a work entitled *Sun Drawing Water*, 1933 (pl. 58), when he learned that his mother had died.[4]

Geneva was not the home that Dove and his second wife, Helen (Reds) Torr, dreamed of by the dock on the North Shore of Long Island. Geneva had always been the option posed by his mother in lieu of funds, and summarily rejected by Dove even when times were toughest. He had grown up in Geneva. He remained there to attend college for two years at Hobart starting in 1899, but at the time of his mother's death Dove had not actually lived in Geneva for nearly thirty years. Now

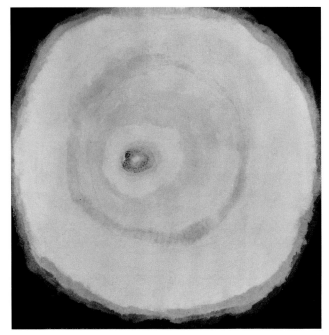

Fig. 21
Dawn I, 1932
Oil on canvas
22 x 21½ in.
Private collection

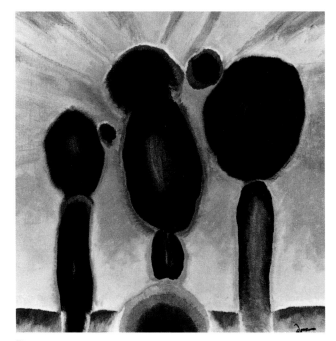

Fig. 22
Dawn III, 1932
Oil on canvas
22 x 22 in.
Collection of the McNay Art Museum,
Sylvan and Mary Lang Collection
(1975.27)

the possibility of returning seemed real enough to elaborate for Stieglitz:

> Could work up there. It is good painting ground. Many lakes and if we can sell house we may all live on the farms—plenty of houses and room to be apart, barns, studio, etc. Everything built to last forever. . . .
>
> I can get enough to eat out of the land there—have proved that.—The paintings ought to pay for paint.[5]

The plan proposed in Dove's January letter contrasted with the urgent messages of a month earlier. The Doves were then facing hunger and cold in the unheated custodian's quarters of a Halesite yacht club awaiting word of help from Stieglitz: "If anything comes up would be glad to take anything edible for paintings at any value."[6] In truth, Dove prided himself on his ability to paint through privation. The December 1932 crisis proved no exception to the rule, with three remarkably luminous paintings, *Dawn I–III* (figs. 21,22)—as he said, "the best yet by far"[7]—emerging from it. "Suppose a grown-up person of 50 is a damn fool to take such close chances, but that seems to be the kind of one I am," Dove had once observed.[8]

Going home is not an easy task for a grown child even in the best of circumstances. For the poverty-stricken Dove, who had rejected convention in turning away from the financial success of commercial illustration and from his first marriage (Florence Dorsey Dove's family and his had been neighbors on South Main Street), the ambivalent feelings about Geneva must have been overwhelming. From January to June 1933, Dove's letters to Stieglitz wrestled with the prospect. As he said, "The dread of going there is almost an obsession."[9] The issue was deep-seated. He wrote: "There is something terrible about 'Up State' to me. I mean that part anyway. It is like walking on the bottom underwater. I did that once there to keep from hitting a boy who thought he was helping me and he was only holding me down."[10]

Nowhere else on earth could Dove have felt the burden of such weighty expectations. The bright Impressionist works of his youth still graced parlor walls in

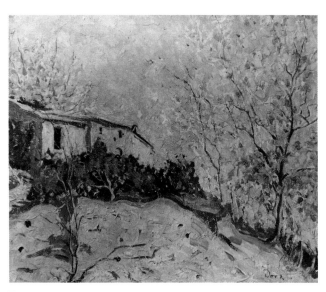

Fig. 23
Landscape at Cagnes, ca. 1909
Oil on canvas
18½ x 21 in.
Herbert F. Johnson Museum of Art,
Cornell University, Ithaca, New York,
Gift of Charles Simon

Fig. 24
Dove and Reds with Car, July 1933
Courtesy Arthur G. Dove Estate

Figs. 25a and b
The Dove Tile Plant, Geneva
Courtesy Geneva Historical Society,
New York

Geneva (fig. 23). His alma mater, Hobart College, had hailed his budding career with an exhibition of these paintings soon after he returned from France in 1909.[11] Yet he abruptly abandoned his Impressionism for something altogether different in 1910. Though Dove's father, a prominent Geneva brickmaker and builder, died in 1921 despairing that his elder son would ever come to his senses after veering off course into the unrewarding and unrewarded world of abstract art, his mother had kept a scrapbook filled with every clipping from every show as if awaiting her son's true vindication.[12]

Perhaps the estate accountants and lawyers had inadvertently summoned Dove to an important moment of reckoning. Whether or not Dove belonged in Geneva, his mother's will dictated that a significant, albeit highly mortgaged, portion of the family properties in Geneva—farms, houses, brick and tile plants (figs. 25a and b), a commercial block—should belong to him and his brother, Paul. Surely Dove must have debated whether taking possession of such an inheritance would be just one more in a series of moves that had interrupted his painting. That March Dove lamented, "Ideas are the only property worth having. Taxes are the penalty you pay for wanting things."[13]

In June the garden planted alongside the south farmhouse beckoned.[14] On July 7, 1933,[15] with the money from one of the long-awaited checks which he periodically received from his patron Duncan Phillips, Dove and Reds, herself a talented painter who had exhibited jointly with Dove that year, packed up the car and headed for Geneva still debating the consequences of their decision (fig. 24). Dove made no promises regarding the length of his stay. Jokingly he vowed not to "be interrupted by Republicans and grown-up college boys any more than necessary."[16] From the outset one thing was abundantly clear. What Dove needed most was a home—a proper place to foster his ideas. And he wanted it badly enough to wrestle with whatever personal demons were still lurking upstate.

Like Thoreau, Dove seemed to "cultivate poverty like a garden herb."[17] Eschewing the comforts of the family home on South Main Street, Dove and Reds set up their studios in a house without electricity or running water on farmland bordering Exchange Street just north of the city line, about a mile or so from the Dove commercial block. Over the course of that summer Dove walked the property from end to end, from the old orchard to the abandoned brickyard. Trying to save money on hired help, Dove and his brother spent the better part of July and August 1933 mowing hay, which they hoped to sell. In September Dove revisited boyhood amusements. He bought hunting and fishing licenses and shells. The early morning found him out and about along the Canandaigua outlet with borrowed gear. He caught bass, gathered mushrooms, chopped wood, and sketched his surroundings in watercolor. By late November he had matted fifty-three watercolors.[18]

Dove had always been an outdoorsman. In 1899 his high-school quarterly reminded its readers, "just look back to a very cold day in February when even Dove wore a sweater."[19] According to Dove, high school was "nothing" when compared to the youthful experience of roughing it outdoors. As he once said, "I can claim no background except perhaps the woods, running streams, hunting, fishing, etc."[20] Dove also liked to recall how he had returned homesick from his stay in France and from painting in Renoir's haunts near Cagnes-sur-Mer, and had gone camping in the Geneva woods "studying butterflies beetles flowers,"[21] only to reject Impressionism and awaken to his own very startling abstract improvisations.

Looking back, Dove, who had traveled abroad and read far and wide from Faraday's physics to Kandinsky's aesthetics, from Einstein's theory to Blavatsky's theosophy and Havelock Ellis's sexology,[22] surely could have claimed many sources of inspiration for his radical stylistic departure. Yet he always associated this juncture with tones and textures permanently imprinted upon his mind's eye in the Geneva woods. Pressing still further back into his childhood memories, the college-educated Dove credited Newton Weatherly (fig. 26), a Geneva strawberry farmer, greenhouse operator, and self-taught naturalist and painter, with making him an artist.[23] Why?

Weatherly did not participate in Geneva's highly lucrative nursery trade, which sent roses, fruit trees, and shrubs nationwide.[24] He raised and sold enough to meet his own needs and still had time to work at his avocation[25]—enough time, Dove recalled, to stretch a canvas for a boy of nine and give him color with which to paint. A courtly gentleman with an unconventional sense of style, Weatherly waded into fishing streams wearing a derby hat and a Prince Albert coat, along with his angler's boots.[26] According to Dove's father, Weatherly could, when a boy, "crack a chestnut burr with his bare heel"; yet his paintings demonstrate a Luminist's delicate palette as well as a naturalist's keen eye and sensitivity to subtle nuances in rushing water and woodland light (fig. 27).[27]

By the fall of 1933 Weatherly, aged eighty-nine, was living nearby in Phelps, having moved four years earlier from the North Main address where Dove had first known him. According to Reds, Weatherly then looked "like the Rembrandt old woman in the Metropolitan."[28] On a warm day in late September, just like old times, Dove and his friend went fishing.[29] Their reunion certainly kindled a sense of grateful recognition in Dove.

There could be no doubt about Dove's passion for those whom he admired. Ranking Weatherly among those he most revered, Dove later wrote: "Shall I say Christ, Einstein, Stieglitz—naming my own experience. Of course if I put them in order of time I should have to name my friend Mr. Weatherly soonest."[30] After Weatherly died in 1935, Dove gathered his memories as if he were making an assemblage. He told Stieglitz, "He was like cloth and vegetables and leaves in the woods. The finest soul I have known up to you."[31] Asked in 1934 to contribute to the volume *America and Alfred Stieglitz*, Dove paid tribute to his friend in short, clipped sentences worthy of his favorite author, Gertrude Stein. The resulting description captures Dove's attraction to an individual who could stand against the tide:

Fig. 26
Newton Weatherly and his son De Forest
Courtesy Geneva Historical Society,
New York

Fig. 27
Newton Weatherly (1846–1935)
Winter Landscape, ca. 1923
Oil on canvas
32 x 28 in.
Courtesy Geneva Historical Society,
New York

Once upon a time the same ones could always take the same
things to the same places and get the same welcome because the
things were the same. . . .

Then there was Stieglitz who at the right time and the
right spot threw the wrench. . . .

I like his being a thorn in the crown of the commonplace.
And I have always been glad to know him more than any other
man.[32]

Dove would be different too. In 1931 he failed to
follow up a suggestion made by Stieglitz, Paul Strand,
and others that he should apply for a Guggenheim fel-
lowship, apparently believing that if successful, he
would be required to go abroad.[33] During the winter of
1933–34, in response to a suggestion made by Duncan
Phillips, Dove echoed Stieglitz's well-known prejudices
against the Public Works of Art Project (PWAP).[34]
Referring to the wage of $34.00 a week that could have
meant his ticket out of Geneva, Dove remarked disdain-
fully, "the bull gets paid better than that for creative
work."[35] On a day in late December when the ther-
mometer read twenty degrees below zero, Dove's
cramped penmanship to Phillips offered a more sober
refusal: "If I leave just now, there will be no chance of
making this a reality for future painting which is impor-
tant to me and I must sow my own seed."[36] Perhaps at
that point Dove felt that he needed Geneva aesthetically.

In January 1934 the *Rochester Democrat and Chronicle*
broke the news that Arthur Dove, "native son of Gene-
va," was "now living in a ramshackle farmhouse while
he continues his battle to bring an understanding of his
art to America."[37] Sometime between July and January,
while conducting his very private agriculture of memory
and experience—of water, woods, and Weatherly—Dove
had made up his mind. Walking the local terrain as "just
the man who wears the high top boots,"[38] according to
the *Rochester Democrat*, Dove had constructed a vantage
point for the foreseeable future. What kind of future did
the artist have in mind? That April the critic Elizabeth
McCausland wrote: "He sees life as an epic drama, a
great Nature myth, a fertility symbol."[39]

WIT AND WATERCOLORS

Dove's 1934 exhibition at An American Place had little new to offer, only "wit and watercolors" as Lewis Mumford titled his review. By way of explanation to his readers in the *New Yorker*, Mumford elaborated upon his own preferences:

> Dove has a light touch, a sense of humor, and an inventive mind. He is most himself when he is most spontaneous, as in the small watercolors. . . . If we Americans did not so often do spurious honor to Art by pulling a long face about it, Dove would long ago have been recognized and valued for what he is: a witty mind whose art is play, and whose play is often art.[40]

There was comedy even among the new canvases, such as the painting of the little engine chugging with its load along the horizon (*The Train*, 1934, The Phillips Collection, Washington, D.C.). Only the lugubrious brown tree stumps undulating in a caldron of flashing white light, entitled *Tree Trunks* [*Life Goes On*] (fig. 28), contained portents of new biomorphic rhythms to follow. Overall Dove appeared more objective, less abstract. As the writer in the *Rochester Democrat* observed earlier that year, "The effect of his residence on the old Dove farm on part of which stand the ruins of the former flourishing Dove brickyards and ovens, is noticeable."[41] Underscoring this impression was Stieglitz's decision to fill the remainder of the show with assemblages such as *Rain*, 1924, and *Goin' Fishin'*, 1925 (pls. 27, 31), which Dove had made nearly a decade earlier.

Dove could be certain of his annual April exhibition with Stieglitz. That assurance guided the rhythm and routine of the year. Now for the first time in his career, while settled on his own land in Geneva, Dove could envision several major painting campaigns. Typically he spent spring and summer scouting for images and committing them to watercolor. The number and frequency of the watercolors gauged his progress. Like a runner to his coach, Dove reported to Stieglitz in June 1936, "We are in training again. Reds has several fine ones and I have somewhat over twenty watercolors."[42] October 1935 saw him well on his way to the

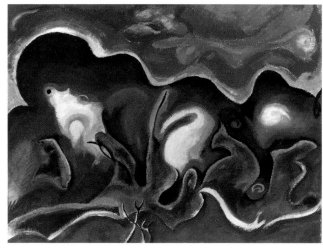

Fig. 28
Tree Trunks [*Life Goes On*], 1934
Oil on canvas
18 x 24 in.
The Phillips Collection, Washington, D.C.

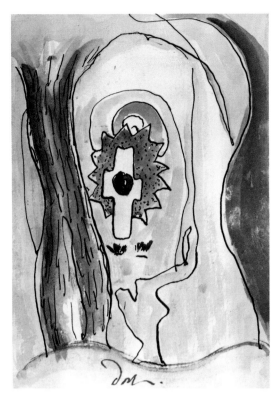

Fig. 29
I Put a Cross in the Tree, 1934
Ink and watercolor on paper
6¾ x 4⅞ in.
William H. Lane Collection
Courtesy, Museum of Fine Arts, Boston

finish that year: "Anyway I have over 110 watercolors all mounted and ready for frames. . . . Am at least two months ahead of last year."[43] Dove made watercolors as cartoons for contemplation, moments of vision and recognition recorded in hopes that, as he once wrote, "the first flash will give the truth of one's feelings."[44]

Line increasingly became the all-encompassing agent in this enterprise. Whether fanning out across the sky in a single curve or sagging along the weathered timbers of the brickyard shed or bearing down into detailed intimations of a cross formed from the knothole of a tree (fig. 29), Dove's fluid brush mapped the terrain near and far. The artist's restless, inductive approach to the day never permitted him the security of knowing the source of his next image. Reds's diary periodically described moments when he was at a loss: "Arthur all over Geneva, said it drops you—to Loomis woods but saw nothing to do." There were also moments of discovery: "out to Chipp's Dam & Farm . . . Arthur got an idea."[45] Every incident or accident, great or small, made fair game. The May carnival, hay and horses in July, September sunrises, October foliage—these captured him year after year.

Watercolors were what Dove called his "models to build from"[46]—records of light and color to be sorted in his winter bunker—a time with no sun, only fog and sudden snowstorms rolling in from the Great Lakes.[47] Other than the occasional trip out to a nearby research facility, the Agricultural Experiment Station, to use their pantograph enlarger, Dove devoted the winter to sustained concentration on his painting, grinding pigment, building up the surfaces of his canvases, and configuring color in paint. March was left for silvering frames and packing. Impatient with the thought of the eight-hour train ride, Dove imagined and actually once suggested flying the work to Stieglitz.[48] During his five years in Geneva, Dove in fact returned to New York only once.

Visitors to Dove's 1935 exhibition at An American Place saw Geneva's high plateau and bright latitudes—even if the titles and imagery recalled tongue in cheek the regionalist scenes by Thomas Hart Benton, whose

critical review of *America and Alfred Stieglitz* had exasperated Stieglitz.[49] Who else but an irreverent caricaturist such as Arthur Dove would in a painting called *Morning Sun, 1935* (fig. 30), seize upon the curve of the horizon and set plowed furrows into an unrelenting forward motion? Had he, like an inquisitive Tom Sawyer, stared too long into the sun in order to find the black spot and spiral within the orbs of light hovering over the landscape?

Certain elements in Dove's Geneva landscapes seemed to advance and recede whimsically with the tides of his imagination. What makes Dove's peach orchard, in his words, "electric"? The wiry skeleton of spring trees in his *Electric Peach Orchard, 1935* (fig. 31), march like so many telephone poles across green and gold into the airy distance. Foliage emerges wet and shiny like a green dolphin out of a mound of earth in *Summer, 1935* (pl. 64). A white star nests in the blue and brown belly of a goat (fig. 32).

If asked directly whether these animistic apparitions came from dream or experience, Dove himself would probably have attributed them to an amorphous residue of Geneva light upon the retina or some other happy coincidence in paint. That spring McCausland emphasized Dove's unique combination of Surrealism and Americanism, invoking Mark Twain's jumping frog and Miró.[50] Later Phillips would speak of Dove's "truly primitive pantheism."[51] However, Van Wyck Brooks, an old friend who had known Dove since his days as a farmer in Westport, recognized something overlooked by the others. He wrote to Dove about what was happening to his color.[52]

NEW COLOR

Having begun his painting career as an Impressionist, perhaps Dove never really gave up the desire to understand and capture what Baudelaire once termed the "great symphony of daylight."[53] Perhaps the particular interplay of heat and light in the Geneva landscape renewed Dove's awareness of certain vibrations. Perhaps this is why, in the midst of his Geneva sojourn, the artist began a systematic study of medium and technique.

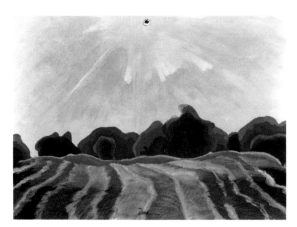

Fig. 30
Morning Sun, 1935
Oil on canvas
20 x 28 in.
The Phillips Collection, Washington, D.C.

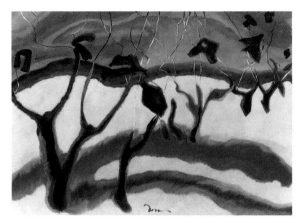

Fig. 31
Electric Peach Orchard, 1935
Oil on canvas
20 x 28 in
The Phillips Collection, Washington, D.C.

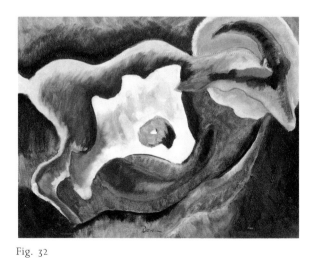

Fig. 32
Goat, 1935
Oil on canvas
23 x 31 in.
The Metropolitan Museum of Art, Alfred Stieglitz Collection, Gift of Georgia O'Keeffe from the estate of Alfred Stieglitz, 1949 (40.70.97)

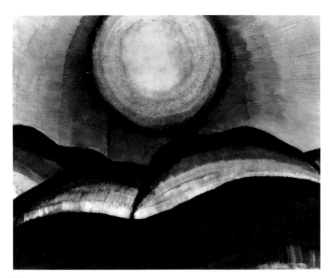

Fig. 33
Moonlit Landscape, 1924
Oil on Bakelite
8 x 10 in.
Aaron I. Fleischman

The fall of 1935 found Dove reading "every inch" of Max Doerner's technical compendium, *The Materials of the Artist*, a translation of which had appeared the previous year.[54] "Wish I had it years ago," Dove wrote to Stieglitz, "Georgia [O'Keeffe] said she reads it like the Bible."[55]

Since the early 1930s, when Dove returned primarily to easel painting, he resolved "to try to make oil paint beautiful in itself with no further wish."[56] To that end he had forsworn fantastic borrowed mixtures of plants, metal, wood, fabric, sand, printed paper—conjuring suns and seas out of silky gauze on metal, or shimmering moonlight out of finely brushed green and gold across Bakelite, as he had done in the 1920s (fig. 33).[57] He ground his own color, even, on occasion, primed his own canvases. As always he found joy in knowing his materials thoroughly, even if critics such as Edward Alden Jewell complained about the heaviness of his oil paintings, which seemed to lose the ease and conviction of his watercolors.[58] Now with the information in Doerner's book to guide him, Dove embarked upon a sustained exploration of media compatible with oil.[59]

Reds's diary tells us of one Sunday in September 1935 when Dove spent the entire afternoon reading about waxes and varnishes before going to sketch by the lake.[60] In his copy of Doerner, he registered his particular interest in a passage concerning resin oil color and resin oil color with wax, the effect of which Doerner describes as colors with "a misty, pleasingly dull and mat appearance, and great brightness and clarity."[61] Later, when he had hit upon just the right combination, Dove inscribed his copy: "1st painting resin oil temp. and resin oil colors with wax, has the most beautiful in itself quality that I have found."[62]

If, as Dove himself once said, late October was when the work went best,[63] then October 1935 must have been an exceptional month—so much so that he named a painting after it. By Dove's standards *October* (pl. 63) was vast, ambitious enough for a muralist in size and scale, comprising two long canvases set end to end, where great overlapping bubbles and commas of

yellow, green, and red make up a marvelously varie-gated panorama. Using the same palette in a painting entitled *Autumn*, 1935 (pl. 60), Dove paid tribute to the lyricism of Geneva's wildly beautiful season, just as Reds's diary described it, filled with crisp, bright days of high wind and sunshine bringing temperatures of ninety in the sun and sixty-four in the shade.[64] At this moment Dove felt strong; as he reported, "Am myself better than in some years. Still run every morning for a half mile. Had to give up bathing in the pool yesterday, as the frost brought down the leaves and left me nude, unless I wear one."[65] He was so sure of his direction that he made plans to travel with his paintings to New York the following spring for his annual exhibition at An American Place. That October Dove told Stieglitz, "I want to be there this year."[66]

Mornings registered in Naples yellow—a color used by the Old Masters which Doerner described as "very heavy and dense and therefore of exceptional covering power," able to cover even zinc white, "invaluable" for varnished tempera painting. As Doerner remarked, "We might well be happy if we had nothing but colors of the quality of pure Naples yellow!"[67] In Dove's *Naples Yellow Morning*, 1935 (pl. 61), day emerges from behind the black spot at the center of the rising sun. The color liter-ally radiates in bands of short, textured brushstrokes which track the vast canopy of sky, behind and under-neath clouds trumpeting violet, penetrating even the innermost arches of greenery with their warmth. In *Moon*, 1935 (pl. 62), night takes on an iridescent green; with the full moon behind it, a single silhouetted tree stands like a totem holding a jewel of light circled in black and crowned by blue.

During this campaign Dove achieved a remarkably consistent combination of depth and matt finish by painting with oil over tempera as Doerner recommend-ed—"according to the old law 'Fat over lean.'"[68] A certain richness came by underpainting with stronger hues.[69] This method, together with the grainy quality of his paint, permitted Dove to create surfaces that reflect diffuse light as in *Cows in Pasture*, 1935 (pl. 59).[70] The

interaction of wet, waxy oils over dry, absorptive, chalky grounds, just as Doerner predicted, achieved a pleasing vibration, which Dove shaped according to his needs. The brown, black, tan, and yellow-green of *Cows in Pasture* appear to be distinct passages of wax emulsion, casein, and gouache.[71] They exude a soft, breathing quality redolent of the warmth of animal hide or of the velvet glow of butterflies studied by Dove so long ago in the Geneva woods. He may have found a similar interaction of color and surface in the grit of charcoal and pastel or in wood panels stroked with silver paint, but until this moment such qualities had eluded him in an oil mixture on canvas.

Dove was present at the opening when his paintings went on exhibition at An American Place in the spring of 1936, only to discover New York oblivious to the artistic breakthrough that his new materials represented. According to Jewell's review in the *New York Times*, *Naples Yellow Morning* seemed "inconsequential."[72] Reds herself admitted that the paintings somehow "looked small there."[73] Jewell's criticism—that Dove's abstractions "nowadays may often seem not indicative of his full artistic potentiality"[74]—must have been particularly gal-ling in light of Dove's omission from The Museum of Modern Art's current exhibition, "Cubism and Abstract Art," which showed a range of both geometric and organic examples from Malevich to Kandinsky, including works by Man Ray and Alexander Calder.[75] Dove's pre-scient abstractions of 1911–12 had apparently been for-gotten. Three days after his own show was hung, Dove stopped by the Modern. Six days after that he went to A. E. Gallatin's Gallery of Living Art and later purchased a catalogue of the collection.[76] If the artist was affected by "Cubism and Abstract Art," no comment is recorded. That June, back in Geneva, however, Reds's diary notes that he spent time translating a "Mondrian article"[77]—Mondrian had been prominently featured in the show.

In August 1936 Dove began a series of large paint-ings of the sunrise.[78] Countless sketches and yearly can-vases document the ways in which Dove had always delighted in drowning his gaze in the immensity of the

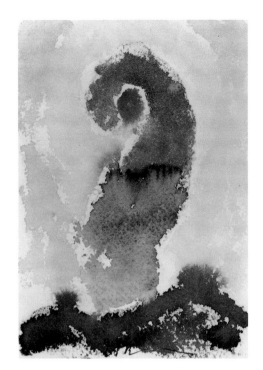

Fig. 34
Sunrise, 1936
Watercolor on paper
7 x 5 in.
Aaron I. Fleischman

sky. Perhaps color alone was enough for other abstract artists, but Dove needed prompting from the outdoors. This point worried him when he wrote Stieglitz concerning the series. "Weather shouldn't be so important to a modern painter—maybe we're still 'too human.' . . . Must get up to work. Have been trying to since 5 A.M."[79] Beyond an Impressionist's fascination for the incidental distribution and relation of tones, Dove's interest in daylight was more akin to that of a modern physicist. Dove did not want simply to describe the light, he wanted to know the speed of it. Short of a conversation with Albert Einstein—an event that he often wished for[80]—Dove believed dawn made him particularly sensible to matter and energy. As he said, "you get to the point where you can feel a certain sensation of light—a certain yellow-green-red—they have nothing to do with tubes of paint."[81]

By virtue of their sheer size and simplicity, the Sunrise paintings achieve an autonomous presence—a quality of abstraction that Dove had called "self-creative in its own space."[82] Earlier in the year the artist had toyed with a watercolor of an O'Keeffe-like spiral unfolding in space (fig. 34).[83] That fall, concentric circles of what Dove called tempera and oil,[84] stripped bare of every illusion except the marvelous expanse of universe, instilled a new intensity which was at once abstract and surreal. A note by Dove dated October 18 reads: "am all excited again about the paintings—what I did today, though slight in a way makes every thing else look a little grayer like last years did the others."[85]

Dove worked intermittently on the Sunrise series over a period of six months from late August 1936 to the end of January 1937. It took several attempts to get just the right quality of medium and color.[86] More often than not he found himself scrubbing out passages that had become too dry and crumbling. Numbered I to IV in the order of their completion, the resulting paintings unfold in the fashion of a narrative: a creation story deep in the microcosm where the first phallic intrusion leads to the fusion of the cell;[87] or out in the stratosphere where light originates; or perhaps from the pages of

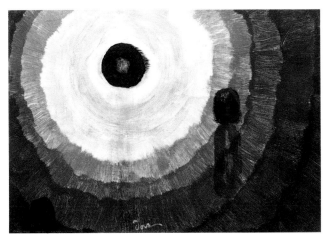

Fig. 35
Sunrise IV, 1937
Oil and wax emulsion on canvas
10 x 14⅛ in.
Hirshhorn Museum and Sculpture
Garden, Smithsonian Institution,
Washington, D.C.
Gift of Joseph H. Hirshhorn, 1972
(HHSG 72.99)
Photograph by Lee Stalsworth

Fig. 36
Brown Sun and Housetop, 1936
Oil and wax emulsion on canvas
11 x 18 in.
Private collection

Genesis, "As it was in the beginning."[88] At dawn in *Sunrise I*, 1936 (pl. 65), fluid linear probes tipped blue stir the vast, cool ether into a yellow-green. A Naples-yellow beacon launches light on a diagonal trajectory in *Sunrise II*, 1936 (pl. 66), animating great arcs of space with contrasts of rose madder, cadmium red, and Prussian blue. When the sun radiates white above the horizon in *Sunrise III*, 1936 (pl. 67), all else is thrown into dim silhouettes alternating blue-green with violet. Bands of turquoise in *Sunrise IV*, 1937 (fig. 35), at last proclaim the brilliant ambience of day.

Dove filled his 1937 show at An American Place with abstractions: water swirls, suns, and moons—free-verse hymns to golden daylight and the deep night sky such as *Me and the Moon*, 1937, *Golden Sun*, 1937, and *Brown Sun and Housetop*, 1936 (pls. 69, 68, fig. 36). If Dove had wanted the last word with The Museum of Modern Art and his critics, Stieglitz at least made certain of it by publishing a catalogue in which the writer William Einstein, a friend of Mondrian and Calder, who had recently returned from Paris, asserted Dove's preeminence:

> His modern language would make him a leader among the so-called abstract painters and as such he would be feted by the American Art-lovers who have found this new fashion and are now feting it in their usual manner, which means good, bad and indifferent—just so it's French. . . .
>
> If one can be sufficiently free to be able to enjoy only the color in Dove—for in his orginality and harmony he is certainly one of the great colorists of today—one will at least have an introduction—a chance to experience the deeper human values that Dove carries from himself into his paintings.[89]

Perhaps Dove's increasing consciousness of his work in relation to European abstraction led him to the bold demonstrations of color and highly simplified forms that others saw in his 1937 show. Dove's friend Sherwood Anderson saw "a new maturity":

> It seems to me, Arthur, that there is in this new work of yours a new sureness of touch. It is something more than that. I do not know how to find a word for it except to say that it is a new maturity. Maturity of this kind is so hard to achieve.[90]

Fig. 37
The Dove Block, Geneva
Courtesy Archives of American Art

Fig. 38
Studio Wall Installation, 1938
Courtesy Archives of American Art

Fig. 39
Studio Wall Installation, 1938
Courtesy Archives of American Art

THE DOVE BLOCK

In the spring of 1937 Dove resisted moving from the north farmhouse (he and Reds had occupied it since April 28, 1934) until after he had sent the work for his show to New York.[91] Over the past twelve months the brickyard had been dismantled and sold;[92] the farm divided into twenty-two lots;[93] and the family home on South Main Street divided and rented as four apartments. Though the burden of the estate had been considerably lightened, Dove still felt obliged to manage the property himself. While his brother spent time off in the winter working on a yacht in Florida, Dove resolved to stay close to home.

For what would be their final year in Geneva, Dove and Reds moved into town to a building known by the name that his father had had cast in concrete on its facade: Dove Block (fig. 37). The Dove Block had stood the test of time as many things: a dance hall, a radio station, a roller-skating rink. On or about May 7 the entire third floor—all sixty-by-seventy square feet of it—became the largest studio that the artist would ever occupy.[94] As he wrote to Stieglitz, "Walk about 10 miles before noon around this huge hall."[95] Dove actually reveled in the space, placing andirons under the radiators beside the Victorian sofa and skating the perimeter between painting sessions.[96]

Situated in the heart of town Dove saw Geneva clearly and in relative comfort: "We overlook the lake from the rear and are on one of the city's main corners on two other sides which have 19 windows ten feet high so we have light—and heat. And a fine roof on top which we haven't had time to see as yet."[97] Living high above the street had its advantages. As he reported, "This room is quite beautiful especially at night, lighted by the city streets."[98] Such vistas gave Dove new mental command over the present to match his understanding of the past. This development in his life must have resonated with the effect of his retrospective organized by Duncan Phillips that spring.[99] Indeed, there were brief moments in 1937 when it was almost possible to see his career cleared of difficulty. He wrote, "The air and ideas

are being bridged over so that they can be lived upon, and it enables a few thoughtful ones communication and mental peace which has heretofore been denied."[100]

The new location yielded new routines. Dove felt especially productive. In June he reported to Stieglitz, "Get up early and usually go on the water here. We have a small boat. And by 8 or 9 I have almost a day's work done."[101] Over the course of the summer and into the fall his work reflected new subjects found in Geneva's urban and industrial development along Lake Seneca—*City Moon, Motor Boat, Power Plant, Flour Mill* I, *Flour Mill* II, and *Shore Front*. By winter their arrangement on the studio walls lit by tall windows inspired him (figs. 38, 39). It was a rare luxury to hang or even see his own works installed in anything resembling a gallery. Dove found himself imagining the walls all painted white, with O'Keeffe arranging the space.[102] That December, in lieu of assessments by Stieglitz or O'Keeffe, the artist offered his own: "They look big on this huge wall. And as each one gets its overcoat they seem to walk forward. There are about 25 now. (Most of them tempera so far. They have still to get final painting.)"[103]

In January 1938 Dove paired *Flour Mill* II and *Holbrook's Bridge to Northwest* (pls. 70, 71). The action was telling. One tall and thin, the other deep and wide—the two paintings could hardly have been more different. Yet together they established the range of Dove's exploration of abstraction and color that year. The giant composition of *Holbrook's Bridge to Northwest* looks deeply into the past. Like the armature in *Goin' Fishin'*, the assemblage he had constructed years earlier with bamboo poles and denim, *Holbrook's Bridge to Northwest* fans out and then directs the eye to a dark center. Squares echoing in ever smaller perimeters of deep colors complete the painting's tightly woven introspective form. Dove called it a homage to his old friend Weatherly, "with whom I used from the age of 5 to go fishing there. And he made a prayer each year that he would see it again."[104] The artist painted the center of the composition more than once so that the last color square would hold the focus.[105]

Fig. 40
Flour Mill, Geneva
Courtesy Geneva Historical Society,
New York

Tall and bright, *Flour Mill II* also vests everything at the center but in quite another way. Leading the eye from top to bottom is what Reds called "a fine flat yellow,"[106] floating against white just as the newly built flour mill soared into the Geneva skyline by the lake (fig. 40). Side by side the rooted resolution of the bridge next to the marvelously transient calligraphy of the mill says volumes about Dove's lack of connection with modern Geneva as well as his imminent departure. Overall Dove spoke of a shift in the work, telling Stieglitz that the paintings "have more bite than last year, naturally. Life must have more than just the beautiful."[107]

Over the course of his last twelve months in Geneva his letters to Stieglitz composed a swelling litany of complaint. The need to leave shouted at him from every corner: the lake, the studio, the street. The pressure of money and sales seemed too much. "Think I'd better not try to like Geneva. It is swell from 3 A.M. until 6.—Then the people begin to appear. 'Buying cheap and selling dear.'" There was also the issue of Reds's health and outlook to consider. The concern was so great in fact at one point that, as Dove reported, their new doctor, Dorothy Loynes, "offered to give me half her salary the other day so that we could get away from this situation & work in peace." Finally, in February 1938 a flash fire in the basement of the Block was a "warning among many others that we should get out of here."[108] The only question remaining was how the move could be financed.[109]

As it happened, the Doves' departure from Geneva was launched that spring in a matter of two weeks after Stieglitz produced money like manna in advance of a proposed purchase by Phillips.[110] Reds's diary notes that they boarded the train on April 16, 1938 at 8:03 A.M.[111] Looking back Dove saw something momentous about the entire venture: "Well, anyway this is a great turning point. With peace next year, I think things will march on. Maybe this strain was good. . . . life after all is pretty damn swell."[112]

In the end, ironically enough, he found that the dreaded Geneva had fueled both his intensity and his productivity as an artist. Never before had Dove been able to sustain such focused exploration in his work; never again would he be as prolific.

NOTES

The diaries referred to in this essay for the years 1933–38 were kept for the most part by Helen Torr Dove, with the occasional entry by Arthur Dove (identified as such in the relevant note). See Dove Papers, reel 38 (1933–October 31, 1934), reel 39 (November 1, 1934–July 30, 1938), reel 40 (July 31, 1938–December 31, 1939), Archives of American Art.

1. For the purposes of this essay I follow Dove's general use of the term "oil" in designating his canvases, even if an additional medium was involved. It should be noted, however, that especially after 1935, Dove's paintings were rarely done exclusively in oil.

2. Sherwood Anderson to Arthur Dove, April 12, 1937, The Alfred Stieglitz and Georgia O'Keeffe Archives, manuscript 85, series 1, box 2, Yale Collection of American Literature, Beinecke Rare Book and Manuscript Library.

3. Arthur Dove to Alfred Stieglitz, January 29, 1933; Morgan 1988, 264–65.

4. Diary, January 22, 1933.

5. Dove to Stieglitz, January 29, 1933; Morgan 1988, 265.

6. Ibid., December 22, 1932; Morgan 1988, 259.

7. Ibid., December 12, 1932; Morgan 1988, 254.

8. Ibid., December 19, 1930; Morgan 1988, 203.

9. Ibid., June 1933; Morgan 1988, 276.

10. Ibid., probably May 18, 1933; Morgan 1988, 271.

11. "An Exhibition of Paintings by Arthur G. Dove," Cox Hall, Hobart College, Geneva, New York, October 7–9, 1909.

12. Paul Dove, "Notes Relative to Arthur G. Dove," Geneva Historical Society, Geneva, New York. The document can also be consulted in the Dove Papers, reel 954.

13. Diary (entry by Dove), March 5, 1933.

14. Dove to Stieglitz and Georgia O'Keeffe, probably June 28, 1933; Morgan 1988, 278–79. There was another farmhouse on the property, located to the north of this one, where Dove and Reds moved on April 28, 1934.

15. Diary, July 7, 1933.

16. Dove to Stieglitz, June 3, 1933; Morgan 1988, 276.

17. Quoted in Havelock Ellis, "Whitman," The New Spirit (Washington, D.C.: National Home Foundation, 1935), 93.

18. Diary, July 13, August 16, September 10 and 22, and November 30, 1933.

19. Daisy Taylor, ed., "The Quartermaster," High School News (February 1899), 8. I am grateful to Steve O'Malley, Curator of the Geneva Historical Society, for bringing this reference to my attention.

20. Arthur Dove, autobiographical statement, ca. 1930, Dove Papers, reel 4682 (frame 0172).

21. Ibid.: "It was so beautiful in the South of France, orange blossoms, peach blossoms, emerald green skies and cerise mountains at five o'clock in the morning. Painted from 5–8, 10–12, 2–5. Outside of a find I'll place a bet against any one who can do that happily here. Then back home again homesick—camping for a month or so. Waking up here looking in the woods for motifs, studying butterflies beetles flowers."

22. Arthur Dove, "Public Speaking," ca. 1930, Dove Papers, reel 4682 (frame 0175). For a discussion of Dove's scientific and philosophical sources, see Sherrye Cohn, Arthur Dove: Nature as Symbol (Ann Arbor, Michigan: UMI Research Press, 1985), 10, 20, 24, 29, 35, 38, 51.

23. Newton Weatherly was listed as a gardener in the 1875 Ontario County Census Records. According to Geneva Historical Society records, he was born in Phelps, New York, on July 25, 1846. His wife, Emma, died April 14, 1909. They had one son, De Forest (1869–1958), who often visited Dove on the latter's return to Geneva and whose occupation was described as music teacher and auto mechanic. Newton Weatherly died October 16, 1935, in Phelps. The Geneva Directory gives his address in 1888 as 80 North Main Street, where he was listed regularly until he moved back to Phelps sometime after 1929. My thanks to Steve O'Malley for bringing this reference to my attention.

24. Paul F. Grebinger and Ellen M. Grebinger, To Dress and Keep the Earth: The Nurseries and Nurserymen of Geneva, New York (Geneva, New York: Geneva Historical Society, 1993), 8–9.

25. Weatherly's amateur pursuit of painting may be connected with the craft revivalist movement as it is discussed in Jackson Lears, No Place of Grace (Chicago: University of Chicago Press, 1994), 73–74.

26. Paul Dove, "Notes Relative to Arthur G. Dove."

27. Dove to Stieglitz, December 9, 1934; Morgan 1988, 319. Mrs. Georgia Means Whitman, who was given a painting by Weatherly each Christmas until his death, donated her collection to the Geneva Historical Society.

28. Diary, September 10, 1933.

29. Ibid., September 28, 1933.

30. Dove to Stieglitz, December 9, 1934; Morgan 1988, 319.

31. Ibid., March 25, 1938; Morgan 1988, 399.

32. Arthur G. Dove, "A Different One," in Waldo Frank et al., eds., America and Alfred Stieglitz: A Collective Portrait (Garden City, New York: Doubleday, Doran, 1934; repr., New York: Aperture, 1979), 243–44.

33. Stieglitz to Dove, May 2, 1931; and Dove to Stieglitz, May 2 and 5/7, 1931; Morgan 1988, 220, 221 n. 1, 222.

34. Dove to Stieglitz, probably January 10, 1934; Morgan 1988, 293: "I do not want to use any gift horse as a mirror, but expect to go on working as usual. . . . I think that '34 ought to be good, especially if they are going to have all the artists on stepladders at $42.50 a week. There will be more room on the ground." Phillips had mentioned $42.50, but subsequently the Buffalo office of the PWAP offered Dove $34 a week (see Dove to Stieglitz, January 12, 1934; Morgan 1988, 294–95).

35. Ibid., January 12, 1934; Morgan 1988, 295.

36. Arthur Dove to Duncan Phillips, December 29, 1933, The Phillips Collection Archives, Washington, D.C.

37. Emmet N. O'Brien, "Leader of Modern Artists Paints in Geneva Farmhouse," Rochester Democrat and Chronicle, January 14, 1934; Suzanne Mullett typescript from clippings in Dove scrapbook, The Phillips Collection Archives.

38. Ibid.

39. Elizabeth McCausland, "Dove's Oils, Water Colors Now at An American Place," *Springfield (Mass.) Union and Republican*, April 22, 1934, excerpted in *Arthur G. Dove: New and Old Paintings, 1912–1934*, exh. brochure (New York: An American Place, 1934), 1–4.

40. Lewis Mumford, "The Art Galleries: Surprise Party—Wit and Watercolors," *New Yorker* 10 (May 5, 1934), 56.

41. O'Brien, "Leader of Modern Artists."

42. Dove to Stieglitz, June 7, 1936; Morgan 1988, 354.

43. Ibid., October 1, 1935; Morgan 1988, 341.

44. From the back of *Image*, 1929 (private collection): "It is said that the first flash will give the truth of one's feelings."

45. Diary, October 1 and 19, 1934.

46. Dove to Stieglitz, July 19, 1930; Morgan 1988, 195.

47. Dove underscored the importance of the watercolor to Elmira Bier, assistant to Duncan Phillips and frequent correspondent of the Doves: "I often find it difficult to do an oil from a watercolor that hasn't been done with the oil in mind" (late December 1933 or early January 1934, The Phillips Collection Archives). I would like to thank Karen Schneider, The Phillips Collection Librarian, for contributing to my view of Dove's creative process and for offering a sensitive reading of Dove's letters in The Phillips Collection Archives.

48. Dove to Stieglitz, probably January 10, 1934; Morgan 1988, 293. Dove considered flying an airplane to New York with Bernard Nebel, a German botanist working at the Agricultural Experiment Station: "We could fly to NY with the paintings and if there were a spill the paintings would be the more valuable." See also Diary, May 30, 1934; and Dove to Stieglitz, early June, 1934; Morgan 1988, 309: "It is just as mad here as you say it is in N.Y. We flew the other day for a few minutes."

49. See Stieglitz to Dove, January 2, 1935; Morgan 1988, 325. For the review, see Thomas H. Benton, "America and/or Alfred Stieglitz," *Common Sense* 4, no. 1 (January 1935), 22–24.

50. Elizabeth McCausland, "Authentic American Is Arthur G. Dove," *Springfield (Mass.) Union and Republican*, May 5, 1935, sec. E, 6.

51. Duncan Phillips, "The Art of Arthur G. Dove," in *Retrospective Exhibition of Works in Various Media by Arthur G. Dove*, exh. brochure (Washington, D.C.: Phillips Memorial Gallery, 1937), n.p.; excerpted in exhibition brochure, An American Place, March 29–May 10, 1938.

52. Diary, April 29, 1935.

53. Baudelaire, "On Color" (1846), quoted in Roger Shattuck, "Vibratory Organism: Baudelaire's First Prose Poem," in *The Innocent Eye* (New York: Farrar, Straus & Giroux, 1984), 137.

54. Max Doerner, *The Materials of the Artist and Their Use in Painting, with Notes on the Techniques of the Old Masters*, trans. Eugen Neuhaus (New York: Harcourt, Brace, 1934). Originally published in German as *Malmaterial und seine Verwendung im Bilde* (Munich: F. Schmidt, 1921).

55. Dove to Stieglitz, October 1, 1935; Morgan 1988, 341. O'Keeffe had visited the Doves earlier on her way from Lake George, New York, to New Mexico.

56. Ibid., February 1, 1932; Morgan 1988, 237.

57. Leo Baekeland to Arthur Dove, June 27, 1924, Dove Papers, reel 954 (frame 63). Baekeland (1863–1944), the inventor of Bakelite, sent Dove six sheets of the product: three black and three natural-colored, three sanded and three polished. I want to thank Justine Wimsatt for bringing this reference to my attention.

58. Edward Alden Jewell, "Three Shows Here of Abstract Art," *New York Times*, May 3, 1935, 22. See also idem, "The Realm of Art: Comment on Current Shows," *New York Times*, April 26, 1936, sec. 9, 7.

59. Dove valued Doerner for the fullness of his knowledge and his scientific organization. See Dove to Stieglitz, October 24, 1935; Morgan 1988, 342.

60. Diary, September 22, 1935.

61. Doerner, *Materials of the Artist*, 154. See Justine S. Wimsatt, "Wax Emulsion, Tempera or Oil? Arthur Dove's Materials, Techniques and Surface Effects," paper presented to The American Institute for Conservation of Historic and Artistic Works, Milwaukee, Wisconsin, 1982, 185–86.

62. Dove's son transcribed these words from his father's book; William Dove to Justine Wimsatt, November 1, 1981, collection Justine Wimsatt: "I now recall that the main body of experiment was with the Doerner. . . . [Dove] had [it] within it's year of publication so it was 34–39 when he was in Geneva N.Y., before he was ill that he discovered wax emulsion, tempera etc. I found this written down by him in one of the books . . . page 151 has the reference to resin oil color."

63. Arthur Dove, "Suggested Interview," Dove Papers, reel 4682 (frame 0162).

64. Diary, September 25, 1935.

65. Dove to Stieglitz, October 1, 1935; Morgan 1988, 341.

66. Ibid., October 24, 1935; Morgan 1988, 342.

67. Doerner, *Materials of the Artist*, 61–62.

68. Dove to Stieglitz, October 24, 1935; Morgan 1988, 342.

69. Richard Newman and Irene Konefal, "Arthur Dove's Binding Media: An Analytical Study," paper presented at The Twenty-First Annual Meeting of The American Institute for Conservation of Historic and Artistic Works, Denver, Colorado, 1993, 84. The paper summarized preliminary results of an ongoing study of Dove's materials used in paintings and sketches in the Museum of Fine Arts, Boston. My thanks to Irene Konefal for discussing Dove's methods and materials with me.

70. See Thomas B. Brill, *Light: Its Interaction with Art and Antiquities* (New York: Plenum Press, 1980), 100. I am indebted to Elizabeth Steele, Associate Conservator, The Phillips Collection, for bringing this reference to my attention and for advice on Dove's methods.

71. This breakdown of media is based on a visual examination by Elizabeth Steele.

72. Jewell, "The Realm of Art."

73. Diary, April 14, 1936.

74. Jewell, "The Realm of Art."

75. This exhibition, organized by Alfred Barr, represented perhaps the most ambitious analysis of modernism to date. Barr's diagrams showing the lineage from Neo-Impressionism to Geometrical Abstract Art and from Japanese Prints to Non-Geometrical Abstract Art were reproduced on the cover of the catalogue. Though he included Dove in the museum's fall 1936 exhibition, "Fantastic Art, Dada, Surrealism," Barr appears to have overlooked Dove's early move toward abstraction.

76. Diary, April 17 and 23, 1936.

77. Ibid., June 27, 1936.

78. Ibid. (entry by Dove), August 29, 1936.

79. Dove to Stieglitz, October 24, 1936; Morgan 1988, 363.

80. See Cohn, *Dove: Nature as Symbol*, 209 (interview with William Dove).

81. Arthur Dove, "How Go About Dawns?" ca. 1932, Dove Papers, reel 4682 (frame 80).

82. Dove to Stieglitz, February 1, 1932; Morgan 1988, 237.

83. Diary, February 3, 1936.

84. Typically Dove called his first paint layer tempera and his next layer oil. See Dove to Stieglitz, probably December 3, 1937, Morgan 1988, 392: "Most of [the paintings] in tempera so far. They have still to get final painting."

85. Arthur Dove, "Oct. 18, 1936," Dove Papers, reel 4682 (frame 0541). This handwritten sheet, separate from the bound diaries, is filmed with typescript material in the Dove Papers.

86. See Diary (entry by Dove), September 19, 1936: "Went over Sun rise I again. Ind. yel. Prus. blue & Rose mad. Egg & oil & water."

87. Frederick S. Wight, *Arthur G. Dove*, exh. cat. (Berkeley: University of California Press, 1958), 68.

88. Arthur Dove Diary, October 23, 1924, Dove Papers, reel N70/52 (frame 0046).

89. William Einstein, "Introduction," in *Arthur G. Dove: New Oils, and Water Colors*, exh. brochure (New York: An American Place, 1937), n.p.

90. Anderson to Dove, April 12, 1937, The Alfred Stieglitz and Georgia O'Keeffe Archives, manuscript 85, series 1, box 2, Yale Collection of American Literature.

91. Diary, March 17, 1937.

92. F. S. Tower, "Dove Brickyard Used to Be One of City's Important Industries," *Geneva Daily Times*, July 3, 1936, 7.

93. Diary, July 20, 1936.

94. My thanks to Barbara Haskell for this insight.

95. Dove to Stieglitz, probably after May 17, 1937; Morgan 1988, 379.

96. See Paul Dove, "Notes Relative to Arthur G. Dove."

97. Dove to Stieglitz, probably after May 17, 1937; Morgan 1988, 379.

98. Ibid., June 14 or 15, 1937; Morgan 1988, 383.

99. "Retrospective Exhibition of Works in Various Media by Arthur G. Dove," March 23–April 18, 1937, Phillips Memorial Gallery, Washington, D.C.

100. Dove to Stieglitz, March 20/26, 1937; Morgan 1988, 370.

101. Ibid., June 29, 1937; Morgan 1988, 384–85.

102. Ibid., July 14, 1937; Morgan 1988, 386: "[Georgia] would enjoy arranging this huge place. If we could only paint it all white, we could make one of the finest galleries in this section." See Stieglitz to Dove, March 19 and 20, 1937 (Morgan 1988, 368), in which Stieglitz refers to the white walls on which Dove's show at An American Place was hung.

103. Ibid., December 3, 1937; Morgan 1988, 392.

104. Ibid., March 25, 1935; Morgan 1988, 399.

105. Diary, January 14, 1938.

106. Ibid., January 21, 1938.

107. Dove to Stieglitz, March 22, 1938; Morgan 1988, 398.

108. Ibid., June 14 or 15, 1937, November 1, December 3, 1937, and February 22/26, 1938; Morgan 1988, 382, 391, 392, 396.

109. Ibid., March 7 and 22, 1938; Morgan 1988, 397, 398. Dove believed that a local couple, Prof. and Mrs. F. P. Boswell, might purchase a work, thereby giving him the money to leave. Mrs. Boswell was a prominent member of Geneva's watercolor society; see Warren Hunting Smith, "Gentle Enthusiasts," in *Art: Geneva's Landscape-Painting Families* (Geneva, N.Y.: Geneva Historical Society, 1986), 25–26. My thanks to Steve O'Malley for bringing this book to my attention.

110. Morgan 1988, 398. See Dove to Stieglitz, March 25, 1938; Morgan 1988, 399.

111. Diary, April 16, 1938.

112. Dove to Stieglitz, March 25, 1938; Morgan 1988, 399.

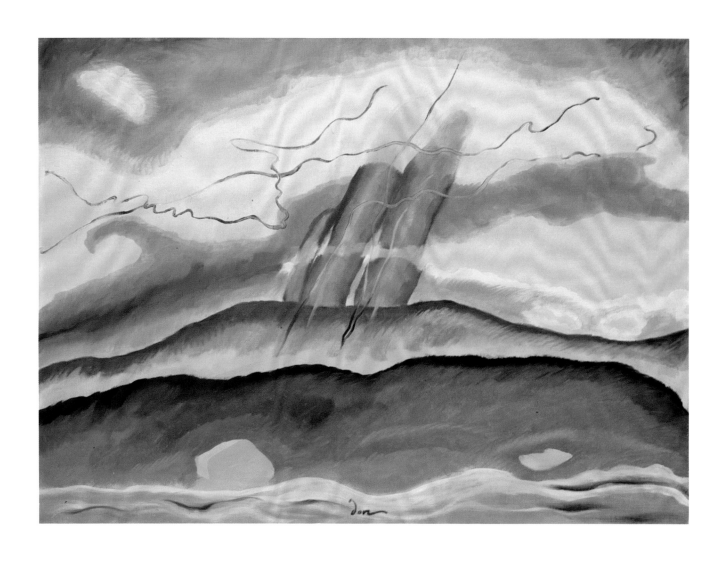

58. *Sun Drawing Water*, 1933
Oil on canvas
24⅜ x 33⅝ in.
The Phillips Collection, Washington, D.C.

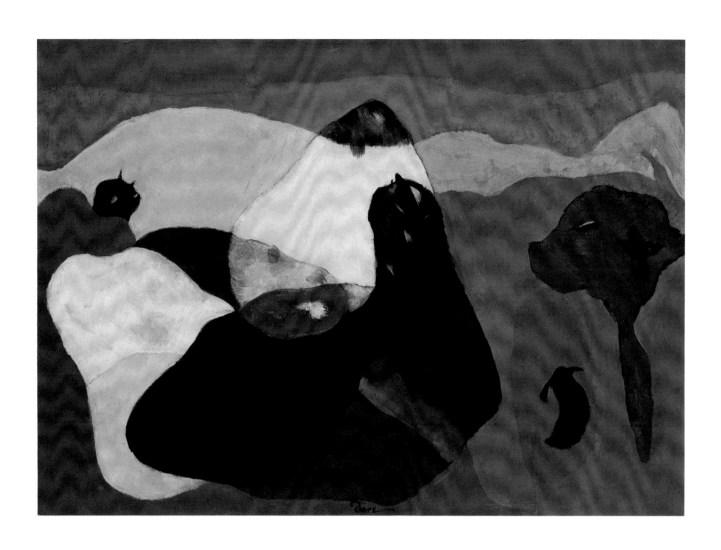

59. *Cows in Pasture*, 1935
Wax emulsion on canvas
20 x 28 in.
The Phillips Collection, Washington, D.C.

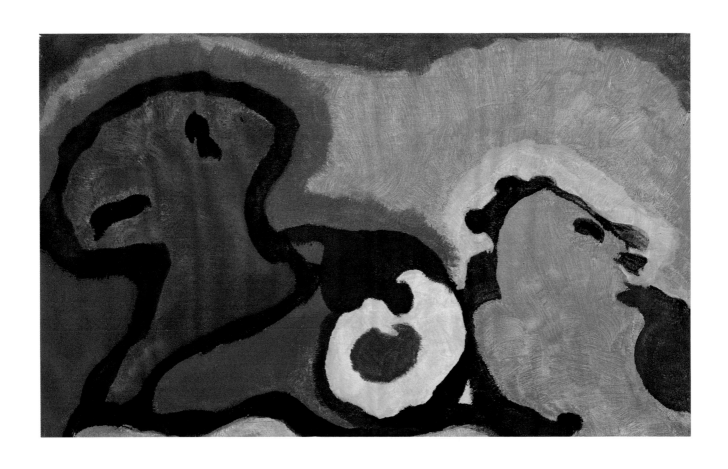

60. *Autumn,* 1935
Tempera on canvas
14 x 23 in.
Addison Gallery of American Art, Phillips Academy, Andover,
Massachusetts, Bequest of Edward Wales Root

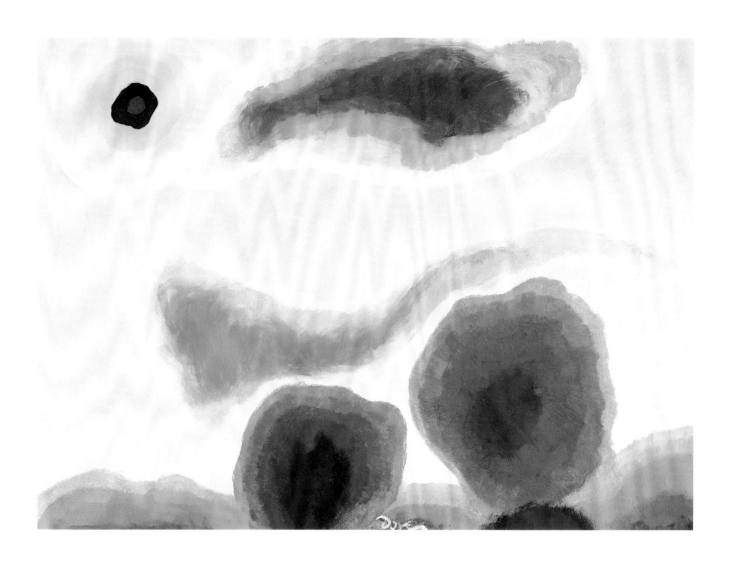

61. *Naples Yellow Morning*, 1935
Oil on canvas
25⅛ x 35 in.
Dr. and Mrs. Meyer P. Potamkin

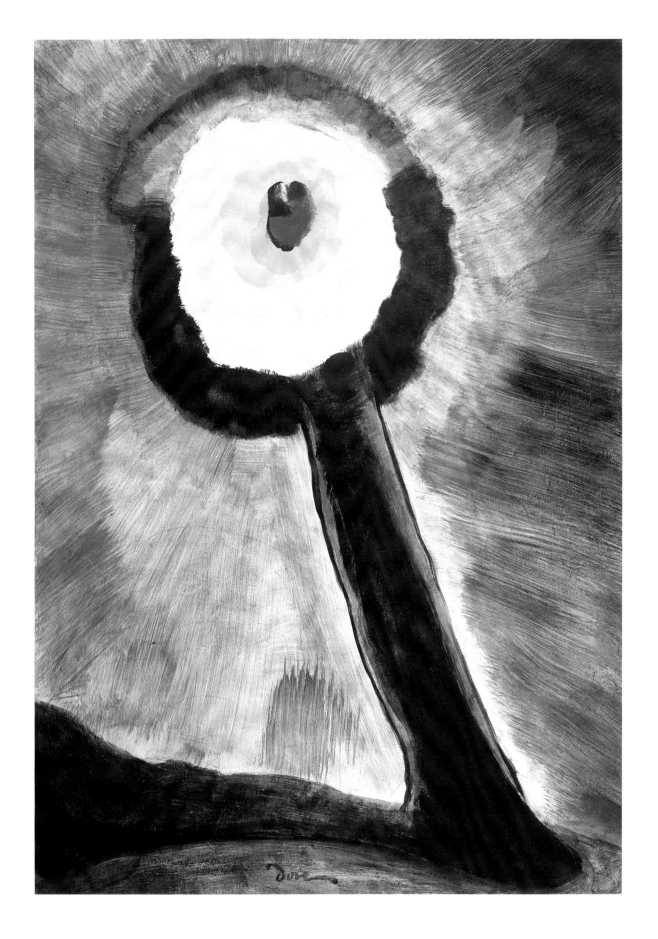

62. Moon, 1935

Oil on canvas

35 x 25 in.

Collection of Mr. and Mrs. Barney A. Ebsworth Foundation

63. *October, 1935*

Oil on canvas, two panels

14 x 35 in. (each panel)

Collection of The Kemper Museum of Contemporary Art & Design. Bebe and Crosby Kemper Collection, Purchased with funds from the R. C. Kemper Charitable Trust and Foundation

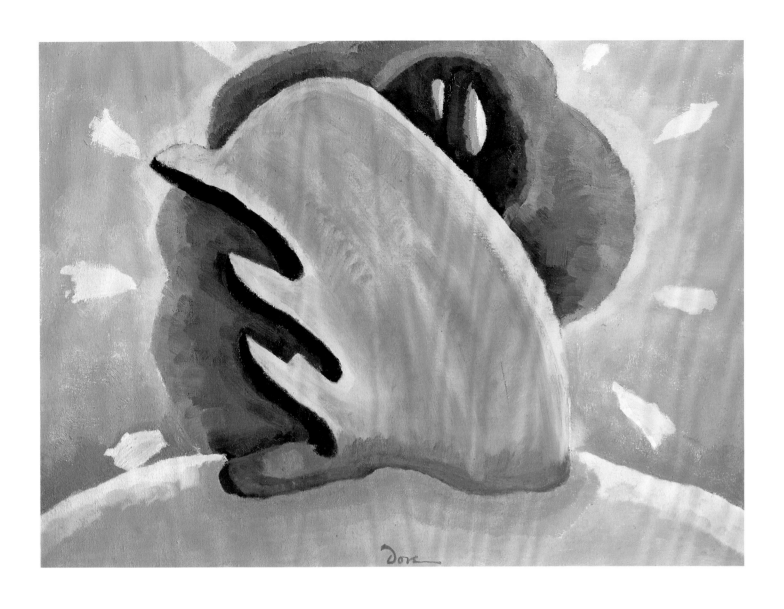

64. Summer, 1935

Oil on canvas

25⅛ x 34 in.

Museum of Fine Arts, Boston. Gift of the William H. Lane
Foundation 1990.405

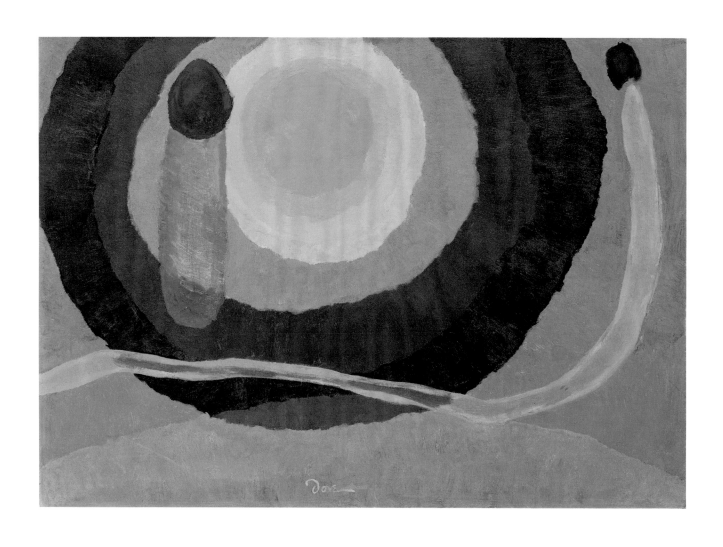

65. Sunrise I, 1936

Tempera on canvas

25 x 35 in.

William H. Lane Collection. Courtesy of the Museum of Fine Arts, Boston

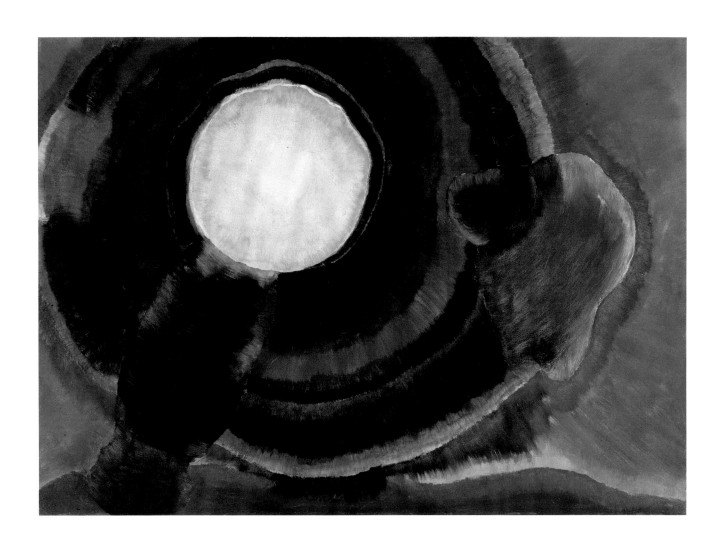

66. *Sunrise II*, 1936
Wax emulsion on canvas
25 x 35 in.
Mr. and Mrs. Meredith J. Long

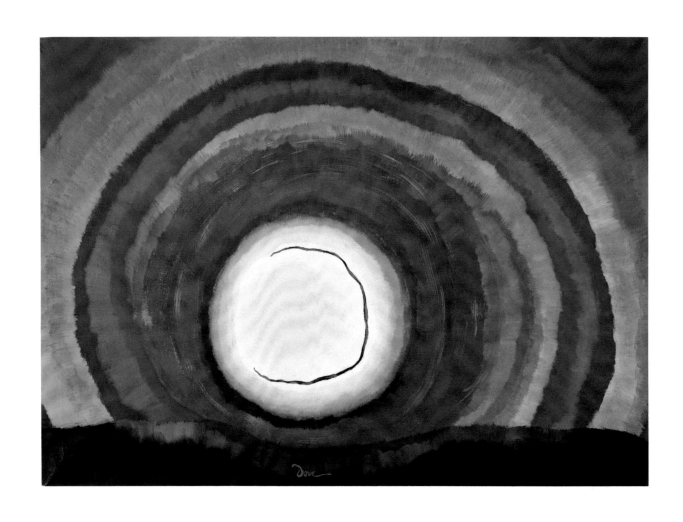

67. *Sunrise III*, 1936

Wax emulsion and oil on canvas

25 x 35 in.

Yale University Art Gallery. Gift of Katherine S. Dreier to the Collection Société Anonyme

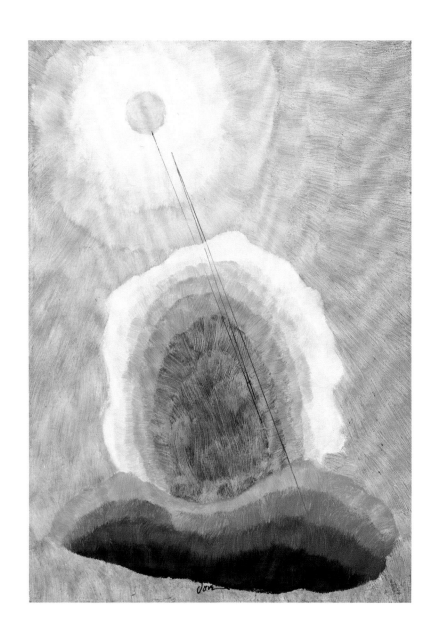

68. *Golden Sun*, 1937
Oil on canvas
9¾ x 13¾ in.
Private collection

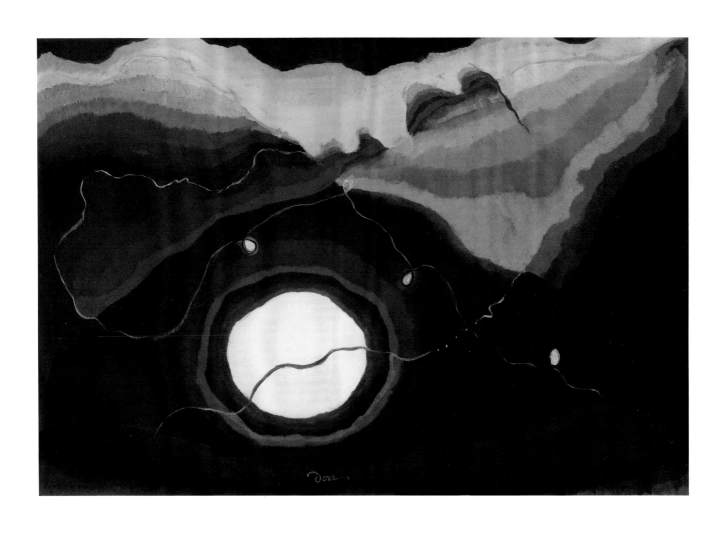

69. *Me and the Moon*, 1937
Wax emulsion on canvas
18 x 26 in.
The Phillips Collection, Washington, D.C.

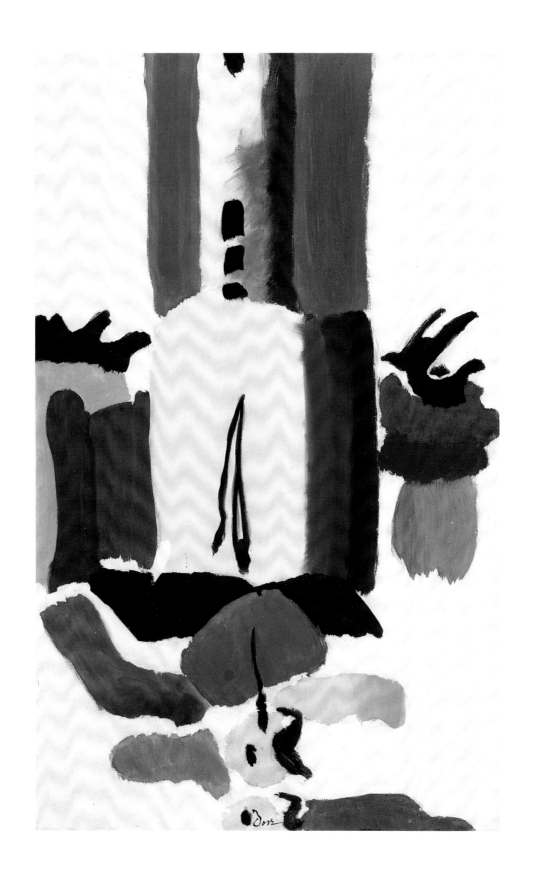

70. *Flour Mill II*, 1938
Oil and wax emulsion on canvas
26⅛ x 16⅛ in.
The Phillips Collection, Washington, D.C.

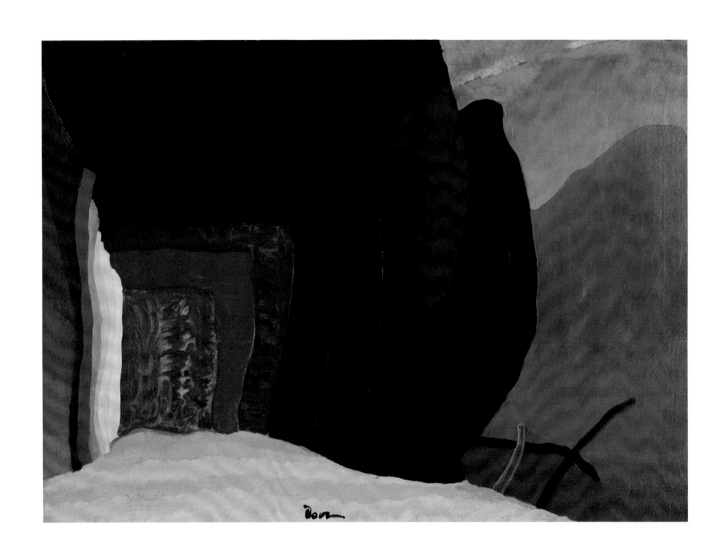

71. *Holbrook's Bridge to Northwest*, 1938
Oil on canvas
25 x 35 in.
Roy R. Neuberger Collection

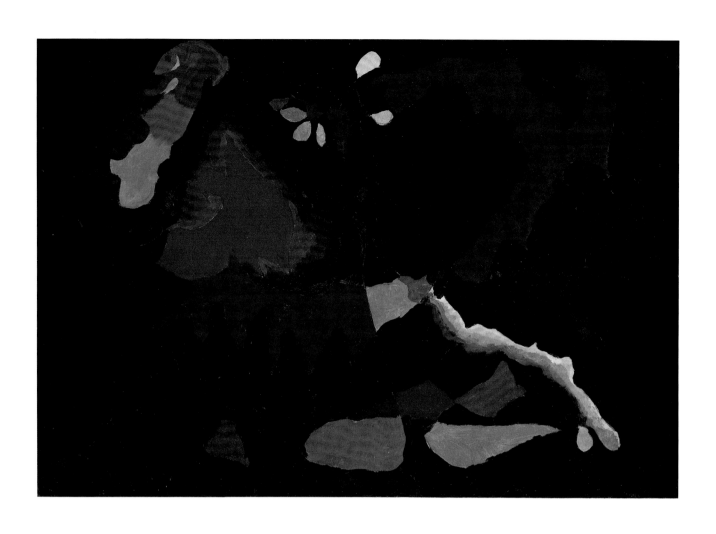

72. Swing Music (Louis Armstrong), 1938
Oil and wax emulsion on canvas
17⅝ x 25⅞ in.
The Art Institute of Chicago, Alfred Stieglitz Collection, 1949.540

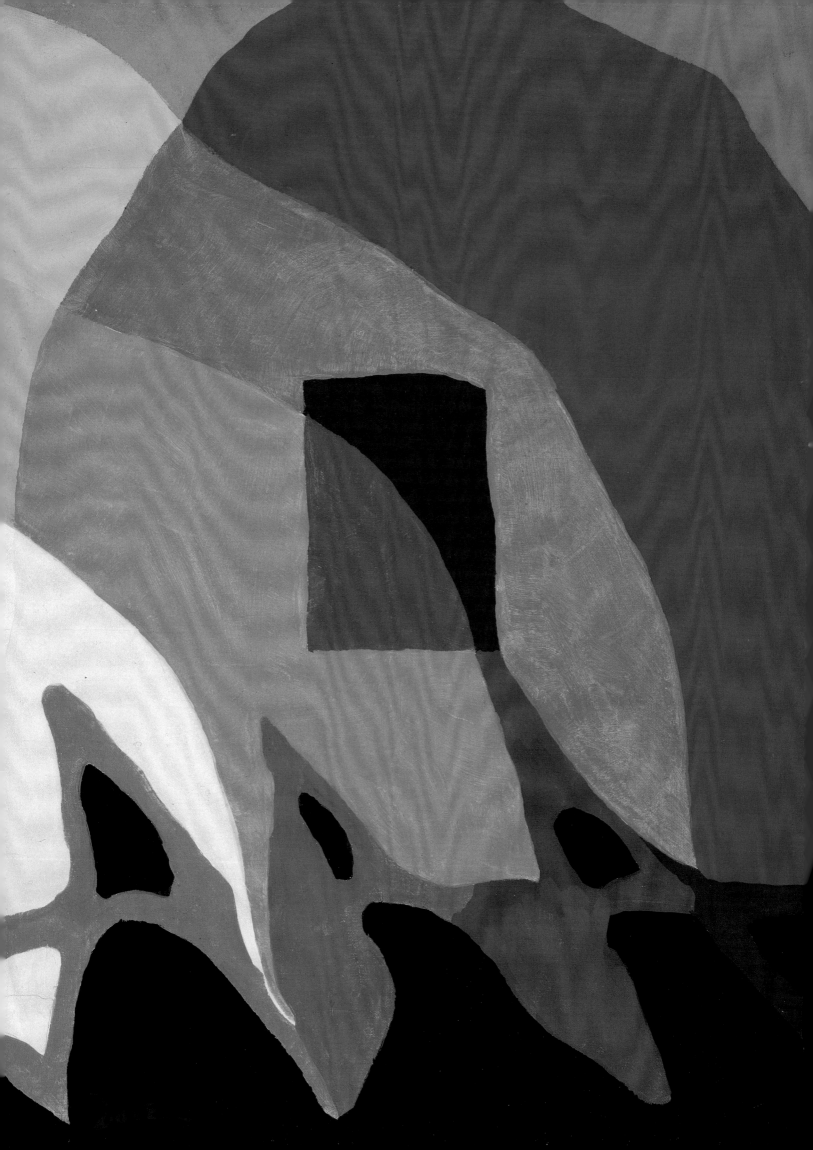

New Directions: The Late Work, 1938–1946

WILLIAM C. AGEE

In April–May 1938, Arthur Dove and his wife, Helen (Reds) Torr, left the bitter isolation of Geneva, New York, where they had lived since 1933.[1] They returned to the North Shore of Long Island, settling in Centerport, on the familiar water of the sound they had both long loved.[2] Thereafter, despite—or perhaps because of—his rapidly failing health, Dove worked with a renewed intensity, and his art entered a distinct phase that lasted until his death in 1946. His painting during this time continued the pioneering direction he had begun thirty years earlier while it explored a more abstract type of art, moving toward what he called "pure painting."[3] It produced some of his best work and must be counted as an intrinsic part of a lifelong achievement that, fifty years after his death, has secured his position as our most cherished modernist. Understanding of the late work has been slow in coming, for it has attracted comparatively little attention.[4] Modern art in America tends to be read as a series of successive breakthroughs by younger men and women, disregarding the mature developments of older artists.[5]

Dove insisted on his independence and chose to live away from the city, close to nature, and for many years on or by the water. The comparison with Thoreau at Walden,[6] while moving and useful, has too often fostered the view of Dove as a recluse, oblivious to the world around him.[7] In fact, however, Dove was a sophisticated, practicing artist well aware of, and vitally interested in, current developments in his field. Indeed, from his earliest to his last paintings, he was alert to a virtual lexicon of Old Masters and modern artists central to the Western tradition.

For most of his life, Dove kept in touch with advanced art circles by frequent trips to New York (although to be sure he went less often as his health failed), when he would see friends and colleagues and visit important exhibitions. He and Reds were serious readers, availing themselves of literature, poetry, and philosophy as well as significant art books, catalogues, and magazines, including the famous *Cahiers d'art*, the periodical that informed two generations of American

artists of developments in Paris and Europe generally.[8] Nor was he a neglected artist, for he was always well respected both critically and professionally, and despite the tough times shared by all during the Depression usually had at least a modest income.

Dove had sought a way of life that would allow him to concentrate solely on his art. He pursued this search at almost any cost, and at considerable, self-inflicted hardship. It entailed years of arduous, time-consuming labor—farming in Westport, Connecticut, keeping a leaky boat afloat and in running order, attempting to salvage the family holdings in Geneva—that often kept him from his painting altogether, as if at some deep and untouched level he found it difficult to confront his calling as an artist. Dove compounded this by spending countless hours at making his own frames and materials.

By a terrible irony, it was only after 1939, when debilitating illness struck him at the age of fifty-nine, that Dove found the independence and freedom to concentrate on his art. With no other endeavor open to him, Dove could finally bring to bear upon it the consistent intensity and focus that had often escaped him.

Dove's late style was new in the sense that all art is new, in that it built on and extended what had come before. The broadness, clarity, and distillation of the late work were rooted in the Symbolist tradition in which he was nurtured, a tradition fostered by Alfred Stieglitz and 291, that sought to find the elemental and the "elimination of the non-essential," as Dove himself had stated in 1914.[9] It was part of the long-standing modernist drive to clarify and simplify the pictorial structure, to discover, like the scientist, the compact and economical solution.[10] Early on, he had given up the "disorderly methods" of Impressionism with its "innumerable little facts," seeking instead the "simple motif," in which a "few forms and a few colors sufficed for the creation of an object."[11] After 1910, Dove had subjected his art to an abstracting, distilling process, seeking to extract fundamental truths. Thus, the art, even as it became more consistently abstract, should be seen as the continuation

and conclusion of principles inherent in a lifelong process. Abstraction itself was not new, but the type of abstraction was.

Forecasts of the late work had appeared long before his move to Centerport. Suggestions of the simplified format found in the late work, which moved away from the earlier multiplicity of smaller, overlapping elements, were apparent as early as 1929 in the clarity of the four-part division of Sun on the Water (pl. 50) and were seen again in the centered and distilled shapes of Dawn I of 1932 (fig. 21), Summer of 1935 (pl. 64), and in the Sunrise paintings of 1936 and 1937 (pls. 65–67, fig. 35). The earlier work, however, was always painterly, with brushed surfaces, and after 1939 it became progressively more linear and hard-edged, comprised of fewer, broader, and more condensed forms. There was, however, no single or predominant type, or look, within the late work. Nor did it reflect a total transformation, for like Picasso, Dove worked simultaneously on different types of paintings. The Surrealist-oriented biomorphic drawing and shaping he had begun in the early 1930s, while it occurred less frequently after 1941, never entirely disappeared, any more than did the brushed, painterly surface. These elements had yielded too much in the way of successful art for Dove to abandon them altogether. However, more progressively abstract formats, at points virtually nonobjective, became increasingly evident after 1941, alternating between the planar and geometric, and the circular and curvilinear.

At the same time, there was no radical change in theme or subjects, and even at their most abstract, his paintings were still apparently often drawn from nature, the visible world of the land, the water, the sky, the sun and moon, the themes that had sustained him throughout his life. But were they always so derived? Questions of the degree of abstraction, as well as the type—was it a distilling process, abstracting from reality ("extraction," as he had called it),[12] or was it an invented, nonobjective art?—inform his late work, just as they had in his early abstractions of 1910/11. Dove's position changed over the years. In 1929, he stated publicly that

there was no such thing as abstraction,[13] but later, in a diary entry of 1942, he could declare that he had "Made abstract painting."[14] Nevertheless, much of the late work, no matter how distilled, retained a source in the natural world.

By early 1938, despite somewhat improved circumstances, the years of struggle in Geneva had taken their toll. In February of that year, Dove remarked to Stieglitz that "Every one in Geneva is either dead or dying or just walking around. Guess we'd better get out."[15] He and Reds vowed to return to the North Shore of Long Island, to live once more on the water. In mid-April, they traveled to Long Island and found a small building which had been a store and a post office, at 30 Center Shore Road in Centerport, a shore-front community just east of Huntington. On June 2, 1938, they moved into the house, which stands to this day, perched on stilts set into a tidal pond, an extension of Centerport Harbor. There Dove lived for the rest of his life, quietly and uneventfully, seeing family and a few friends, and concentrating on his painting. But in the move, Dove had exhausted himself and had taken ill, on the verge of collapse, with pneumonia. For the remainder of 1938, he did only two paintings *Graphite and Blue* (fig. 42) and *Hardware Store* (Collection Mr. and Mrs. Robert Lifton, New York), carried out in November and December. Both paintings contain elements long present in Dove's art, the singular, organic drawing and shaping that recall Kandinsky, Klee, and Miró.

Painting and all else, however, became secondary in January 1939 when Dove suffered a heart attack, brought on by the rigors of the move and surely by the thirty years of labor that preceded it. This blow was followed by a diagnosis of Bright's disease, a kidney disorder that was even more serious than his heart condition. Thereafter, Dove had to combat myriad other ailments including arthritis, colitis, cysts of the eye and vision impairment, and circulatory problems. His life changed forever, and often ill health and overexertion would keep him from working for days at a time. But like

Fig. 41
Dove's House—Old Centerport Post Office
Courtesy Huntington Historical Society,
New York

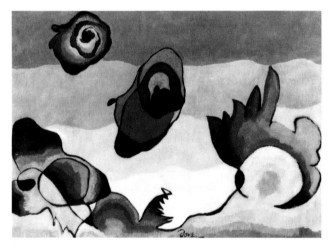

Fig. 42
Graphite and Blue, 1938
Oil on canvas
25 x 35 in.
Collection Tina and Paul Schmid

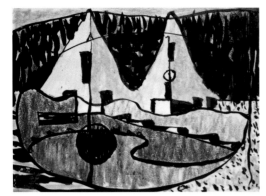

Fig. 43
Study for *The Brothers*, 1939
Watercolor on paper
3¹⁵⁄₁₆ x 5½ in.
Collection of the McNay Art Museum,
Gift of Robert L. B. Tobin through the
Friends of the McNay (1962.4.1)

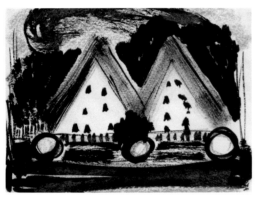

Fig. 44
Study for *The Brothers*, 1939
Watercolor on paper
3¹⁵⁄₁₆ x 5¾ in.
Collection of the McNay Art Museum,
Gift of Robert L. B. Tobin through the
Friends of the McNay (1962.4.2)

Fig. 45
Franciscan Brothers Monastery
Courtesy Huntington Historical Society,
New York

Vincent van Gogh, whose letters he read and whom he deeply admired, he painted when he could, and now with a renewed determination.

By May 1939, Dove was well enough to work in watercolor, a medium that had become central to his art, and in June he could report to Stieglitz, "The work is going fine." Certainly it is clear that he had been thinking intently about his art, for he went on: "Am getting some new directions, so we think."[16] Just what did he mean by these "new directions"? One answer most likely may be found in two small works in watercolor (figs. 43, 44), the medium in which Dove developed his pictorial ideas and then enlarged the results onto canvas by using a pantograph. We know from his diary that one of these watercolors was done on July 25 and worked over the next day.[17] Their subject is the prominent twin-peaked gables of the building occupied by the Franciscan Brothers (formerly the Chalmers House and later Camp Alvernia) located on the eastern shore of Centerport Harbor (fig. 45), on the other side of the causeway road separating the harbor from Mill Pond on which Dove lived. We might assume that Dove's world was narrowed by his illness, but in truth he found from his back porch and within a half mile of his house enough intriguing and challenging motifs to last him another lifetime.

In what seems to be the earlier of the two watercolors, which may have been done from the causeway (fig. 43), the roofs are depicted as part of an expansive space of organic, surrealizing forms that suggest Picasso of the early thirties.[18] Then, as if renewing his stated aims of twenty-five years earlier to eliminate "the nonessential," to find the "simple motif," Dove, in the other watercolor, radically condensed the space and enlarged the roofs so that their architecture became the architecture of the composition, rendered close up as two prominent, vertical triangles. Although Dove apparently did not return to the motif until the summer of 1941, the two sketches were the first in a succession of ten watercolors (all now in the McNay Art Museum, San Antonio, Texas) extending into the summer of 1942,

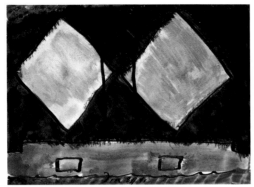

Fig. 46
Study for *The Brothers*, 1941
Watercolor on paper
3¹⁵⁄₁₆ x 5½ in.
Collection of the McNay Art Museum,
Gift of Robert L. B. Tobin through the
Friends of the McNay (1962.4.5)

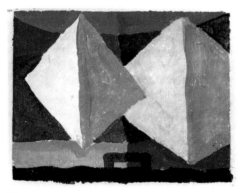

Fig. 47
Study for *The Brothers*, 1942
Watercolor on paper
2¹⁵⁄₁₆ x 3⅞ in.
Collection of the McNay Art Museum,
Gift of Robert L. B. Tobin through the
Friends of the McNay (1962.4.10)

which became progressively more abstract, freed from
any overt reference to architecture, concluding as two
free-floating diamonds, in fully abstract configurations
(figs. 46, 47). It is in these watercolors of 1939–42 that
we can trace the evolution of one of Dove's "new direc-
tions." They culminated in the two versions of *The
Brothers*, the first done in September 1941, the second in
1942 (pls. 77, 78), and a series of paintings of 1942, for
example, *Square on the Pond* (fig. 48) and *Structure* (pl. 79).
The geometry of the diamond shapes constitutes one
pole in his drive to what he termed in 1942 as "pure
painting."[19] That its starting point was a source in the
known world accounts for Dove's diary notation of
August 20, 1942, two days before the last watercolor in
the series was done: "Work at point where abstraction
and reality meet."

This new direction is not as surprising as it may
first seem, for by 1939 a more geometric, reductive type
of abstract and nonobjective art had deeply affected both
international and American art. We tend to think of
American art of the 1930s primarily in terms of poverty
and politics, of dust-bowl realism, but modernist im-
pulses remained strong and included variations of De
Stijl, Constructivism, and the Abstraction-Création and
Cercle et Carré groups in Paris.[20] Dove was well aware of
these developments and was clearly interested in them.
Indeed, in works such as the extraordinary untitled cork
and plaster collage of around 1925 (fig. 49), Dove had
already worked in what can be fairly termed a nonobjec-
tive manner.

In April 1936, while visiting New York, Dove had
seen and commented favorably on the landmark exhi-
bition "Cubism and Abstract Art" at The Museum of
Modern Art. A week later, on April 23, he visited A. E.
Gallatin's Gallery of Living Art at New York University,
where he would have seen a broad group of important
abstract and nonobjective paintings, including work by
Mondrian.[21] He had a copy of "Gallatin's book," and
probably the Modern's exhibition catalogue.[22] Two
months later, Dove went to the trouble of translating an
article by Mondrian, most likely Mondrian's response to

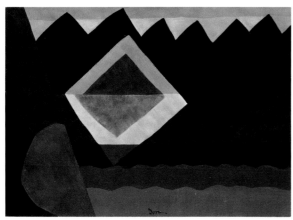

Fig. 48
Square on the Pond, 1942
Wax-based paint on canvas
20 x 28 in.
Gift of the William H. and Saundra B.
Lane and Henry H. and Zoe Oliver
Sherman Fund, M. Theresa B. Hopkins
Fund, Seth K. Sweester Fund, Robert
Jordan Fund and Museum Purchase
(1990.373)
Courtesy, Museum of Fine Arts, Boston

Fig. 49
Untitled, ca. 1925
Crayon and graphite on plaster, wire
mesh, cloth, and cork
25¾ x 32 in.
©Amon Carter Museum, Fort Worth,
Gift of Georgia O'Keeffe (1966.17)

an inquiry into the state of modern art published in a 1935 issue of *Cahiers d'art*.[23] Here Mondrian spoke of how true art, pure plastic art, arrives through an evolution that follows the immutable laws of nature that are discovered through the continuous culture of life, science, and art, a statement entirely consistent with Dove's own principles.

On April 29, 1938, the day on which he saw the Miró show at the Pierre Matisse Gallery in New York, he had also visited an exhibition of Naum Gabo's Constructivist art (fig. 50) at the Julian Levy Gallery, and "had liked it very much."

On July 6, 1939, Reds noted in their diary that they had received a copy of the catalogue of The Museum of Modern Art's large exhibition "Art in Our Time," organized to coincide with the World's Fair, which included Dove's assemblage *Goin' Fishin'*, 1925 (pl. 31). More important, the show included a veritable history of the modern movement from Cubism to the new abstract art of Arp, Brancusi, Mondrian, Léger, Gabo, and Pevsner, and although Dove was apparently unable to visit it, the extensive and fully illustrated catalogue would have served him as a constant visual reference.

As the threat of war drew nearer, artists the world over were drawn to the more universal language of abstract and nonobjective art, which offered the ideal of a new harmony, stability, and order. De Stijl and Constructivism had grown out of this need in the wake of World War I, and it now offered renewed hope in the face of World War II. The seeds of geometric abstraction, planted here during the early 1930s, took full root with the founding of the American Abstract Artists in 1937. With the arrival of Mondrian in New York in 1940, the new plastic language of abstraction began an unbroken tradition in America that has lasted to this day.

Dove had ample precedent for this shift in the paths taken by Kandinsky and Klee, artists long crucial to him, for both had moved to a more geometric and Constructivist type of art by the early 1930s while teaching at the Bauhaus, a mecca of abstraction. Dove, it can

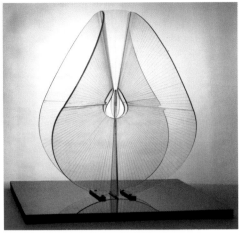

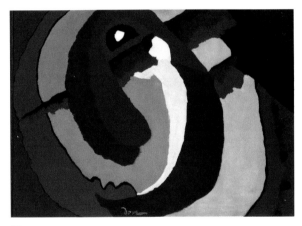

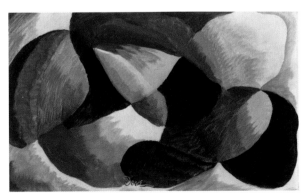

be said, participated in a widespread shift to a broader, more abstract style in the late thirties that included artists as disparate as Henri Matisse and the American modernist Stuart Davis. "Americans are supposed to paint as if they had never seen another picture," he once said, and we know Dove was well aware of new developments in world art.[24] And what, after all, is the basis of abstract art if not the elimination of the nonessential, the seeking of the simple motif, the very aims that had driven Dove and his art for thirty years? The concrete art of the 1930s, then, offered Dove a new means of realizing lifelong artistic goals.

In 1939–40, simultaneously with the geometry of The Brothers, Dove developed another pole of his "new directions," a type of abstraction based on intersecting curves, spheres, cones, and circles. In his usual cryptic fashion, he wrote in his diary on August 12, 1939: "Painting as seen from locale to locale in space . . . not static planes in space not form but formation. To set planes in motion"; and on August 20: "Trying to have a single event rather than to make an arrangement of many." From this we may gather that Dove also sought, in addition to the planar geometry of The Brothers, a type of art in which shapes would flow together with a sense of constant motion and fuse into a single, whole, and centered composition.

The seeds of this development can be traced as far back as the spiral motif in the pastel *Movement No. 1* of about 1911 (pl. 7), and more immediately to the concentric circles within the Sunrise series of 1936–37, and subsequent pictures of 1937 such as *Summer Orchard* (Munson-Williams-Proctor Institute, Utica, New York). But it began in earnest in 1939, a year in which he otherwise did little painting, in the single centered shape of the spiral configurations of *Out The Window* (St. Louis Art Museum, Missouri), and was expanded to fill the entire surface in *A Few Shapes* of 1940 (fig. 51), a painting whose very title indicates Dove's new approach to a less referential image. The sequence was completed in 1940 or 1941 by an even more abstract painting, simply titled *Shapes* (fig. 52),[25] composed of a series of

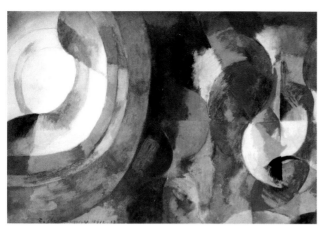

Fig. 53
Robert Delaunay (1885–1941)
Circular Forms, Sun and Moon, 1912–13
Oil on canvas
25½ x 39⅜ in.
Stedelijk Museum, Amsterdam

flowing and intersecting circles, half-circles, and ovoids. The two "shape" pictures may well have stemmed from two unidentified watercolors done on May 14, 1940, which Dove described in his diary as "composed in the conic manner." For Dove, lines, form, and color could often take the shape of conic sections.[26]

In 1940, Dove often mentioned his exact placement of specific colors. This followed his notation of October 11, 1939, that he was "Putting down one color after another in formation." These procedures can be taken as an indication of Dove's new approach to a more carefully conceived and executed, and more abstract, type of picture. The precise placement of what he called a "certain red" or a "certain blue" was an inherent part of this process.[27] Dove took great care with his color, and the fact that he was a master colorist, though noted by contemporary critics, has more recently been all but overlooked.[28] His color had often been realized by means of patches of parallel brushstrokes, a method he had learned from Cézanne. He continued to employ this method after 1938, but as the work became more abstract he increasingly used broad, clear, flat planes of color, each put down one after the other, with little or no modulation.

While these curvilinear "formations" recall aspects of Picasso's work, as well as Klee's singular line, they also suggest new connections. There are parallels, for example, with the elaborate curvatures of Gabo's constructions. Particularly striking is the relation of *Shapes* with the abstract Sun and Moon series of Robert Delaunay (fig. 53), first done in 1911–12 and restated in more geometric formats in the 1930s. Dove would have seen the early Delaunays in the 1936 "Cubism and Abstract Art" show, and he might well have been drawn to them simply because he and Delaunay shared a long-standing fascination with cosmic themes. In addition to their subject, the circle shapes in these and subsequent works were important because of the clear structural foundation that they imparted.[29]

In the course of 1940, Dove had recovered to the extent that he was able to work with a consistency miss-

ing from his life for two years. He reached a new level of accomplishment that spring, acknowledged by Robert Coates, who wrote in the *New Yorker* on the occasion of Dove's annual show that his paintings were "well above anything he has done before."[30]

Dove's drive toward abstraction was not an unbroken line. He could retain older, even figurative elements of his art as was evident in *Long Island* (pl. 73), completed in March 1940, and surely one of his most poetic and moving paintings. Although its mood suggests otherworldly Symbolist themes, in fact it represents a scene in Dove's immediate neighborhood. Painted from the nearby shore of Lloyd Harbor where he often worked,[31] it bespeaks a new serenity and harmony in Dove's life, an ode to the land and the water he loved.

Dove's range of mood and type of painting were clearly evident in this year. Both *Thunder Shower* and *U.S.* (pls. 74, 75) were as explosive as *Long Island* was calm and benign, bursting from the center, and filling the surface by means of the sharply delineated type of organic drawing that had marked much of his painting in the 1930s, a type which was not seen again in American art until the emergence of Clyfford Still in 1946.

The dual modes of Dove's "new directions," the geometric and the curvilinear, were firmly established in the course of 1941. The first version of *The Brothers*, with its irregular diamond shapes, had actually been preceded in January by *Lloyd's Harbor* (fig. 54), a view of two distant lighthouses compressed together in flat, adjacent planes that echoed their rectangular architecture. These paintings coincided with the development of a more complex series of eliding and intersecting curves in *Through a Frosty Moon* (fig. 55), an accomplished update of the 1940/41 *Shapes*. But for all its complexity, the painting is structured around a dominant anchoring circle directly at center. Just as the architecture of the lighthouses offered an inherent structure for the planar works, so the sun and moon provided an inherent, cosmic structure within the curvilinear paintings.

By 1942, Dove's "new directions" were fully assimilated, and his paintings became consistently more

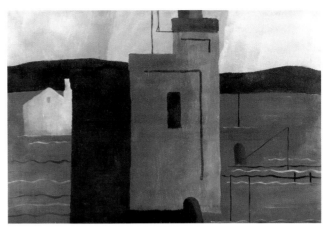

Fig. 54
Lloyd's Harbor, 1941
Oil on canvas
20 x 30 in.
The Detroit Institute of Arts
Photograph ©1990 The Detroit Institute of Arts,
Gift of Robert H. Tannahill

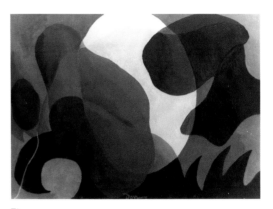

Fig. 55
Through a Frosty Moon, 1941
Oil on canvas
14¾ x 20⅞ in.
Collection of Robert H. Ginter, Los
Angeles, California
Photograph courtesy Terry Dintenfass

Fig. 56
Untitled, ca. 1940
Tempera on paper
3¼ x 4⅛ n.
The Metropolitan Museum of Art, Gift
of William C. Dove, 1984
(1984.536.6a)

abstract. This was the summer, as we have seen, when Dove wrote in his diary on August 20: "Work at point where abstraction and reality meet." That winter, on December 8, he could claim unequivocally to have "Made abstract painting." He was bearing down, working hard and with the sure confidence of thirty-five years of experience. He was experimenting with new forms as well as materials in an extensive series of what he called "Sketches" (fig. 56),[32] small works measuring no more than three by four inches on paper of mixed media as diverse as watercolor, gouache, tempera, ink, graphite, wax emulsion, and oil.[33] There is no doubt that the Sketches, which form a group distinct from his regular watercolors, gave Dove a new freedom and played a pivotal role in the evolution of his late art. In them Dove explored countless pictorial ideas; many of them were fresh, but with others he was looking back and recasting old themes, as Charles Eldredge has pointed out.[34] Sometimes the Sketches resulted in large oil paintings but often they were simply independent works of art. They are sometimes abstracting, distilling from nature, but not always, and sometimes they appear to be composed of totally invented forms. Dove spent much of the spring and summer of 1942 and 1943 working on the Sketches, in effect as a prelude to a sustained painting campaign in the fall and winter, a run that lasted until mid-1944. These Sketches are of such quality and import, if only for their still fresh and inventive color, that they must be counted as part of the tradition of American watercolors and works on paper that includes Winslow Homer, John Marin, Charles Demuth, and Georgia O'Keeffe.

In the fall of 1942, Dove continued his habit of working simultaneously on both geometric and curvilinear paintings. While completing the second, now highly distilled version of *The Brothers*, he undertook an apparently equally abstract painting, *Structure*, dominated by a single, large diamond at the exact center, intersecting a smaller diamond above. As in *The Brothers*, its source, too, was architectural, if not the Franciscan monastery, then perhaps the single peak of the firehouse recently built on

the shore opposite the Doves, or even the roof of the Centerport Yacht Club (fig. 57), on the causeway, where Dove often painted. No shape could be more conducive to what Dove termed in his diary on December 31, 1943, his "straight scientific painting."

Dove went through a long process of internal distillation to reach this point, as is recorded in at least forty Sketches that contain versions of the diamond or pyramid. But one wonders if his conclusions were not encouraged by the example of Mondrian's diamond paintings, the very height of a lean, pure abstraction. They were certainly well known in this country. One version (fig. 58), then owned by Katherine Dreier, had been seen in New York in 1926 and 1927,[35] and was included in the 1936 "Cubism and Abstract Art" exhibition which we know Dove saw. Other versions were acquired by A. E. Gallatin for the Gallery of Living Art and by Hilla Rebay for the Museum of Non-Objective Art. This is not to make a case for Dove as a disciple of Mondrian, but it is to say that in the early 1940s, the rigor, probity, and clarity of Mondrian's art affected artists beyond Neo-Plastic circles in myriad ways. It should be remembered that Mondrian was in New York from 1940 until his death in 1944, and had exhibited at the Valentine Dudensing Gallery in 1942.

At the same time, Dove painted *Parabola* (pl. 80), a complex work of overlapping and intersecting circles moving around and behind the large conical shape at center. In its flowing, rotating movement, it is very different from *The Brothers*, but the two are similar in their few broad, clearly defined, and separate shapes, and their clean, flat, and high color. *Parabola*, however, is more abstract, and even its source Sketches done that summer (figs. 59–61) have no discernible reference. It is as if Dove had projected himself into time and space and described the passing earth and sky in these kaleidoscopic shapes, beyond the here and now. There is much in Dove's writing to support this intepretation. He had spoken previously of formations, as in his diary entry for October 11, 1939, which he elaborated in a statement for his 1940 exhibition at An American Place:

Fig. 57
Townsend/Titus Mill from Centershore Road (Main Street). Note the Chalmers House in the distance and the Old Yacht Club on the mill dam
Brooklyn Historical Society
Photograph by Eugene Armbruster

Fig. 58
Piet Mondrian
Painting, I, 1926
Oil on canvas
44¾ x 44 in.
The Museum of Modern Art, New York, Katherine S. Dreier Bequest
Photograph © 1997 The Museum of Modern Art, New York

Fig. 59
Untitled, 1942
Watercolor on paper
3⅛ x 4⅛ (image);
7 x 5 (sheet) in.
Wichita Art Museum, Gift of
William Dove (1989.22.19)

Fig. 60
Untitled, July 16, 1942
Watercolor on paper
3 x 4 (image);
7 x 5 (sheet) in.
Wichita Art Museum, Gift of
William Dove (1989.22.12)

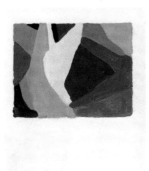

Fig. 61
Untitled, July 8, 1942
Watercolor on paper
3⅛ x 4⅛ (image);
7 x 5 (sheet) in.
Wichita Art Museum, Gift of
William Dove (1989.22.1)

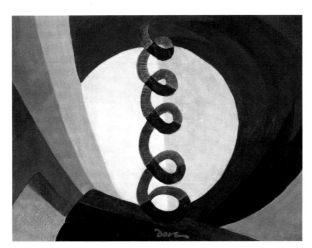

Fig. 62
Spring, 1943
Oil on canvas
18 x 24 in.
Gift of the Stephen and Sybil Stone
Foundation (1971.699); Courtesy,
Museum of Fine Arts, Boston

As I see from one point in space to another, from the top of the tree to the top of the sun, from right to left, or up, or down, these are drawn as any line around a thing to give the colored stuff of it, to weave the whole into a sequence of formations rather than to form an arrangement of facts [emphasis added].[36]

Dove also stated in his diary for February 27, 1942, that he was "trying to add time to the idea," and noted that he was working in "2/4" time while painting *The Inn* (The Metropolitan Museum of Art, New York). Some two months later, in a letter to Stieglitz, he mentioned "timing," which was "comparable to music but not the same. It is coming out of space rather than drawing 'From the eye back' which is still a relic. It can come as a thought, a form, or sensation."[37] Ideas of space and time, then, were firmly planted, as was the analogy of making a painting as if composing music. This was related to his method of painting while listening to music, practiced by Dove as recently as the great *Swing Music (Louis Armstrong)* of early 1938 (pl. 72), and repeated on June 27 and 28, 1943. Possibly he was rethinking his old interest in Henri Bergson, whose enormously influential ideas of time and space were at the heart of much of Symbolist theory.

From the beginning, Dove had worked in series, and the 1940s were no exception. *Parabola* was part of a sequence that began with the "spiral" pictures of 1937–39, moved to the "shape" pictures of 1941, and pointed to the Formation series of 1942–43 (pl. 81), as well as *Flight* and *Dancing Willows*, both of 1943 (pls. 82, 88). It also included *Spring* of 1943 (fig. 62), in which a coiled spring moves up and through a dominant centering circle, as if a pictorial embodiment of something Dove had written to Stieglitz as early as 1925: "The future seems to be gone through by a spiral spring from the past. The tension of that spring is the important thing."[38] This series reached a new degree of abstraction, with full, expansive linear shapes and a fluid richness of hard, flat color. Dove's drive to abstraction at this time was confirmed when he listed in his diary on December

17, 1942, "names for pure paintings: Design, arrangement, monochrome—polychrome—unochrome—duochrome trio-quatro-sexo etc. Motif plan—venture adventure Formation." Two weeks later, on December 30, 1942, Dove could speak of being "Free from all motifs etc just put down one color after another." The motif of intersecting curves was also to distill itself into an ever larger and more centralized shape of the single circle in paintings such as *Mars Yellow, Red and Green* of 1943 and *Painting in Tempera* of 1944 (figs. 63, 64), a theme that was also developed extensively in the Sketches of 1942–43.

It was as if with this freedom Dove could now move at one with his internal self, through the external world and into another realm, an infinite, timeless space of a higher consciousness. This is how the fourth dimension, a popular topic in early modernism, was originally defined, until Einstein codified it as time in 1919; in the 1940s it almost appears that Dove was attempting to fuse both conceptions.[39] That these matters were on Dove's mind is indicated by his diary reference on February 14, 1942, to "Futurism. 4th dimension etc."

The real, tangible world as experienced in modern life, however, was also evident. As *Flight* of 1943 makes abundantly clear, the new vistas opened by aviation, the new ways of experiencing the world that displaced the grounding of old perspectives, had made an impression on Dove, who himself had flown, as it had on Delaunay, Stuart Davis, and Jackson Pollock among others.[40]

From even closer to Dove's immediate world—his small yard and the shore front—came *Dancing Willows*, as well as the lean and spare *Flagpole, Apple Tree and Garden*, dated to 1943–44 but possibly of 1942 (pl. 86).[41] Dove especially cherished the willow trees, standing to this day in the yard and across the street, even using them as a barometer of the changing seasons. *Dancing Willows* tells us once more that even as he moved toward a pure, virtually nonobjective painting, he still remained closely connected to the natural world. (Dove defined this tension between the natural and the nonobjective with the whimsical thought he recorded on October 30, 1942:

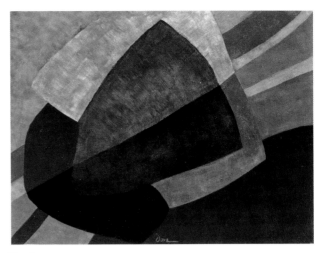

Fig. 63
Mars Yellow, Red and Green, 1943
Oil on canvas
28 x 18 in.
The John and Mable Ringling Museum of
Art, Museum Purchase, 1973 (S.N. 935)

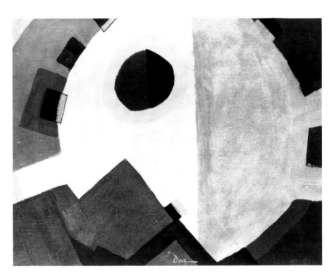

Fig. 64
Painting in Tempera, 1944
Tempera and oil on canvas
24 x 32 in.
Collection of Robert Ellison
Courtesy Archives of American Art
Photograph by Ed Owens

Fig. 65
Léopold Survage (1879–1968)
Colored Rhythm, 1913
Six of fifty-nine studies for a film
Watercolor, brush, and ink on paper
Each approx. 13 x 12¼ in.
The Museum of Modern Art, New
York, Purchase

Photograph ©1997 The Museum of Modern Art,
New York

the same person who objects to non-objectivity will object to objectivity if it is objective enough.") In the field of expanding and eliding circles, there is little identifiable reference except the rectangle that perhaps indicates the frame of his small house, or Mueller's Inn across the street. We feel rather the movement and the sound of these trees, recalling the evocations of the forces of nature that had animated his early pastels. But the scale is now greatly expanded, in keeping with his own directive of August 5, 1942: "Try larger oils. People do not see small ones. Large ones give onlooker larger idea of himself—Identification."

This and other paintings of 1942–44 fulfilled Dove's aim of getting down one shape and one color at a time, as directly and clearly as possible, as he had stated on December 5, 1942. The result is a new, more abstract manifestation of his stated credo of 1914 to find a simple motif, a few forms, and a few colors. So right do they seem that their complexity of technique and effect may escape us. The sense of constant, shifting movement is almost cinematic, and raises the possibility that Dove had been touched by the compositions of Léopold Survage; Survage's designs of 1913 for an abstract film called *Le Rhythme coloré* or *Colored Rhythm*, had been shown in The Museum of Modern Art's 1939 exhibition "Art in Our Time" and published in the catalogue, a copy of which Dove owned.[42] Further, the sweep of the high-keyed, transparent veils of color, created by the intricate weaving in sequential gradations of the primaries, blue, yellow, and red, fully identify Dove as a master colorist. Indeed, we can say that in such works Dove extended the twentieth-century tradition of color painting initiated by Orphism-Synchromism, while pointing the way to later American color-field painting.[43]

At the same time, Dove once more shifted easily to his sparer, more planar kind of painting as in *Roof Tops* of 1943 (pl. 87) and *Flagpole, Apple Tree and Garden*. The rectangular elements of *Roof Tops* refer to architecture on the shore of Mill Pond, which Anne Cohen DePietro believes may be the row of restaurants that still stands just south and across from the Dove house.[44] The question of how

to read these shapes remains; are we looking at the roofs frontally, or was Dove working as if from an aerial viewpoint? Dove had never stopped learning from Klee, whose 1941 memorial show at The Museum of Modern Art may have kindled a renewed appreciation, for the format of *Roof Tops* calls to mind Klee's planar Constructivist paintings such as *Two Ways* of 1932 (fig. 66).

It may be that *Sand and Sea* (pl. 85), done in the spring and fall of 1943, also takes an aerial view as its perspective.[45] While it, too, moves in a reductivist direction, with broad, clear divisions of the surface, it is anchored by the central biomorphic shape, which suggests another master of abstract art, Jean Arp, as well as paralleling the work of both Arshile Gorky and the early Mark Rothko. At the same time, this shape, which abuts the blue area that embodies both sky and water, distinctly echoes the curvature of the shore line of Mill Pond immediately across from Dove's house. Here the application of sand, which was taken from the shore ("Dove's Beach," the artist termed it in his diary on April 5) accounts for a literalness of the surface that makes this the last of his assemblages, a "stuff thing," as he called it in the same entry. The heightened physicality exemplifies another of Dove's aims at the time, "to make something that is real in itself, that does not remind anyone of any other thing, and that does not have to be explained."[46] Finally, for Dove and for others, there was no discrepancy between abstraction and representation, for to make abstract was to make more concrete, more real.

Just as *Sand and Sea* completed Dove's series of radical collages of the 1920s, so other late paintings restate and summarize old concerns. *Rain or Snow* (pl. 83), begun in late December 1942 and finished in early 1943,[47] continued a theme of natural forces that can be traced to *Thunderstorm* of 1921 (pl. 26), the assemblage *Rain*, 1924 (pl. 27), and the more explosive *Thunder Shower*, 1940. The ultimate source for *Rain or Snow*, however, may well be van Gogh's famous painting *Rain* (fig. 67), which had been included in the 1935 van Gogh exhibition at The Museum of Modern Art. There are deep bonds between Dove and van Gogh, for both artists found solace and

Fig. 66
Paul Klee (1879–1940)
Two Ways (Zwei Gänge), 1932
Watercolor on paper
12¼ x 18⅛ in.
Solomon R. Guggenheim Museum, New York
Photograph by David Heald ©The Solomon R. Guggenheim Foundation, New York
(FN48.1172X139)

Fig. 67
Vincent van Gogh (1853–1890)
Rain, 1889
Oil on canvas
28⅞ x 36⅜ in.
Philadelphia Museum of Art, The Henry P. McIlhenny Collection in memory of Frances P. McIlhenny
(1986-26-36)

Fig. 68
Rectangles, 1943–44
Oil on canvas
21 x 28 in.
Collection unknown
Courtesy Archives of American Art
Photograph by Ed Owens

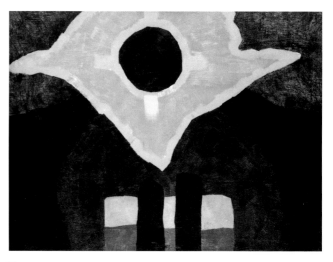

Fig. 70
High Noon, 1944
Oil and wax emulsion on linen
27 x 36 in.
The Roland P. Murdock Collection,
Wichita Art Museum, Kansas

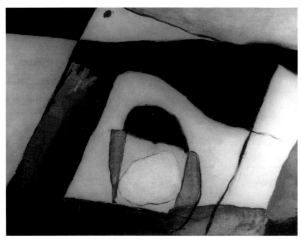

Fig. 69
Green and Brown, 1945
Oil on canvas
18 x 24 in.
Collection of Peter and Patty Findlay,
New York

comfort in nature and went to it for their inspiration; and Dove, we know, was again reading van Gogh's letters in 1944.[48] Both paintings have a similar silver, gray, and blue-gray cast to them, and both depict the actual lines of rain.

The silver and gray coloration of *Rain or Snow* and *Partly Cloudy*, 1942 (pl. 84), places them in the same tonal family, a modern update of Whistlerian hues, which had a long history in Dove's work reaching back to the 1929 *Silver Sun* (pl. 47). But Dove here extended his experiments with color and materials to include a use of grays and silvers on an unprecedented scale, embodying the very sense of icy winter cold. The hard, flat, nonillusionistic color, which emphasizes the concrete, abstract feel of the painting, is made all the more tangible by the use of actual silver leaf applied to the prominent vertical borders. This type of coloration, on this scale, was not to be seen again until 1960 in the aluminum paintings of Frank Stella.

Combined with the rain and brown branches are outsized snowflakes, moving toward us and progressively enlarged to a gargantuan scale as if conceived cinematically in a Surrealist dream. At the same time, the geometries of the topmost snowflakes assume a diamond shape, however irregular, that is a further variant of the architectural forms engendered in *The Brothers #1* and *The Brothers*. The strong silver verticals that Dove carefully laid in, so as to frame the painting as if we were literally looking out the window, call to mind the powerful verticals of Mondrian's grids of the late 1930s. Further, even more abstract variants of the diamond and geometric shapes appeared in *Polygons and Textures* and *Rectangles*, of 1943–44 and *The Other Side* of 1944 (fig. 68, pl. 91) as well as in *Green and Brown* of 1945 (fig. 69).

The three great sun paintings, *Partly Cloudy*, 1942, and *High Noon* and *That Red One*, both of 1944 (fig. 70, pl. 89), mark the culmination of a theme that had occupied Dove since the start and had accounted for some of his best work. In certain ways *Partly Cloudy* looks back to the 1930s, but the fullness and singularity of the shapes place it in the forties. It is unusual, for it takes not a brilliant sun but a muted one, emerging from above and through billowing gray clouds, as if in the moments after a rainstorm, and as if the viewer were above the clouds, suspended in space. Certainly, its range of grays, of the same family as *Rain or Snow*, modulated by yellow and then blue and blue-black, is exceptional. It led a contemporary critic to speak of the painting as "pure poetry," in which "color alone can lift up the heart."[49] But it is not just hue alone that is so affective. The very handling of the paint, the modulation of its weight and density from transparent to opaque, the variations of touch and surface nuance in the medium itself are equally potent.[50] In Dove's own words: "I am trying to get oil paint beautiful in itself without any further wish."[51]

This sky in *Partly Cloudy* and its churning, cellular shapes bring to mind the active patterning of clouds and skies in Stieglitz's famous Equivalents and Clouds series, small photographs taken from 1923 to 1932. Dove used the same size—four by three inches—for his late Sketches. He had, in fact, acquired two Equivalents in July 1942.[52] They were a source of inspiration to him, for Dove had always considered Stieglitz a great artist, and he reported that "new ideas have come since they have been here."[53]

That Red One, surely among Dove's greatest paintings, can be taken as the summation not only of his sun paintings but of his late style as well. It can also be taken as the conclusion of a long tradition rooted in American Luminism and in Symbolism that reaches back to van Gogh's famous sun paintings and includes the sun paintings of Marin, Oscar Bluemner, Charles Burchfield, and O'Keeffe. It is highly abstract, more so than *Partly Cloudy*, but with a clear source in nature; it is large (for Dove) with an expansive internal scale achieved through a minimum of broad shapes, rendered in clear, flat, linear divisions. There are no extraneous parts. The bold, intense colors are few, only the primaries and their graded variants. This is a frontal and declarative work that fulfills Dove's old aims of finding a simple motif and a few forms and colors, now rendered in a painting both of its time and a singular forecast of the future. It also fulfills

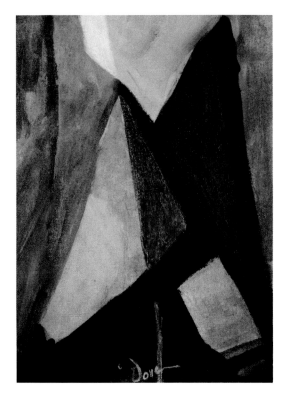

Fig. 71
Beyond Abstraction, 1946
Oil on canvas
12 x 9 in.
Collection of Michael and Juliet
Rubenstein

the more recently stated aim, in Dove's diary for July 22, 1944, of "Trying to make planes as I draw them exist in themselves," an aim at the core of the abstract art of the 1930s and 1940s.

The mood bespeaks "something of the eternal" that van Gogh had sought to symbolize by the "actual radiance and vibration of our colorings."[54] Yet it is once more a picture of the here and now, a view at sunrise, through the red trees, across the familar water of Mill Pond to the other shore. The sun is darker, as it can appear through the fall foliage at daybreak. Dove had done a painting in 1929 entitled *Red Tree and Sun* (Fisk University Collection, Nashville, Tennessee), but this is a work of the forties; the powerful red verticals can be seen as a personal allusion to Mondrian, while its clarity points to the French abstractionist Jean Hélion, then in New York, whom Dove had mentioned to Stieglitz in a letter of March 20, 1944.[55]

In mid-1944, Dove's health suffered a serious setback, and he was confined to bed for several weeks. Thereafter, his condition steadily declined, and he could do little sustained work. While the great run that had lasted for five years had ended, he still managed to do notable paintings, if only infrequently. Among them is *The Other Side*; although highly abstract this is derived, just as its title declares, from a view across Mill Pond to the other side, where the broad yellow band indicates the sun rising over the water and the eastern shore. It was thus another in Dove's long series of sun pictures. So, too, *Flat Surfaces* of 1946 (pl. 92), his last major picture, was a view across the pond, the shore line indicated by the vertical band, the architecture and foliage by the flat forms themselves. Even here, however, the presence of the sun is suggested by the lighter shapes and hues at center. It is a singularly personal variant of abstract art of the time, while also closely paralleling the work of Robert Motherwell, and within a few years, of David Smith and Ellsworth Kelly.

That Dove had come full circle is evident even in one of his last paintings, *Beyond Abstraction* (fig. 71), done when he was so weak and infirm that he could not

work without Reds's assistance. As the title implies, it is apparently abstract, even nonobjective. But on close examination of the original (the feature is not legible in a photograph), we find at the lower left a faint but unmistakable circular burst of pale yellow: the rising sun. To the last, Dove could not help but paint the sun and its light, as he had his entire life.

In 1924, Paul Rosenfeld characterized Dove's art as "still rather more the prelude than the symphony," the art of a man not able "to give the power in him the chance of manifesting itself in all its altitude."[56] In the decades that followed, Dove more than answered the challenge, finishing at an "altitude" not often approached by artists in their last years. The clear, direct abstract forms and colors of the late work were well suited to convey the plainspoken authenticity of Dove's voice, the unadorned honesty and sincerity to which Frank Stella was to respond: "I loved Arthur Dove when I was young, and I still think he was a wonderful painter. . . . I would like to be a successor . . . by following in that tradition."[57] Dove's art speaks of the power of painting. As such, it is part of a modern tradition whose possibilities are still being explored today.

NOTES

The diaries referred to in this essay were kept by Helen (Reds) Torr Dove in 1938 and 1939, and by Arthur Dove thereafter; see Dove Papers, reel 40 (1938, 1939), reel 725 (1940–44), and reel 4681 (1945), Archives of American Art. When a diary entry is identified in the text, no note is given. Dated information for which no source is given is from the diaries.

The entries are brief, cryptic, and often difficult to read, but they are enormously useful and revealing. I wish to thank Pam Koob, my student in the Graduate Program at Hunter College, for her assistance with this and other research matters.

1. The chronology of the move, as recorded in the diaries, is as follows: on April 16, 1938, the Doves left Geneva by train and traveled to Long Island; from there they visited New York City on April 19 to see Dove's show; on April 21, they found a place to live in Centerport, a small ex-post office and store, which they rented on April 22 for $10 a month until the sale could be completed. By April 30, Arthur had taken ill. He remained on Long Island at his son's house when Reds and the son traveled to Geneva on May 17 to pack and, one surmises, to settle matters there. On May 30, Reds and William Dove drove back to Long Island.

2. Diary, June 2, 1938: Reds noted that "Arthur and I moved into Centerport house." Ibid., June 7: they purchased the house from their neighbor, Captain Benham, for $980.

3. Ibid., December 17, 1942.

4. See, for example, Ann Lee Morgan, *Arthur Dove: Life and Work, with a Catalogue Raisonné* (Newark: University of Delaware Press, 1984), 60–67. Anne Cohen DePietro, "Beyond Abstraction: The Late Work of Arthur Dove," in her *Arthur Dove and Helen Torr: The Huntington Years*, exh. cat. (Huntington, N.Y.: Heckscher Museum, 1989), 39–59, has treated the period in depth. Sherrye Cohn, *Arthur Dove: Nature as Symbol* (Ann Arbor, Mich.: UMI Press, 1985), 81–90, discusses the late work from a specialized point of view.

5. Inclusion of Dove in an exhibition of American art in the thirties as one of this country's best painters at the time does not, of course, preclude discussion elsewhere of his work either before or after the 1930s; see William C. Agee, *The 1930s: Painting and Sculpture in America*, exh. cat. (New York: Whitney Museum of American Art, 1968), 9. Unfortunately, Theodore E. Stebbins, Jr., "The Memory and the Present: Romantic American Painting in The Lane Collection," in idem and Carol Troyen, *The Lane Collection: Twentieth-Century Paintings in the American Tradition*, exh. cat. (Boston: Museum of Fine Arts, 1983), 12, n. 4, quoted my words so selectively as to suggest I had discounted Dove's later work and had thus distorted the history of American modernism.

6. See especially Charles C. Eldredge, *Arthur Dove: Small Paintings*, exh. cat. (New York: American Federation of Arts, 1997). I am grateful to Professor Eldredge for generously allowing me to read his essay prior to publication.

7. See, for example, Sanford Schwartz, "On Arthur Dove," *Artforum* 14 (February 1976), 89–91. Only Sasha M. Newman, *Arthur Dove and Duncan Phillips: Artist and Patron*, exh. cat. (Washington, D.C.: The Phillips Collection, 1981), has treated Dove as an aware and active artist in the larger world.

8. The range of their reading is well documented in the diaries.

9. Arthur G. Dove, "291," *Camera Work*, no. 47 (July 1914), 37.

10. See William C. Agee, *Kenneth Noland: The Circle Paintings, 1956–1963*, exh. cat. (Houston, Texas: Museum of Fine Arts, 1993), 23–31, for a fuller discussion of this process.

11. Arthur G. Dove, in Arthur Jerome Eddy, *Cubists and Post-Impressionism* (Chicago: A. C. McClurg, 1914), 48. See also Morgan, *Dove: Life and Work*, 39–47.

12. "Notes by Arthur G. Dove," in *Dove Exhibition*, exh. brochure (New York: The Intimate Gallery, 1929), n.p.

13. Ibid.

14. Diary, December 8, 1942.

15. Arthur Dove to Alfred Stieglitz, February 1938; Morgan 1988, 395.

16. Ibid., probably June 19, 1938; Morgan 1988, 421.

17. It is not clear which of the two watercolors Dove was referring to in these entries. Although neither watercolor is dated, they were invoiced as of 1939 when sold by the Downtown Gallery in 1962 to the Marion Koogler McNay Institute (now McNay Art Museum), San Antonio, Texas, where the invoice is on file.

18. In diary entries for June 19, 1939, Dove made special mention of Salvador Dalí and "his declaration of the Independence of the Imagination," and on July 20, 1939, he noted one word: "Surrealism."

19. Diary, December 17, 1942.

20. This history was first traced in 1968 in Agee, *The 1930s*, n.p.

21. Diary, April 17 and 23, 1936.

22. Ibid., July 23, 1936. "Gallatin's book" was probably the catalogue of the collection (*Gallery of Living Art: A. E. Gallatin Collection* [New York: The Gallery, 1933]). In addition, Dove probably had a copy of Alfred H. Barr, Jr., *Cubism and Abstract Art*, exh. cat. (New York: The Museum of Modern Art, 1936), or possibly idem, *Dada, Surrealism, and Fantastic Art*, exh. cat. (New York: The Museum of Modern Art, 1936).

23. Ibid., June 27, 1936. See Piet Mondrian, in "Enquête," *Cahiers d'art* 10, nos. 1–4 (1935), 31.

24. Helen Torr Dove, notes, n.d. [ca. 1935?], Dove Papers, reel 4682 (frame no. illegible).

25. The date is in question between The Phillips Collection, which gives it as 1941, and Morgan, *Dove: Life and Work*, who gives it as 1940 (no. 40.16).

26. See Arthur G. Dove, in Samuel M. Kootz, *Modern American Painters* (New York: Brewer & Warren, 1930), 36–38.

27. Arthur Dove to Susan Mullet Smith, March 15, 1943, Susan Mullet Smith Papers, Archives of American Art, Smithsonian Institution, reel 1043 (frames 374–75).

28. Henry McBride, for example, critic of the *New York Sun*, was quoted by *Art News* 42 (March 1–14, 1943), 23, as saying that Dove was "the best colorist among American abstractionists."

29. In Agee, *Kenneth Noland*, 23–31, I discuss how Noland views the circle as an element of focusing and of centering the composition, a principle that extends from Cézanne to Pollock, and that was certainly followed by Dove, whose work Noland was familiar with from his visits to The Phillips Collection.

30. Robert Coates, "In the Galleries," *New Yorker* 16 (April 20, 1940), 50–53.

31. I am indebted throughout this essay to Anne Cohen DePietro, Curator at the Heckscher Museum, Huntington, New York and to Mitzi Caputo, Curator, Huntington Historical Society, for sharing with me their knowledge of Dove and the area. The large shape at left in *Long Island* is Target Rock, so named because the British used it for target practice in the Revolutionary War.

32. His experiments are well chronicled in the diaries and letters. Dove had read and been particularly impressed by Max Doerner, *The Materials of the Artist and Their Use in Painting, with Notes on the Techniques of the Old Masters*, trans. Eugen Neuhaus (New York: Harcourt, Brace, 1934). See Dove to Stieglitz, October 1, 1935; Morgan 1988, 341.

33. On Stieglitz's *Equivalents* as a precedent for the size, see below and note 52. There are approximately 190 of these Sketches. They were given in roughly equal groups by the artist's son and daughter-in-law, Mr. and Mrs. William C. Dove, to six museums beginning in 1984: Museum of Fine Arts, Boston; Amon Carter Museum, Fort Worth, Texas; The Arkansas Art Center, Little Rock; The Metropolitan Museum of Art, New York; National Gallery of Art, Washington, D.C.; and Wichita Art Museum, Kansas. See Eldredge, *Dove: Small Paintings*, for a full description. There are also ten watercolors at the McNay Art Museum, San Antonio, Texas that relate to the two *Brothers* paintings and date from 1939 to 1942.

34. Eldredge, *Dove: Small Paintings*.

35. In the Société Anonyme exhibitions of modern art held at The Brooklyn Museum in 1926 and at the Anderson Galleries in New York in 1927.

36. Arthur G. Dove, in *Arthur Dove: New Exhibition of Oils and Water Colors*, exh. brochure (New York: An American Place, 1940), n.p.

37. Dove to Stieglitz, May 4, 1942; Morgan 1988, 469.

38. Ibid., August 28, 1925; Morgan 1988, 117.

39. The standard work in this field is Linda Dalrymple Henderson, *The Fourth Dimension and Non-Euclidean Geometry in Modern Art* (Princeton, New Jersey: Princeton University Press, 1983).

40. See Dove to Stieglitz, September 3, 1936; Morgan 1988, 359.

41. See Morgan, *Dove: Life and Work*, no. 44.4. In his diary for December 16, 1942, Dove noted that he had finished "Garden" and there is no other painting from these years with the word *Garden* in the title.

42. See Diary, July 6, 1939. For the Survage designs, see The Museum of Modern Art, *Art in Our Time*, exh. cat. (New York: The Museum of Modern Art, 1939), 367.

43. For a full discussion of American color abstraction and its influence, see William C. Agee, *Synchromism and Color Principles in American Painting, 1910–1930* (New York: M. Knoedler, 1965), and idem, *Kenneth Noland*.

44. In conversation with the author, September 1996.

45. See Diary, April 3 and 5, October 20, 25, and 26, and November 12, 1943.

46. Arthur G. Dove, in *Arthur G. Dove: Paintings, 1942–43*, exh. brochure (New York: An American Place, 1943). Jackson Pollock and Robert Motherwell were also using sand in their works at this time.

47. See Diary, December 29 and 30, 1942, where Dove at first called it *Rain II*.

48. See ibid., February 20, 1944.

49. James W. Lane, "Dove: Abstract Poet of Color," *Art News* 41 (May 15–31, 1942), 21. Indeed, color is so important in Dove's work that the success of a painting generally depends upon it.

50. A quality appreciated by later painters such as Kenneth Noland. See Agee, *Kenneth Noland*, 33–35.

51. Arthur Dove, statements and notes recorded by Helen Torr Dove, n.d. [ca. 1935?], Dove Papers, reel 4682 (frame no. illegible).

52. See Dove to Stieglitz, July 7, 1942; and Stieglitz to Dove, July 8 and 17, 1942; Morgan 1988, 471. It is not clear which ones Dove acquired, however.

53. Dove to Stieglitz, August 9, 1942; Morgan 1988, 473. It is interesting to note that the installation of Dove's *Partly Cloudy* next to a Rothko of the 1950s in the permanent collection of the Museum of Art, University of Arizona, Tucson, reveals similar sensibilities.

54. Vincent van Gogh, letter to his brother, Theo, early September 1888; see Mark Roskill, ed., *The Letters of Vincent Van Gogh* (New York: Atheneum, 1963), 286.

55. Dove to Stieglitz, March 20, 1944; Morgan 1988, 490. At the same time *That Red One* looks ahead to the zonal divisions in the *Je t'aime* series of 1955–58 by Motherwell, as well as to Noland and Jules Olitski of the early 1960s.

56. Paul Rosenfeld, "Arthur G. Dove," in *Port of New York: Essays on Fourteen American Moderns* (New York: Harcourt, Brace, 1924), 174. For Rosenfeld's later appreciation of Dove, see idem, "Art—Dove and the Independents," *The Nation* 150, no. 17 (April 27, 1940), 549. Here, Rosenfeld also states his belief that the late work, after study, shows its sources in nature.

57. Quoted in Avis Berman, "Artist's Dialogue: A Conversation with Frank Stella," *Architectural Digest* 40, no. 9 (September 1983), 74.

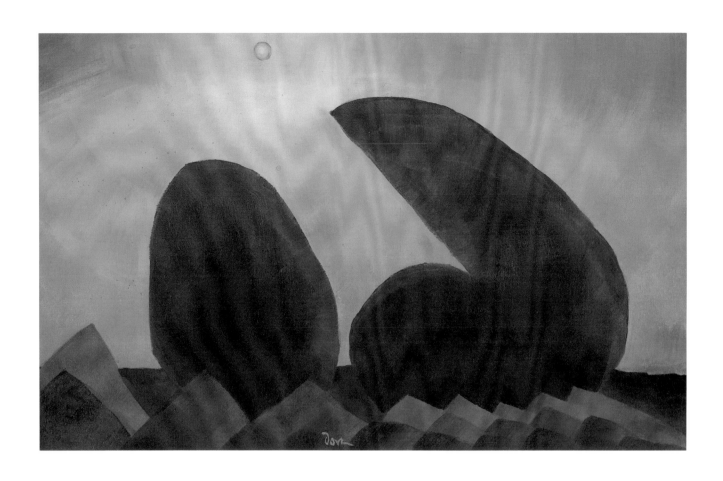

73. Long Island, 1940
Oil on canvas
20 x 32 in.
Private collection, New York

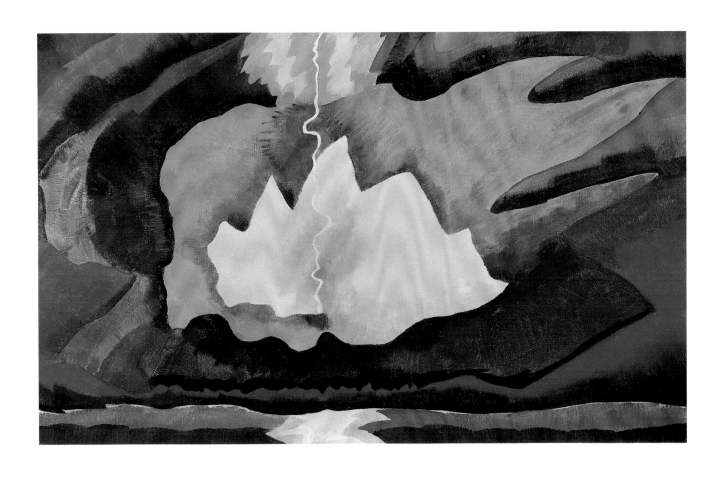

74. *Thunder Shower*, 1940
Oil and wax emulsion on canvas
20¼ x 32 in.
Amon Carter Museum, Fort Worth (1967.190)

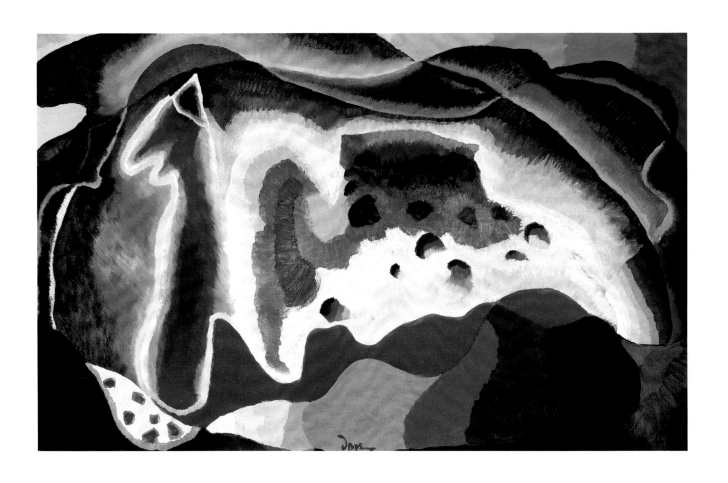

75. U.S., 1940
Oil on canvas
20 x 32 in.
Fundación Colección Thyssen-Bornemisza, Madrid

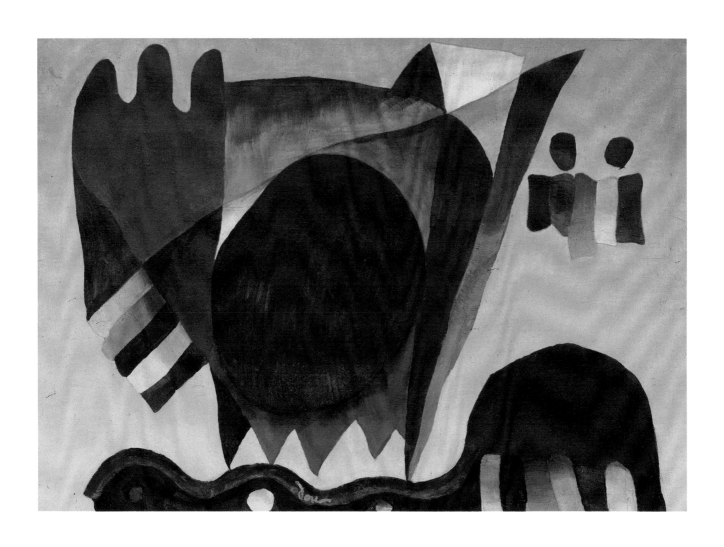

76. *Indian Summer*, 1941

Oil on canvas

20 x 28 in.

Collection of the Heckscher Museum of Art, Huntington, New York. Museum Purchase: Heckscher Trust Fund

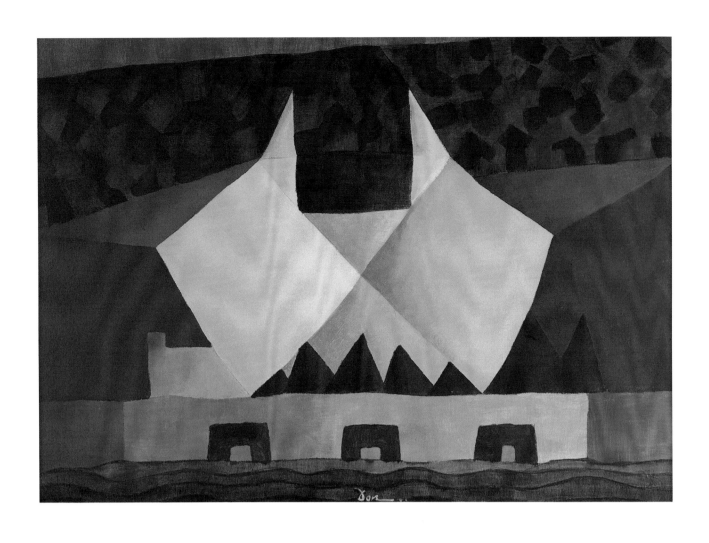

77. *The Brothers #1*, 1941
Oil on canvas
20 x 28 in.
Honolulu Academy of Arts, Gift of Friends of the Academy, 1947
(HAA 450.1)

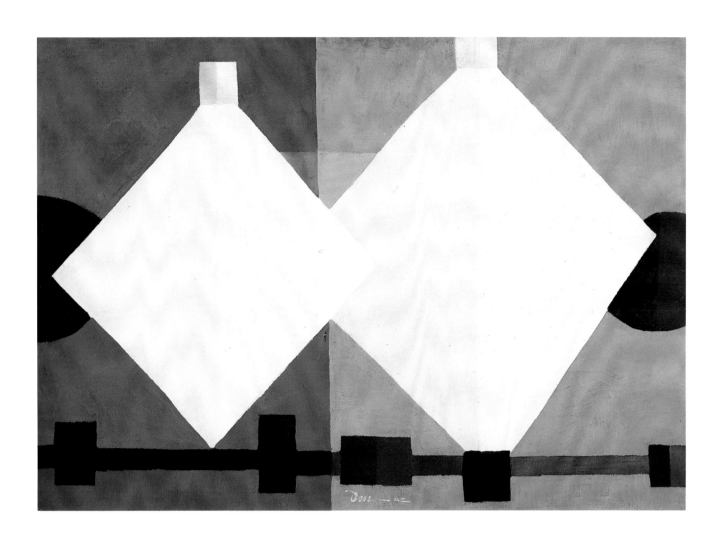

78. The Brothers, 1942

Tempera and wax emulsion on canvas

20 x 28 in.

Collection of the McNay Art Museum, Gift of Robert L. B. Tobin
through the Friends of the McNay

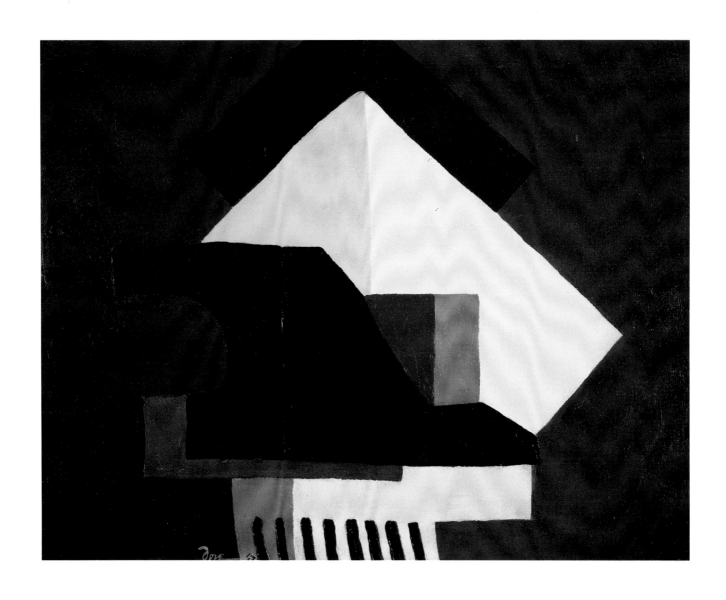

79. Structure, 1942
Oil and wax emulsion on canvas
25 x 32 in.
Curtis Galleries, Minneapolis, Minnesota

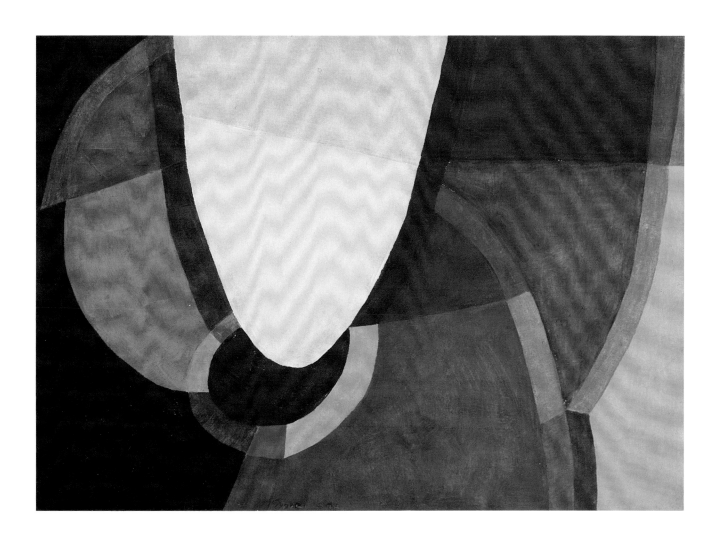

80. *Parabola*, 1942
Oil on canvas
24 x 35 in.
Michael Scharf G. I. T.

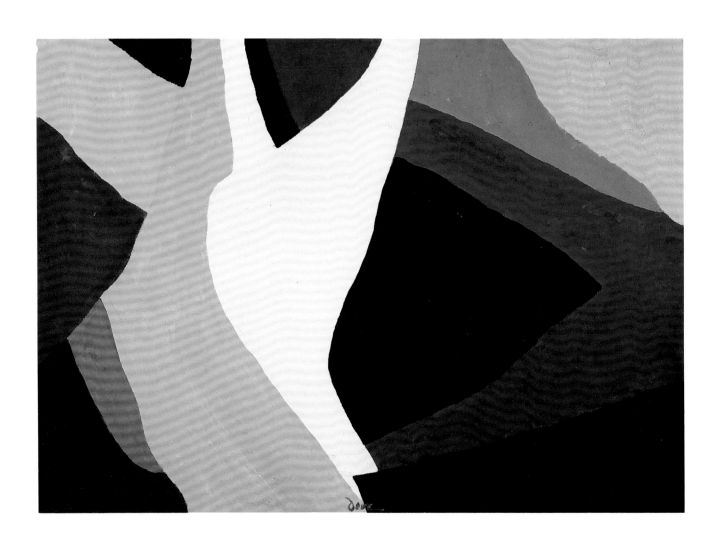

81. *Formation I*, 1943
Oil and wax emulsion on canvas
25 x 35 in.
San Diego Museum of Art, Purchased with Funds Provided by
The Helen M. Towle Bequest

162

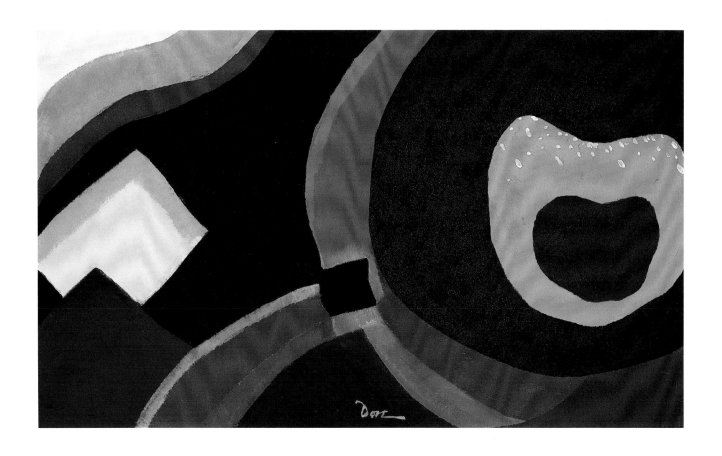

82. *Flight*, 1943
Wax emulsion on canvas
12 x 20 in.
The Phillips Collection, Washington, D.C.;
Bequest of Elmira Bier, 1976

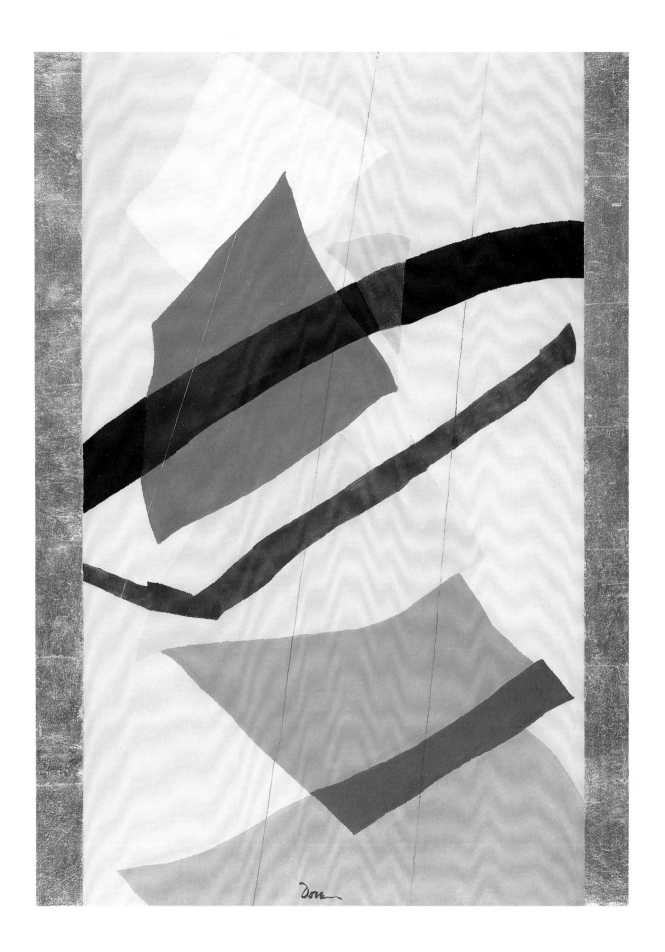

83. *Rain or Snow*, 1943
Metallic leaf and wax emulsion on canvas
35 x 25 in.
The Phillips Collection, Washington, D.C.

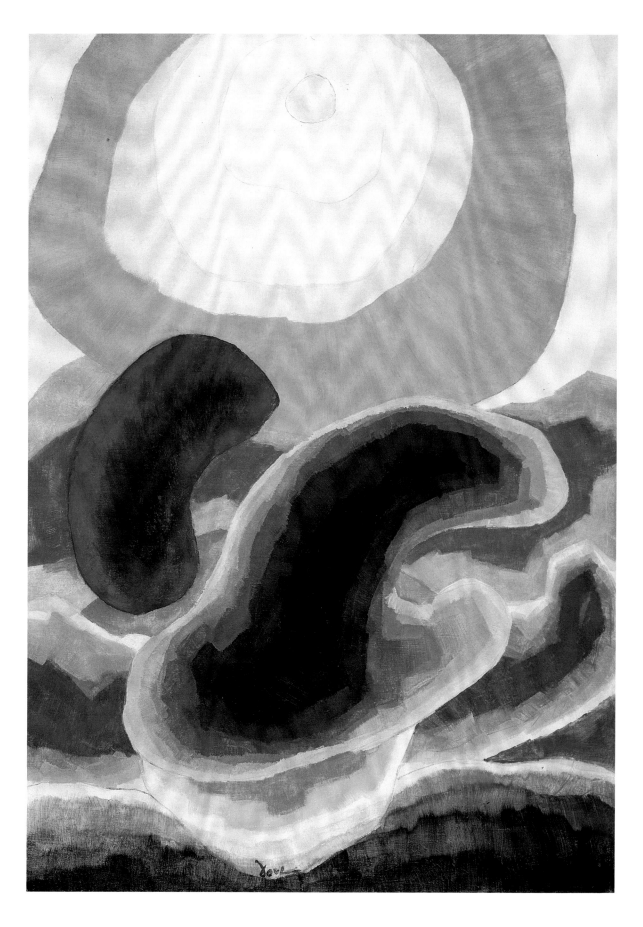

84. *Partly Cloudy*, 1942

Oil on canvas mounted on masonite

35¼ x 25¼ in.

Collection of The University of Arizona Museum of Art, Tucson;
Gift of Oliver James

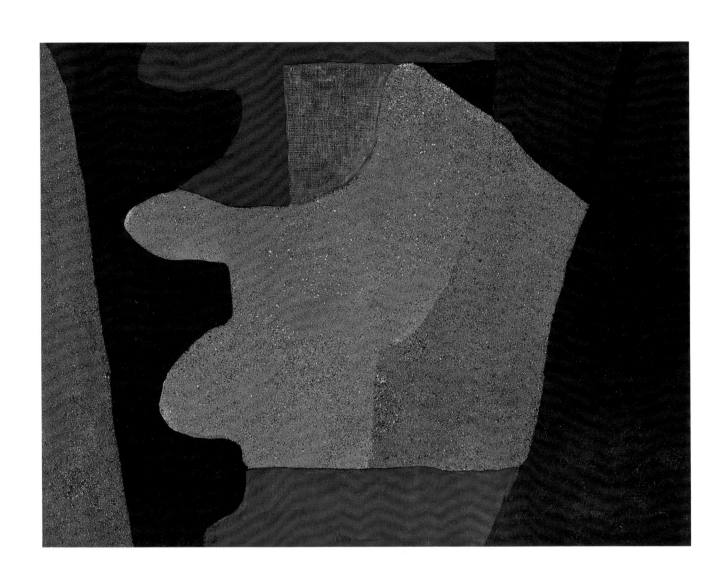

85. *Sand and Sea*, 1943
Oil and sand on canvas
27 x 36 in.
Washington University Gallery of Art, St. Louis, Missouri,
University Purchase, Bixby Fund, 1952

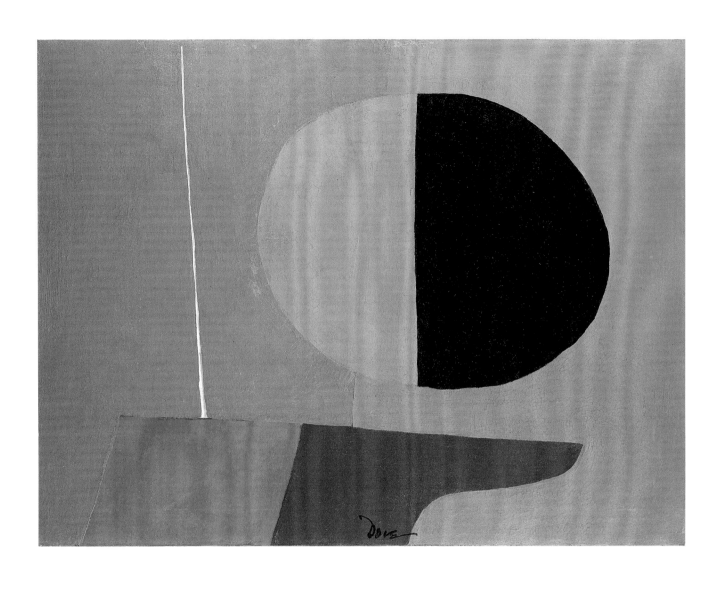

86. *Flagpole, Apple Tree and Garden*, 1943–44

Oil and wax emulsion on canvas

24 x 32 in.

William H. Lane Collection. Courtesy of the Museum of Fine Arts, Boston

167

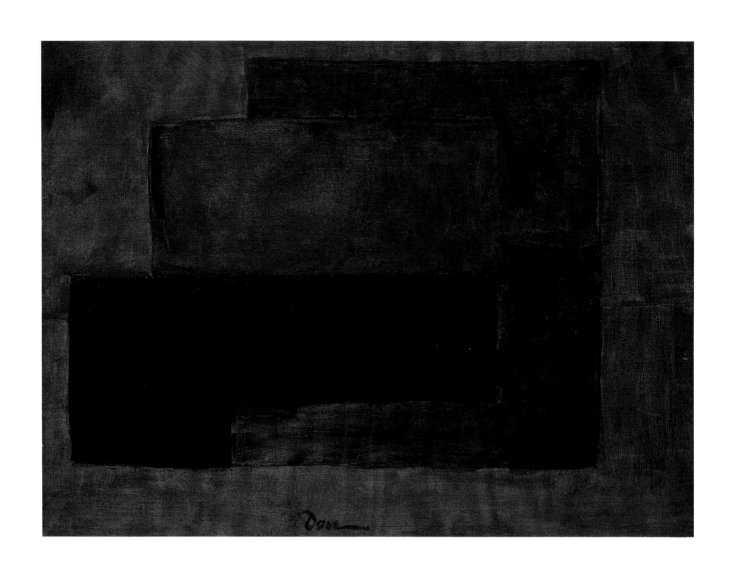

87. *Roof Tops*, 1943

Oil and resin on canvas

24 x 32 in.

Museum of Fine Arts, Boston. Gift of the William H. Lane
Foundation 1990.403

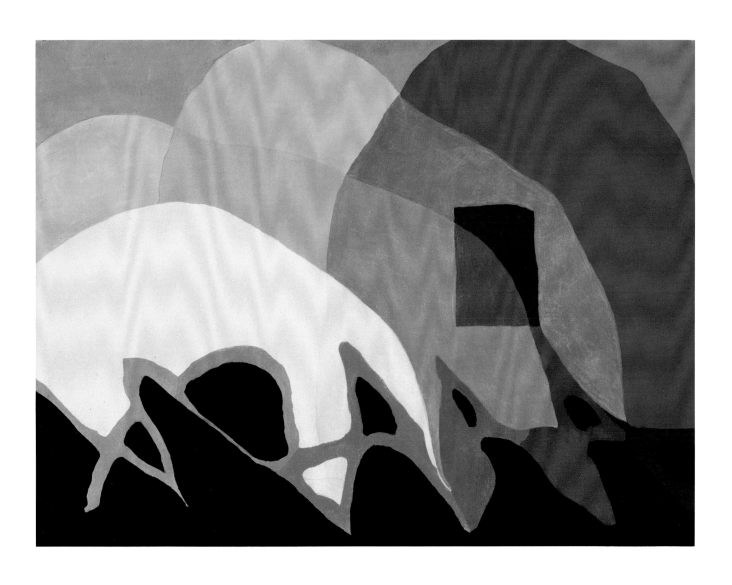

88. *Dancing Willows*, 1943

Oil and wax on canvas

27 x 35⁷/₈ in.

Museum of Fine Arts, Boston. Gift of the William H. Lane
Foundation 1990.406

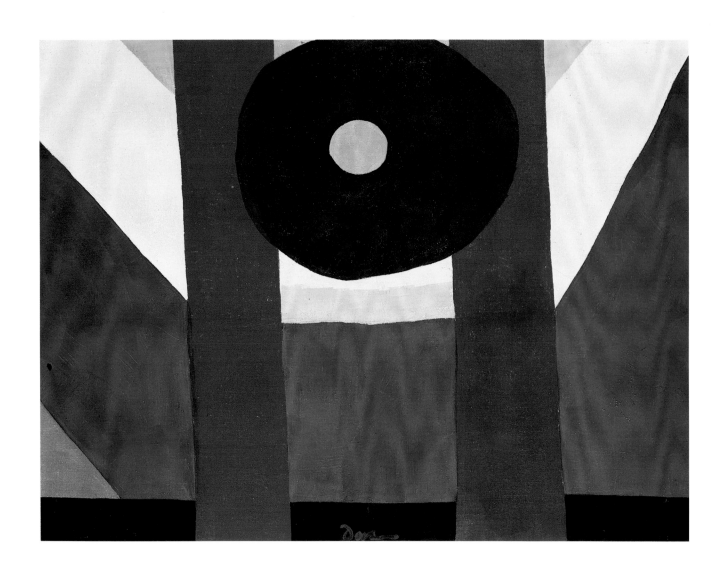

89. *That Red One*, 1944

Oil and wax on canvas

27 x 36 in.

Museum of Fine Arts, Boston. Gift of the William H. Lane
Foundation 1990.408

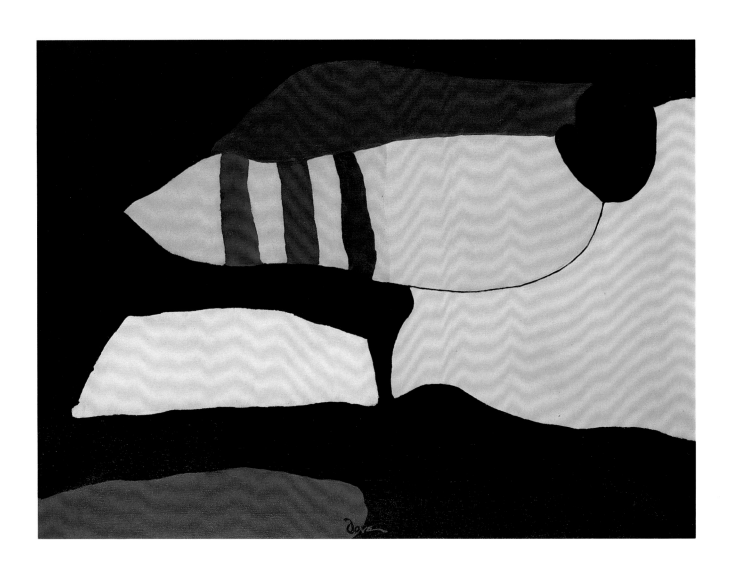

90. *Another Arrangement*, 1944

Oil on canvas

27⅛ x 36⅛ in.

Jane Voorhees Zimmerli Art Museum, Rutgers, The State
University of New Jersey

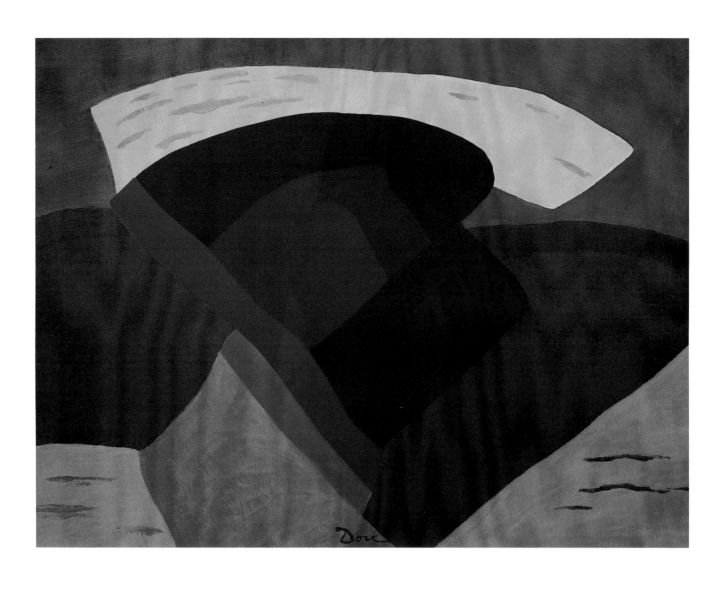

91. *The Other Side*, 1944
Oil on canvas
21 x 28 in.
Munson-Williams-Proctor Institute Museum of Art, Utica, New York

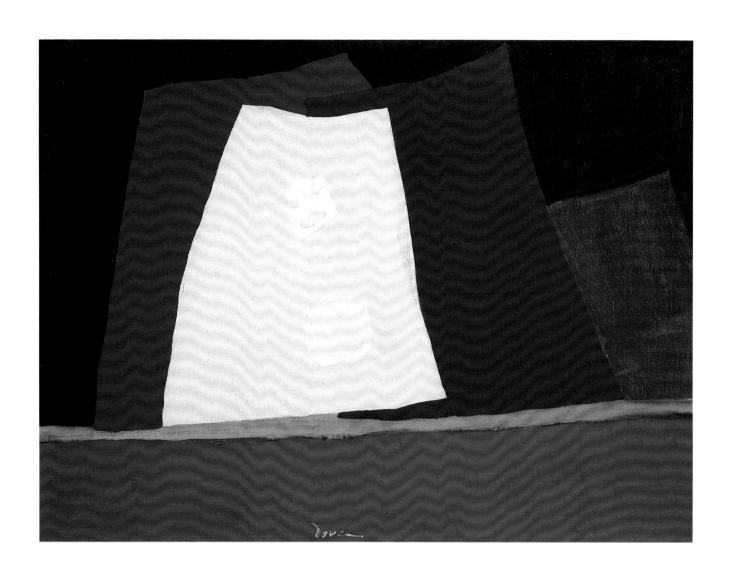

92. *Flat Surfaces*, 1946
Oil on canvas
27 x 36 in.
Brooklyn Museum of Art, Dick S. Ramsay Fund 55.21

93. Alfred Stieglitz (1864–1946)
Dove, ca. 1922

Gelatin silver print

9³⁄₈ x 7¹⁄₂ in.

Philadelphia Museum of Art: from the collection of Dorothy
Norman

Chronology

Dove as a child
Courtesy Arthur G. Dove Estate

512 South Main Street, Geneva
Courtesy Geneva Historical Society,
New York

1880

August 2, Arthur Garfield Dove born in Canandaigua, Ontario County, New York, the first child of William and Anna Chipps Dove. Father serves as County Clerk.

1885

Family moves to Geneva, New York, where father becomes a successful brick manufacturer and contractor.

1889

Dove meets Newton Weatherly, a truck farmer and avocational naturalist and artist, who lives across from his family on North Main Street in Geneva.

1892

Birth of brother, Paul.

1896

Family moves to 512 South Main Street, a more affluent neighborhood in Geneva.

1899

Graduates from public high school. Enrolls at Hobart College, Geneva.

1901

Transfers to Cornell University, where he registers in prelaw program at his father's insistence. Enrolls in art classes at School of Mechanical Engineering with Charles Wellington Furlong.

1903

Graduates from Cornell University with a B.A. Moves to New York. Begins illustrating for periodicals such as *Century*, *Cosmopolitan Magazine*, and *Life*.

1904

Joins Society of Illustrators. Marries Florence, daughter of George C. Dorsey, 517 South Main Street, Geneva, his boyhood sweetheart. They live on Stuyvesant Square.

1906

Meets Robert Henri, John Sloan, and William Glackens, all of whom encourage him to concentrate on painting.

1908

The Doves leave for France. They spend time in Paris, but Dove apparently paints primarily in parts of the country outside Paris, especially at Cagnes-sur-Mer, in the South of France. May have made short trips to Spain and Italy. Meets Alfred Maurer. Alfred Stieglitz, who was subsequently to become Dove's lifelong friend, dealer, and patron, begins showing works other than photographs at his Gallery of the Photo-Secession, known as 291 from its address, 291 Fifth Avenue, New York; also begins to reproduce painting and sculpture in his publication, *Camera Work*.

1909

The Doves return to New York. *The Lobster*, 1908, is exhibited at the Salon d'Automne, Grand Palais, Paris. Dove resumes illustration but longs to work full-time as an artist. Meets Stieglitz sometime in late 1909/early 1910.

1910–11

Shows *The Lobster* at 291 in "Younger American Painters," along with work by Maurer, John Marin, Marsden Hartley, Max Weber, Arthur B. Carles, and Edward Steichen. Son, William, born. The family moves to Westport, Connecticut, where Dove has purchased a farm with the aim of earning a living through farming and commercial illustrating. Social life includes contact with other residents such as Van Wyck Brooks, Sherwood Anderson, Paul Rosenfeld, Marin, and Paul Strand. Among frequent visitors are Maurer and Abraham Walkowitz. Begins to work in pastel.

1912

First one-person exhibition at 291. Subsequently, shows some ten pastels (the so-called Ten Commandments) at

Thurber Galleries, Chicago, where he visits the exhibit. Relinquishes the first farm and purchases another, Beldon Pond, near Westport.

1913

The Armory Show (which Dove does not participate in).

1914

Outbreak of World War I.

1916

Participates in the Forum Exhibition of Modern American Painters, Anderson Galleries, New York.

1917

America enters the war. 291 closes; the last issue of *Camera Work* appears. Dove apparently stops painting and confines himself to charcoal drawing.

1918

Dove gives up farming and returns full-time to commercial illustration for source of livelihood. Spends winters in New York, summers in Westport. Stieglitz leaves his wife to live with Georgia O'Keeffe. End of World War I.

1920

Women in the United States gain right to vote.

1921

Dove's father dies. Dove resumes painting. Leaves his wife and son for Helen (Reds) Torr, wife of the illustrator Clive Weed, who with her husband was in the Doves' circle of acquaintances in Westport. Dove and Torr take up life together on a houseboat in the Harlem River.

1922

Purchases a 42-foot yawl, the *Mona*, as a residence for himself and Torr; they sail her around Long Island Sound in the vicinity of Port Washington, Lloyd Harbor, and Huntington Harbor.

The Mona
Courtesy Arthur G. Dove Estate

Dove on board the Mona
Courtesy Arthur G. Dove Estate

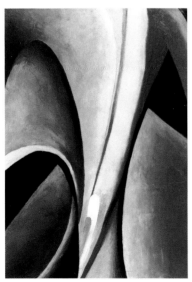

Georgia O'Keeffe (1887–1986)
Untitled (*Abstraction*)
Oil on canvas
10 x 7 in.
Private collection

1924

The *Mona* is moored at Halesite, Long Island. Dove produces his first assemblage. Stieglitz and O'Keeffe are married. Dove acquires *Untitled* (*Abstraction*) by O'Keeffe.

1925

Stieglitz opens the Intimate Gallery. Dove participates in "Seven Americans" exhibition at Anderson Galleries, New York.

1926

One-person show at the Intimate Gallery; Dove's first one-person show since 1912, it marks what is to become almost an annual event. Two paintings sold to the collector Duncan Phillips, thereby laying the foundation of a long-standing relationship. Participates in the International Exhibition of Modern Art organized by the Société Anonyme at The Brooklyn Museum.

1927

One-person show at the Intimate Gallery.

1928

Spends winter as caretaker on Pratt's Island, Noroton, Connecticut.

1929

Stock-market crash. Dove ceases to work as an illustrator. Stieglitz opens An American Place, his third and last gallery. Dove and Torr move the *Mona* to Ketewomoke Yacht Club, Halesite, where they have the use of a room in exchange for upkeep. Florence Dorsey Dove dies. Dove reunited with his son, William.

1930

Phillips undertakes active patronage of Dove's work with monthly stipend of $50.00 in exchange for the first choice of paintings from annual exhibition. Dove begins to produce small preparatory studies in watercolor and occasionally in pencil.

South Farmhouse
Courtesy Arthur G. Dove Estate

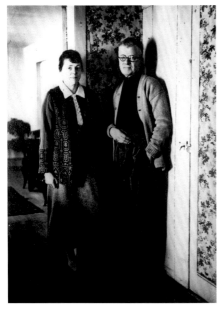

Torr and Dove in Geneva, New York,
ca. 1936
Courtesy Arthur G. Dove Estate

1932
Dove and Torr are married. Maurer takes his own life. Dove participates in the Whitney Museum's First Biennial of Contemporary American Painting.

1933
Dove's mother dies. Joint show of Dove and Torr at An American Place. Selling the Mona, they move to Geneva, New York, to settle family estate, and take up residence in small farmhouse on the south side of family property on the edge of town.

1934
Dove and Torr move into second, larger farmhouse on the property. He exhibits in Whitney Museum of American Art's Second Biennial Exhibition of Contemporary American Painting. O'Keeffe stops in Geneva on her way to Lake George from New Mexico.

1935
Exhibits at An American Place as well as in the Whitney's "Abstract Painting in America." O'Keeffe's second visit to Geneva. Dove begins to experiment with tempera.

1936
Travels to New York for what would be his only trip in five years. Meets Phillips during his exhibition at An American Place. Participates in Museum of Modern Art's "Fantastic Art, Dada, Surrealism."

1937
The Phillips Memorial Gallery, Washington, D.C., organizes Dove's first retrospective exhibition. Dove and Torr move to top floor of the Dove Block, a commercial building in town erected by his father. O'Keeffe's third and last visit to Geneva.

1938
Winds up family estate and personal affairs in Geneva. One-person show at An American Place. The Doves

move to a small house, formerly a post office, in Centerport, near Huntington, Long Island, which they occupy for the rest of Dove's life. Exhausted by the move, he is taken ill with pneumonia.

1939
Suffers first heart attack; also diagnosed with Bright's disease, a kidney condition. Thereafter, is afflicted with various ailments, tires easily, and leads life as a semi-invalid. One-person show at An American Place. Included in "Art in Our Time" at The Museum of Modern Art. The outbreak of World War II.

1940
Dove included in Annual Exhibition of Contemporary Art at the Whitney Museum of American Art. One-person show at An American Place. Also participates in "Golden Gate International Exposition" at Palace of Fine Arts, San Francisco, and Fifty-First Annual Exhibition of American Paintings and Sculptures at Art Institute of Chicago.

1941
One-person show at An American Place. Japanese attack on Pearl Harbor; U.S. enters the war.

1942
One-person show at An American Place. Acquires two of Stieglitz's cloud photographs from the Equivalents series.

1943
One-person show at An American Place. Participates in "Collages" at Art of This Century, Peggy Guggenheim's gallery in New York.

1944
One-person show at An American Place. His health rapidly deteriorating after June, Dove works only occasionally.

1945
Participates in 140th Annual Exhibition of Painting and Sculpture at the Pennsylvania Academy of the Fine Arts, Philadelphia. Also included in "Contemporary American Painting" at the California Palace of the Legion of Honor, San Francisco. End of World War II.

1946
Participates in "Pioneers of American Art" at Whitney Museum of American Art. Granddaughter, Toni, is born. Stieglitz dies in July. Dove suffers second heart attack, which leaves him half-paralyzed. Dies, November 22, in Huntington Hospital, Long Island. Ashes are interred in St. John's Cemetery, Cold Spring Harbor.

Dove, ca. 1945
Courtesy Arthur G. Dove Estate

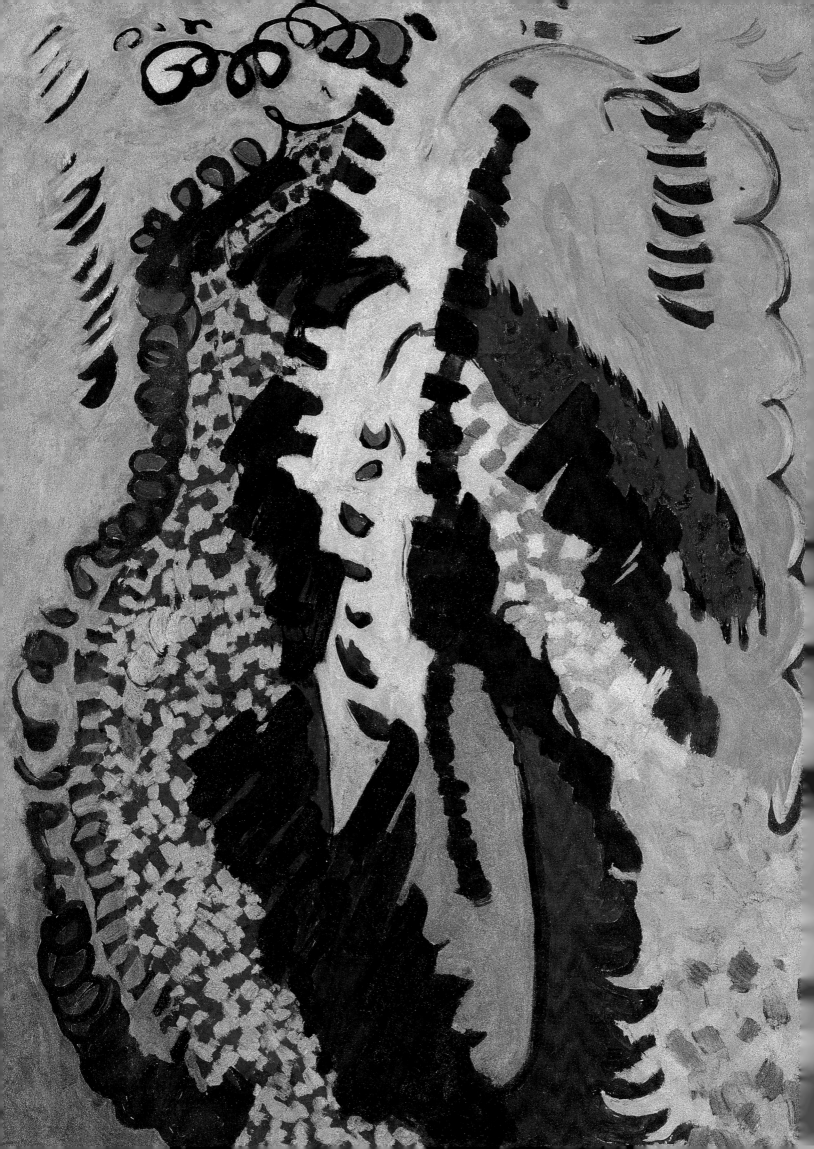

Checklist

Arthur G. Dove
George Gershwin—I'll Build a Stairway to Paradise, 1927
(detail), pl. 40
Ink, metallic paint, and oil on paperboard
20 x 15 in.
Museum of Fine Arts, Boston. Gift of the William
H. Lane Foundation 1990.407

WORKS BY ARTHUR DOVE

Still Life Against Flowered Wallpaper, 1909
Oil on canvas
25⅝ x 31⅞ in.
Curtis Galleries, Minneapolis, Minnesota

Abstraction No. 1, 1910/11
Oil on board
8½ x 10½ in.
Private collection

Abstraction No. 2, ca. 1911
Oil on paper on board
8½ x 10½ in.
Private collection

Abstraction No. 3, 1910/11
Oil on board
9 x 10½ in.
Private collection

Abstraction No. 4, 1910/11
Oil on board
8½ x 10½ in.
Private collection

Abstraction No. 5, 1910/11
Oil on board
8½ x 10½ in.
Private collection

Abstraction, Number 2, ca. 1911 [1917–1920]
Charcoal and graphite on paper
20⅝ x 17½ in.
Whitney Museum of American Art, New York. Purchase

Movement No. 1, ca. 1911
Pastel on canvas
21⅜ x 18 in.
Columbus Museum of Art, Ohio; Gift of Ferdinand
Howald
Washington, D.C., only

Nature Symbolized No. 1, or Roofs, 1911/12
Pastel on paper
18 x 21½ in.
Michael Scharf Collection

Nature Symbolized No. 3: Steeple and Trees, 1911/12
Pastel on composition board mounted on panel
18 x 21½ in.
Terra Foundation for the Arts, Daniel J. Terra Collection,
1992.33
Washington, D.C., and New York only

Sails, 1911/12
Pastel on composition board mounted on panel
17⅞ x 21½ in.
Terra Foundation for the Arts, Daniel J. Terra Collection,
1993.10
Washington, D.C., and New York only

Team of Horses, 1911/12
Pastel on composition board mounted on plywood
18⅛ x 21½ in.
Amon Carter Museum, Fort Worth (1984.29)
Los Angeles only

Plant Forms, ca. 1912
Pastel on canvas
17¼ x 23⅞ in.
Whitney Museum of American Art, New York. Purchase,
with funds from Mr. and Mrs. Roy R. Neuberger
New York and Andover only

Drawing [Sunrise II], 1913
Wolffe carbon on manila paper mounted on board
21⁷⁄₁₆ x 17¹⁵⁄₁₆ in.
Addison Gallery of American Art, Phillips Academy,
Andover, Massachusetts

Pagan Philosophy, 1913
Pastel on cardboard
21⅜ x 17⅞ in.
The Metropolitan Museum of Art, New York, Alfred
Stieglitz Collection, 1949 (49.70.74)
New York only

Abstraction, 1914/17
Oil on canvas on board
18 x 22 in.
Michael Scharf G. I. T.

Abstraction Untitled, Nature Symbolized, 1917–20
Charcoal on paper
20¾ x 17½ in.
Edward Lenkin and Katherine Meier
Washington, D.C., only

Thunderstorm, 1917–20
Charcoal on paper
21 x 17½ in.
The University of Iowa Museum of Art, Purchase,
Mark Ranney Memorial Fund, 1976.15

Sun on Water, 1917/20
Charcoal on paper
20½ x 17 in.
Michael Scharf G. I. T.

4 Creek, ca. 1919
Charcoal on paper
21½ x 17⅞ in.
The Corcoran Gallery of Art, Washington, D.C., Museum
Purchase
New York and Andover only

River Bottom, Silver, Ochre, Carmine, Green, 1920
Oil on canvas
24 x 18 in.
Michael Scharf

Mowing Machine, 1921
Charcoal on paper
18⅛ x 21⅞ in.
Alfred Stieglitz Collection, Fisk University, Nashville,
Tennessee
Andover and Los Angeles only

Thunderstorm, 1921
Oil and metallic paint on canvas
21½ x 18⅛ in.
Columbus Museum of Art, Ohio; Gift of Ferdinand
Howald
New York, Andover, and Los Angeles only

After the Storm, Silver and Green (Vault Sky), ca. 1923
Oil and metallic paint on wood panel
24 x 18 in.
New Jersey State Museum Collection, Gift of Mr. and
Mrs. L. B. Wescott, FA 1974.75

Penetration, 1924
Oil on board
21¼ x 17¾ in.
The Bedford Family Collection
New York and Andover only

Rain, 1924
Assemblage of twigs and rubber cement on metal and glass
19½ x 15⅝ in.
National Gallery of Art, Washington, D.C., Avalon Fund
1997.1.1

Ralph Dusenberry, 1924
Oil, folding wooden ruler, wood, and printed paper pasted on canvas
22 x 18 in.
The Metropolitan Museum of Art, New York, Alfred Stieglitz Collection, 1949 (49.70.36)
Andover only

Starry Heavens, 1924
Oil and metallic paint on reverse side of glass with black paper
18 x 16 in.
Michael Scharf G. I. T.

Sunrise, 1924
Oil on panel
18¼ x 20⅞ in.
Milwaukee Art Museum, Gift of Mrs. Edward R. Wehr

Ten Cent Store, 1924
Assemblage of plain and printed paper, fibers, foliage, and paint on paper
18 x 16¼ in.
Sheldon Memorial Art Gallery, University of Nebraska–Lincoln, Nebraska Art Association Collection, Nelle Cochrane Woods Memorial, 1972. N-273

Goin' Fishin', 1925
Assemblage of bamboo, denim shirt sleeves, buttons, wood, and oil on wood panel
21¼ x 25½ in.
The Phillips Collection, Washington, D.C.

Golden Storm, 1925
Oil on plywood panel
18⅝ x 20½ in.
The Phillips Collection, Washington, D.C.

Sea II, 1925
Chiffon over metal with sand
12½ x 20½ in.
Collection of Mr. and Mrs. Barney A. Ebsworth

The Critic, 1925
Collage
19¾ x 13½ x 3⅝ in.
Whitney Museum of American Art, New York. Purchase, with funds from the Historic Art Association of the Whitney Museum of American Art, Mr. and Mrs. Morton L. Janklow, the Howard and Jean Lipman Foundation, Inc., and Hannelore Schulhof
New York only

Waterfall, 1925
Oil on hardboard
10 x 8 in.
The Phillips Collection, Washington, D.C.

Huntington Harbor I, 1926
Collage on metal panel
12 x 9½ in.
The Phillips Collection, Washington, D.C.
Washington, D.C., only

Huntington Harbor II, 1926
Sand, cloth, wood chips, and oil on metal support
9⅞ x 12⅛ in.
Carnegie Museum of Art, Pittsburgh; Bequest of Mr. and Mrs. James H. Beal, 1993.189.25

George Gershwin—I'll Build a Stairway to Paradise, 1927
Ink, metallic paint, and oil on paperboard
20 x 15 in.
Museum of Fine Arts, Boston. Gift of the William H. Lane Foundation 1990.407
Andover only

George Gershwin—"Rhapsody in Blue," Part II, 1927
Oil, metallic paint, and ink on paper
20½ x 15½ in.
Michael Scharf G. I. T.

Hand Sewing Machine, 1927
Oil, cut and pasted linen, and graphite on aluminum
14⅞ x 19¾ in.
The Metropolitan Museum of Art, New York, Alfred Stieglitz Collection, 1949 (49.92.2)
Washington, D.C., only

Orange Grove in California by Irving Berlin, 1927
Oil on board
20¹⁄₁₆ x 15 in.
Fundación Colección Thyssen-Bornemisza, Madrid
Andover and Los Angeles only

Something in Brown, Carmine, and Blue, 1927
Oil on metal
27¾ x 19⅝ in.
Alfred Stieglitz Collection, Fisk University, Nashville,
Tennessee

The Park, 1927
Oil on cardboard
16 x 21 in.
The Phillips Collection, Washington, D.C.; Bequest of
Elmira Bier, 1976

Seagull Motif (Violet and Green), 1928
Oil on metal
28 x 20 in.
The Rifkin Family
Washington, D.C., New York, and Andover only

Alfie's Delight, 1929
Oil on canvas
22¾ x 31 in.
Herbert F. Johnson Museum of Art, Cornell University.
Dr. and Mrs. Milton Lurie Kramer Collection; Bequest of
Helen Kroll Kramer

Fog Horns, 1929
Oil on canvas
18 x 26 in.
Colorado Springs Fine Arts Center

Silver Log, 1929
Oil on canvas
29⅝ x 17⅜ in.
Private collection of Elaine and Henry Kaufman

Silver Sun, 1929
Oil and metallic paint on canvas
21⅝ x 29⅝ in.
The Art Institute of Chicago, Alfred Stieglitz Collection,
1949.531
Washington, D.C., only

Sun on the Water, 1929
Oil, metallic paint, and charcoal on paper
14 x 19 in.
Private collection

Telegraph Pole, 1929
Oil, metallic paint, and pencil on steel plate
28⅜ x 20⁵⁄₁₆ in.
The Art Institute of Chicago, Alfred Stieglitz Collection,
1949.535

Sand Barge, 1930
Oil on cardboard
30⅛ x 40¼ in.
The Phillips Collection, Washington, D.C.

Silver Tanks and Moon, 1930
Oil and silver paint on canvas
28³⁄₁₆ x 18¹⁄₁₆ in.
Philadelphia Museum of Art: The Alfred Stieglitz
Collection

Snow Thaw, 1930
Oil on canvas
18 x 24 in.
The Phillips Collection, Washington, D.C.

The Mill Wheel, Huntington Harbor, 1930
Oil on canvas
23¾ x 27⅞ in.
Curtis Galleries, Minneapolis, Minnesota

Ferry Boat Wreck, 1931
Oil on canvas
18 x 30 in.
Whitney Museum of American Art, New York. Purchase,
with funds from Mr. and Mrs. Roy R. Neuberger
New York and Los Angeles only

Fields of Grain as Seen from Train, 1931
Oil on canvas
24 x 34⅛ in.
Albright-Knox Art Gallery, Buffalo, New York; gift of
Seymour H. Knox, 1958

Pine Tree, 1931
Oil on canvas
30 x 40 in.
The Cleveland Museum of Art, Leonard C. Hanna, Jr.,
Fund

Sun Drawing Water, 1933
Oil on canvas
24⅜ x 33⅝ in.
The Phillips Collection, Washington, D.C.

Autumn, 1935
Tempera on canvas
14 x 23 in.
Addison Gallery of American Art, Phillips Academy,
Andover, Massachusetts, Bequest of Edward Wales Root

Cows in Pasture, 1935
Wax emulsion on canvas
20 x 28 in.
The Phillips Collection, Washington, D.C.

Moon, 1935
Oil on canvas
35 x 25 in.
Collection of Mr. and Mrs. Barney A. Ebsworth
Foundation

Naples Yellow Morning, 1935
Oil on canvas
25⅛ x 35 in.
Dr. and Mrs. Meyer P. Potamkin

October, 1935
Oil on canvas, two panels
14 x 35 in. (each panel)
Collection of The Kemper Museum of Contemporary
Art & Design. Bebe and Crosby Kemper Collection,
Purchased with funds from the R. C. Kemper Charitable
Trust and Foundation

Summer, 1935
Oil on canvas
25⅛ x 34 in.
Museum of Fine Arts, Boston. Gift of the William H.
Lane Foundation 1990.405

Sunrise I, 1936
Tempera on canvas
25 x 35 in.
William H. Lane Collection. Courtesy of the Museum of
Fine Arts, Boston

Sunrise II, 1936
Wax emulsion on canvas
25 x 35 in.
Mr. and Mrs. Meredith J. Long

Sunrise III, 1936
Wax emulsion and oil on canvas
25 x 35 in.
Yale University Art Gallery. Gift of Katherine S. Dreier to
the Collection Société Anonyme
Washington, D.C., New York, and Andover only

Golden Sun, 1937
Oil on canvas
9¾ x 13¾ in.
Private collection

Me and the Moon, 1937
Wax emulsion on canvas
18 x 26 in.
The Phillips Collection, Washington, D.C.

Flour Mill II, 1938
Oil and wax emulsion on canvas
26⅛ x 16⅛ in.
The Phillips Collection, Washington, D.C.

Holbrook's Bridge to Northwest, 1938
Oil on canvas
25 x 35 in.
Roy R. Neuberger Collection

Swing Music (Louis Armstrong), 1938
Oil and wax emulsion on canvas
17⅝ x 25⅞ in.
The Art Institute of Chicago, Alfred Stieglitz Collection,
1949.540
Andover and Los Angeles only

Long Island, 1940
Oil on canvas
20 x 32 in.
Private collection, New York
New York only

Thunder Shower, 1940
Oil and wax emulsion on canvas
20¼ x 32 in.
Amon Carter Museum, Fort Worth (1967.190)

U.S., 1940
Oil on canvas
20 x 32 in.
Fundación Colección Thyssen-Bornemisza, Madrid
Andover and Los Angeles only

Indian Summer, 1941
Oil on canvas
20 x 28 in.
Collection of the Heckscher Museum of Art, Huntington,
New York. Museum Purchase: Heckscher Trust Fund

The Brothers #1, 1941
Oil on canvas
20 x 28 in.
Honolulu Academy of Arts, Gift of Friends of the
Academy, 1947 (HAA 450.1)

Parabola, 1942
Oil on canvas
24 x 35 in.
Michael Scharf G. I. T.

Partly Cloudy, 1942
Oil on canvas mounted on masonite
35¼ x 25¼ in.
Collection of The University of Arizona Museum of Art,
Tucson; Gift of Oliver James

Structure, 1942
Oil and wax emulsion on canvas
25 x 32 in.
Curtis Galleries, Minneapolis, Minnesota

The Brothers, 1942
Tempera and wax emulsion on canvas
20 x 28 in.
Collection of the McNay Art Museum, Gift of Robert L.
B. Tobin through the Friends of the McNay
Andover and Los Angeles only

Dancing Willows, 1943
Oil and wax on canvas
27 x 35⅞ in.
Museum of Fine Arts, Boston. Gift of the William H.
Lane Foundation 1990.406

Flight, 1943
Wax emulsion on canvas
12 x 20 in.
The Phillips Collection, Washington, D.C.; Bequest of
Elmira Bier, 1976

Formation I, 1943
Oil and wax emulsion on canvas
25 x 35 in.
San Diego Museum of Art, Purchased with Funds
Provided by The Helen M. Towle Bequest

Rain or Snow, 1943
Metallic leaf and wax emulsion on canvas
35 x 25 in.
The Phillips Collection, Washington, D.C.

Roof Tops, 1943
Oil and resin on canvas
24 x 32 in.
Museum of Fine Arts, Boston. Gift of the William H.
Lane Foundation 1990.403

Sand and Sea, 1943
Oil and sand on canvas
27 x 36 in.
Washington University Gallery of Art, St. Louis,
Missouri, University Purchase, Bixby Fund, 1952
Washington, D.C., only

Flagpole, Apple Tree and Garden, 1943–44
Oil and wax emulsion on canvas
24 x 32 in.
William H. Lane Collection. Courtesy of the Museum of
Fine Arts, Boston
Andover only

Another Arrangement, 1944
Oil on canvas
27⅛ x 36⅛ in.
Jane Voorhees Zimmerli Art Museum, Rutgers, The State
University of New Jersey
New York, Andover, and Los Angeles only

That Red One, 1944
Oil and wax on canvas
27 x 36 in.
Museum of Fine Arts, Boston. Gift of the William H.
Lane Foundation 1990.408
Washington, D.C., and New York only

The Other Side, 1944
Oil on canvas
21 x 28 in.
Munson-Williams-Proctor Institute Museum of Art,
Utica, New York

Flat Surfaces, 1946
Oil on canvas
27 x 36 in.
Brooklyn Museum of Art, Dick S. Ramsay Fund 55.21

WORKS BY ALFRED STIEGLITZ

Arthur Dove, 1911
Platinum print
9⁹⁄₁₆ x 7¹¹⁄₁₆ in.
The Art Institute of Chicago, Alfred Stieglitz Collection,
1949.713

Dove, ca. 1922
Gelatin silver print
9³⁄₈ x 7½ in.
Philadelphia Museum of Art: From the Collection of
Dorothy Norman

Index